PHOTOGRAPHY
EXPOSED

Champion skydiver Cheryl Stearns trains
for an attempt at a 130,000-foot world-record
free fall. It is hoped that the jump will provide
research for astronauts forced to bail out of a
space shuttle.

Previous page: Photographer Phil Stern first
met James Dean when the actor ran a red
light on his motorcycle and nearly crashed
into Stern's car. They ended up having a
two-hour breakfast at Schwab's drugstore.

PHOTOGRAPHY
EXPOSED
THE STORY BEHIND THE IMAGE

LIFE Books

Editor Robert Andreas
Director of Photography
Barbara Baker Burrows
Creative Director Mimi Park
Deputy Picture Editor Christina Lieberman
Writer-Reporters Hildegard Anderson (Chief),
Cathrine Wolf
Copy Wendy Williams (Chief),
Christine Q. Brennan, Lesley Gaspar
Production Manager Michael Roseman
Assistant Production Managers
Leenda Bonilla, Rachel Hendrick
Photo Assistant Joshua Colow
Consulting Picture Editors
Mimi Murphy (Rome), Tala Skari (Paris)

Editorial Director Robert Sullivan

Special thanks to John Loengard,
Suzanne Hodgart and Bill Hooper

President Andrew Blau
Finance Director Craig Ettinger
Assistant Finance Manager Karen Tortora

Editorial Operations
Richard K. Prue (Director), Richard Shaffer
(Manager), Brian Fellows, Raphael Joa,
Stanley E. Moyse (Supervisors),
Keith Aurelio, Charlotte Coco, Erin Collity,
Scott Dvorin, Kevin Hart, Rosalie Khan, Marco
Lau, Po Fung Ng, Barry Pribula, Albert Rufino,
David Spatz, Vaune Trachtman, David Weiner

Time Inc. Home Entertainment

Publisher Richard Fraiman
Executive Director, Marketing Services
Carol Pittard
Director, Retail & Special Sales Tom Mifsud
Marketing Director, Branded Businesses
Swati Rao
Assistant Financial Director
Steven Sandonato
Prepress Manager Emily Rabin
Book Production Manager Jonathan Polsky
Marketing Manager Laura Adam
Associate Prepress Manager
Anne-Michelle Gallero

Special thanks to Bozena Bannett,
Alexandra Bliss, Bernadette Corbie,
Peter Harper, Suzanne Janso,
Robert Marasco, Brooke McGuire

Classic images from the pages and covers of
LIFE are now available. Posters can be ordered
at www.LIFEposters.com.
Fine-art prints from the LIFE Picture Collection
and the LIFE Gallery of Photography can be
viewed at www.LIFEphotographs.com.

Published by LIFE Books

Time Inc.
1271 Avenue of the Americas, New York, NY 10020

ISBN: 1-932994-03-3
Library of Congress Control Number: 2005900741
"LIFE" is a trademark of Time Inc.

We welcome your comments and suggestions about
LIFE Books. Please write to us at: LIFE Books, Attention:
Book Editors, PO Box 11016, Des Moines, IA 50336-1016

If you would like to order any of our hardcover Collector's
Edition books, please call us at 1-800-327-6388
(Monday through Friday, 7:00 a.m.– 8:00 p.m.,
or Saturday, 7:00 a.m.–6:00 p.m., Central Time).

Please visit us, and sample past editions of LIFE,
at www.LIFE.com.

A Russian icebreaker brought Steve Bloom to Antarctica, and the chance to photograph these Adélie penguins. This looks like a time-lapse photo, but it is indeed a proper procession of leaping penguins.

Every Picture Has a Story

by Gordon Parks

PHOTOGRAPHERS. There are millions of ordinary ones content with recording marriages, births or lovely vacation spots by the sea. And with each click of the shutter, they attempt to create a mirror-image of their own past. All who will then gaze upon the photograph will inherit that past. Every picture tells a story, and has a story.

My concern is with the dedicated photographers who, even when their approaches take on entirely different shapes, are aiming to make an image that puts mediocrity to flight. Besides whatever human drama they are attempting to capture, there are certain truths to be told. They try to get it *just right* at a moment in time. Unlike the painters, poets and composers who have touched us, the photographers face a stricter task—responding to the moment, not dwelling on it. An angel—or the devil—can lurk behind the trigger-finger on their cameras. What happens at the crucial moment becomes part of the story.

There is no place for bias. The faces of preachers, sinners, lawyers, cops, mailmen, doctors or tailors should all be examined without arrogance or prejudice. The camera can be a dangerous weapon when aimed by a treacherous hand. There is courage in being clear-eyed, and sometimes there is courage in simply getting the shot. Martin Luther King, Malcolm X, John Kennedy, Bobby Kennedy—all shot, all dead. And in the moments and hours afterward, photographers were kept busy.

There are times when photographers find themselves in places they would rather not be, never mind that the subject matter confronting them is rare. A monk sets fire to his robe and dies in its flames. One prefers not to be there. An angry Vietnamese colonel puts a pistol to a betrayer's head and fires. Eddie Adams was there, but I expect he would much rather not have been. It was a tragic and painful last moment for the criminal—and an unforgettably dark one for Eddie. Nevertheless, he did what his assignment demanded of him. When the gun fired, Eddie fired! Bob Capa, Larry Burrows, Paul Schutzer and all the others who pointed their cameras at death: We long remember these men, each of whom came to a grievous end in war.

There are stories behind the dramatic, harrowing pictures, but stories behind the lighter images, too. Cecil Beaton's Audrey Hepburn stands out among so many Audrey Hepburns—how so, and why so? What was Dmitri Kessel's fascination with Monet about, and how did he make those Monet-like photographs? Have there ever been wild animals like James Balog's wild animals, and how did he get the idea for that lion picture?

Sometimes, there is a story and the picture is missing. I can recall a photograph I did not take. A pitiful request had brought me to San Quentin's gas chamber one dreary morning. The request had been made by a condemned man, sentenced to die at dawn. I accepted his invitation simply because he had asked me to come and say a prayer for him. This was, yes, another instance when I would rather not have been there. I was placed a few feet outside the death cell. Several moments before the warden's hand would give the signal, the condemned man asked for a Bible. Quickly he was given one. He was reading from the Book of Job when the pellet dropped. His head snapped backward, then his entire body trembled violently—until he was dead. The final moments were terrible. Secretly I gave thanks to the warden for not allowing me to bring my camera.

That's a story without a picture. The pictures in this book—the exciting, the strange, the famous, the odd, the casual—all have stories behind them, stories you're about to read. The stories fascinate, though they do not necessarily fascinate the photographer. His or her job was to get the picture.

It's interesting: If you ask a famed photographer to explain his success, the response is often puzzlement. He hasn't thought the answer out for himself. When I'm asked why I chose photography along with writing, music or film, I'm tempted to say, "I was simply guided by my heart." And there would be absolute truth in the statement. You just do what you do—you open the shutter—and the interesting stories come later.

As you will see in this book, the camera is an effective medium when the wind is blowing roughest. Recently, when the tsunami struck, photographers were rushed in to record the devastation. Gunfire in Iraq is more constant and predictable than natural calamity, and photographers send back the story (each image with a story of bravery behind it). Lennart Nilsson is still using his camera to advance science—today, to help cure disease. Others are using their cameras to make art. You are using your camera at that wedding, that birth, that sublime moment on vacation.

Yes, bad and good things are happening. That's the way things are. And when they happen, some dedicated photographer's camera will surely be there—watching. Making a picture. The picture will tell a story—and have a story behind it, too. ∎

Malcolm X, here preaching to a congregation of Black Muslims at a Chicago mosque in 1963, and Parks were friends, as evidenced by the fact that Gordon serves as godfather to one of his daughters. Parks once said, "My problem was to keep faith with the people I was photographing, and at the same time hold the confidence of the editors of LIFE."

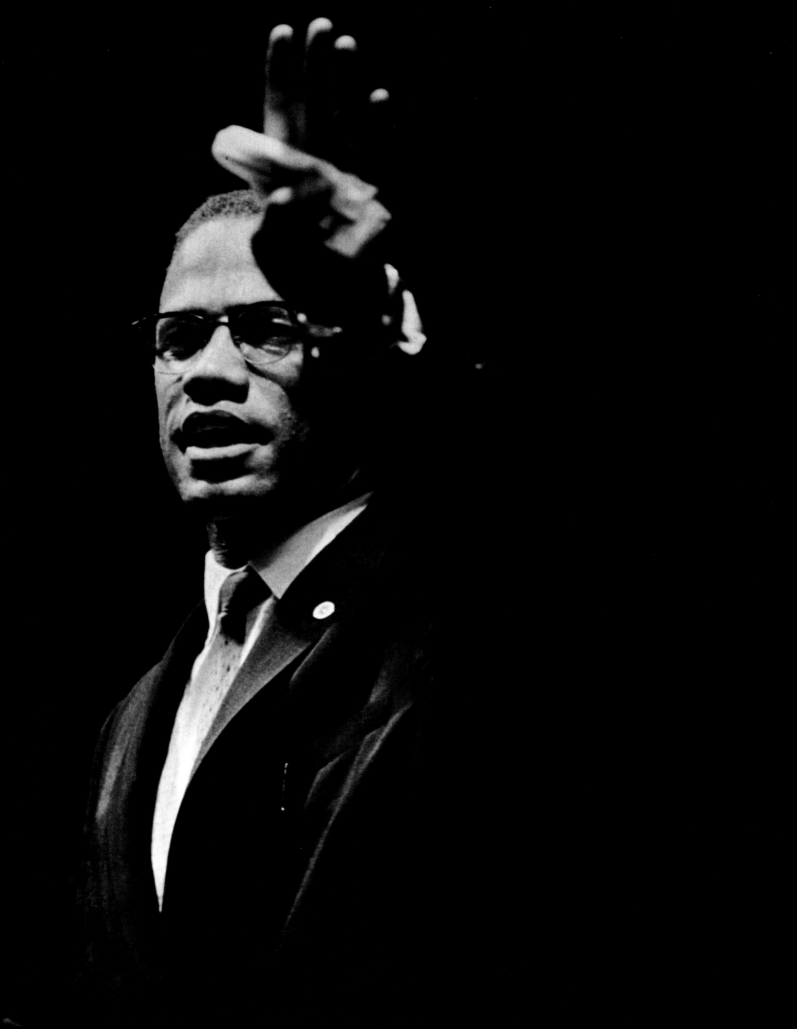

The Arts

Gjon Mili was a photographer of many talents, but it is likely that he will best be remembered for his stroboscopic work. He surely had a divine inspiration in Vallauris, France, in 1949 when he used the technique to capture the vital kinetic energy of perhaps the 20th century's greatest artist, Pablo Picasso, as the master uses a penlight to sketch a vase of flowers. This picture is the equivalent of capturing lightning in a bottle.

Photograph by **Gjon Mili**

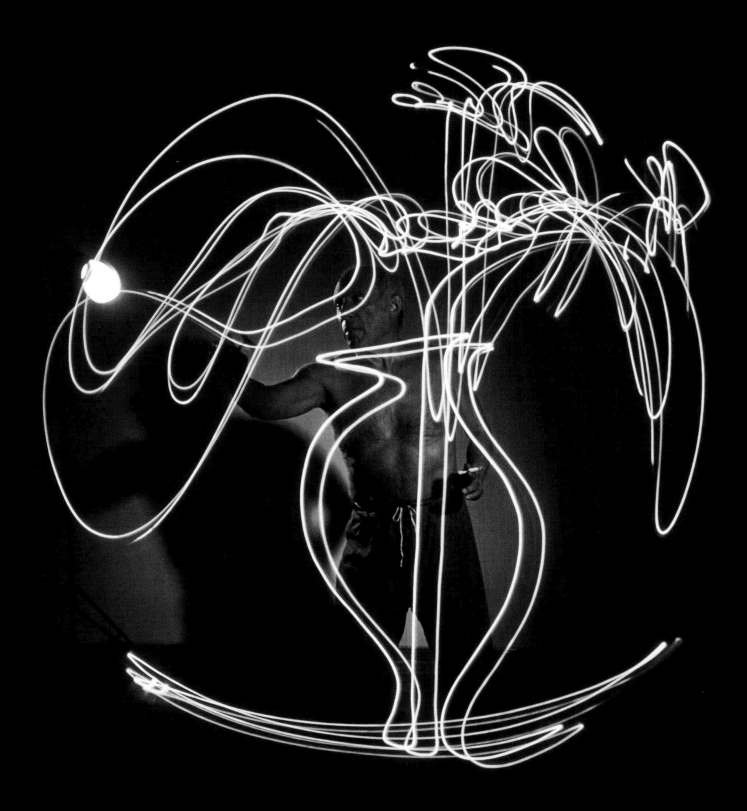

M

ovement fascinated Barbara Morgan from an early age, but the notion of recording that "rhythmic vitality" with a camera came later. Trained as a painter at UCLA, she used pen and brush to illustrate Native American dances in the 1920s. By the mid-'30s, when she met Martha Graham, Barbara's husband, Willard Morgan, the Museum of Modern Art's first curator of photography, had pointed Barbara toward photography, and she agreed to work with the great dancer and choreographer on a book. Before each shoot, Morgan would talk with Graham, attend several performances of a particular work and select specific moments to photograph. These moments were then re-created in a photography studio. The two artists enjoyed a unique collaboration. "When we worked together, and I'd be setting up my lights and she'd be doing her performance makeup, we wouldn't talk. When both of us were ready we'd lift a hand, and then we'd go and sit on the floor at quite a distance while we were 'becoming' what we were going to be and do," explained Morgan. "And then we'd lift a finger and that was it and then we'd do it." Morgan often furthered her effort to capture the essence of a dance by employing various photographic techniques, as in this double exposure image of "Lamentation," Graham's famous solo depiction of a grieving woman. Morgan went on to photograph other dancers, such as Merce Cunningham, Doris Humphrey and José Limón. Said Morgan, "I am after that instant of combustion, when all the energies of the spirit are wonderfully coordinated with the actions of the body."

Photograph by **Barbara Morgan**

Improvisation

The French photographer Guy Le Querrec got his first camera when he was 12, an Ultraflex that he received as a present. That same year, 1953, he went to the movies by himself and saw *Mogambo,* a film set in Africa starring Clark Gable, Ava Gardner and Grace Kelly. It was heady stuff for the lad, and started him dreaming of going to Africa. As time passed, Le Querrec started listening to John Coltrane and Thelonious Monk, and jazz, like photography, became an important facet of his life. He often went to jazz clubs and, at first timidly, took pictures. Eventually, jazz became his primary photographic subject. In the late '60s, he began going to Africa to shoot a variety of subjects. In 1990, the director of the French Cultural Centre in Equatorial Guinea invited him to central Africa. Le Querrec suggested he bring along the French-Italian jazz musician Aldo Romano, who said let's also take the musicians Louis Sclavis and Henri Texier. Le Querrec had an idea, a wonderful one: The trio would go from village to village, set up shop under a central baobab tree, start playing, and then just see what happened. Initially, villagers were shy and puzzled. But within an hour, they, too, became participants, completely involved in the music, sometimes bringing out their own drums and ancestral masks. This photo was taken in Pointe-Noire, Congo. Said Le Querrec, "For me, it was all a beautiful, true story."

Photograph by **Guy Le Querrec**

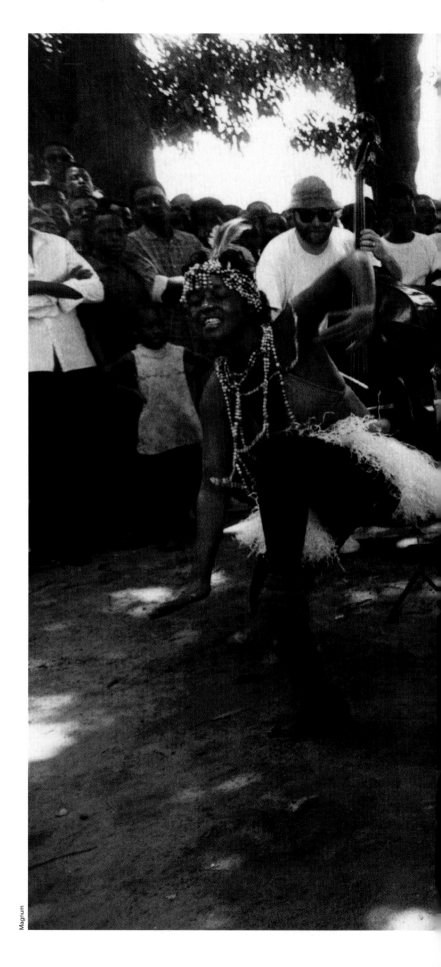

Magnum

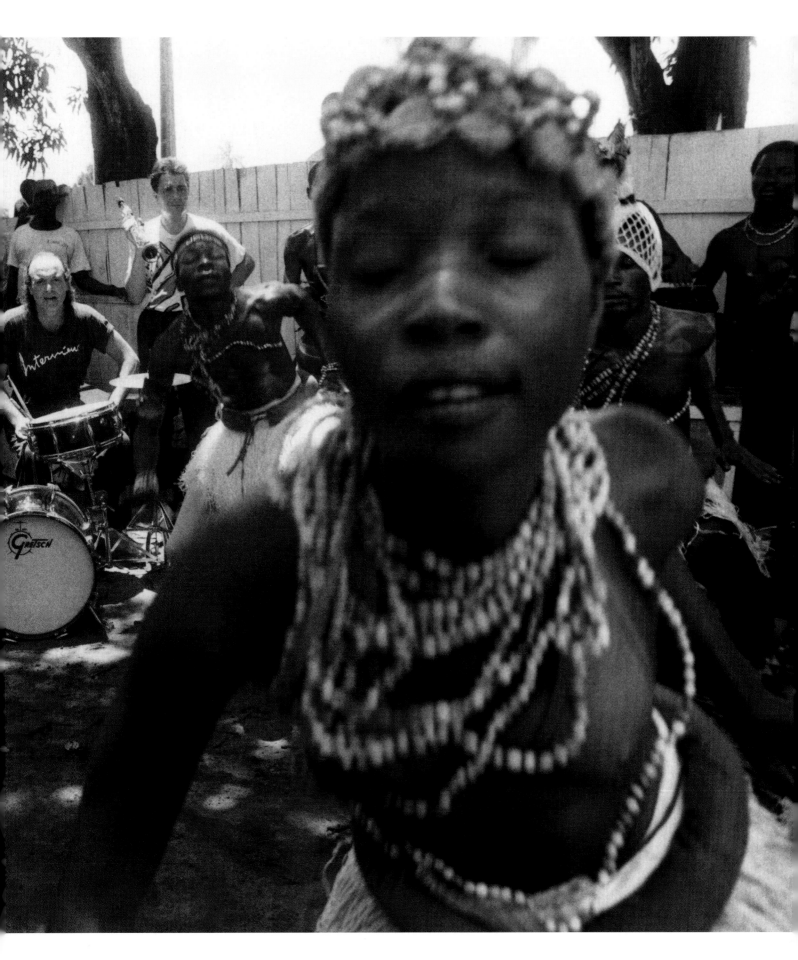

The Bright Side of the Moon

One of the most famous photographers in the world, Gordon Parks has had a long and varied career in which he has photographed movie stars and models, and revealed the boulevards of the City of Light at their most romantic. But Gordon is best known for his gritty images of the mean streets of New York and Brazil, of hardworking but impoverished Americans striving to snap the shackles of a society that often smothers the aspirations of the poor. In the 1990s, Parks was writing a fictionalized biography of the 19th century English landscape painter J.M.W. Turner, whose early period was defined by accuracy and detail, while his later canvases were essentially studies of color and light. Working on the Turner monograph, which is called *The Sun Stalker,* had a salutary effect on Parks, who began experimenting with abstract compositions that liberated him from his compulsion to concentrate on social ills. In 1998, Parks said, "You know, the camera is not meant just to show misery . . . And I think that after nearly 85 years upon this planet that I have a right, after working so hard at showing the desolation and the poverty, to show something beautiful for somebody as well. It's all there, and you've only done half the job if you don't do that." For this picture, he first created a background with a watercolor. Then he found a couple of shells that were lying about his New York City apartment and arranged them against the painting. Finally, he reached for his camera and took this enchanting photograph.

Photograph by **Gordon Parks**

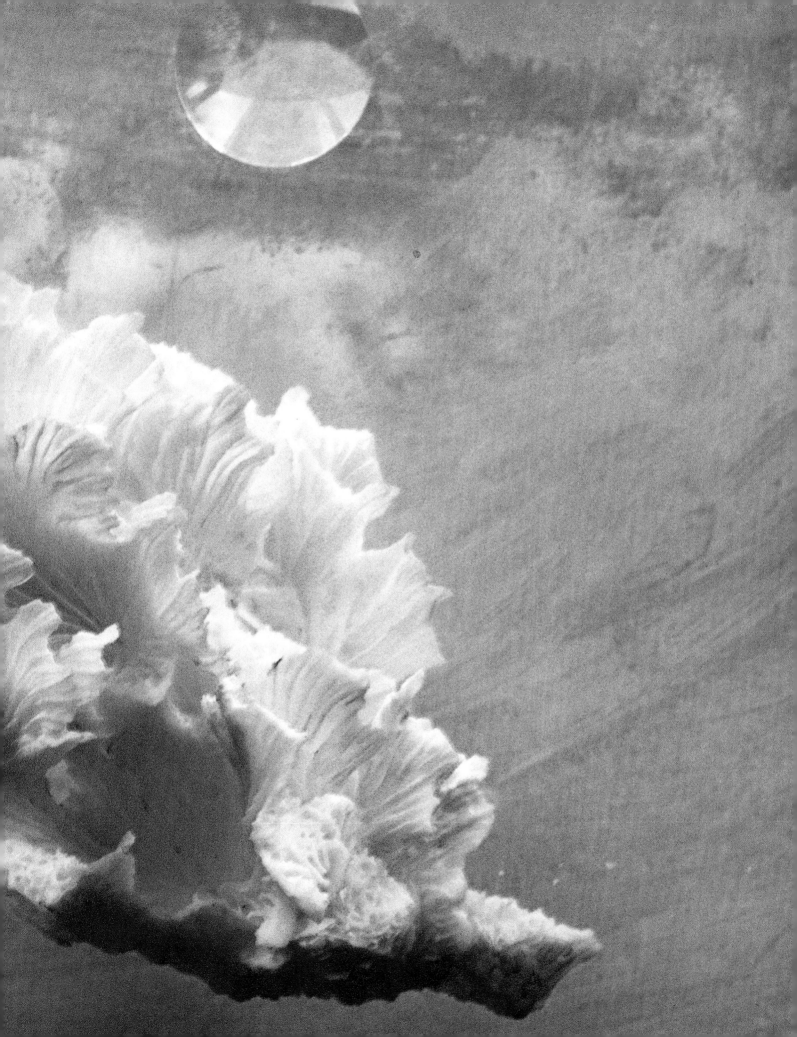

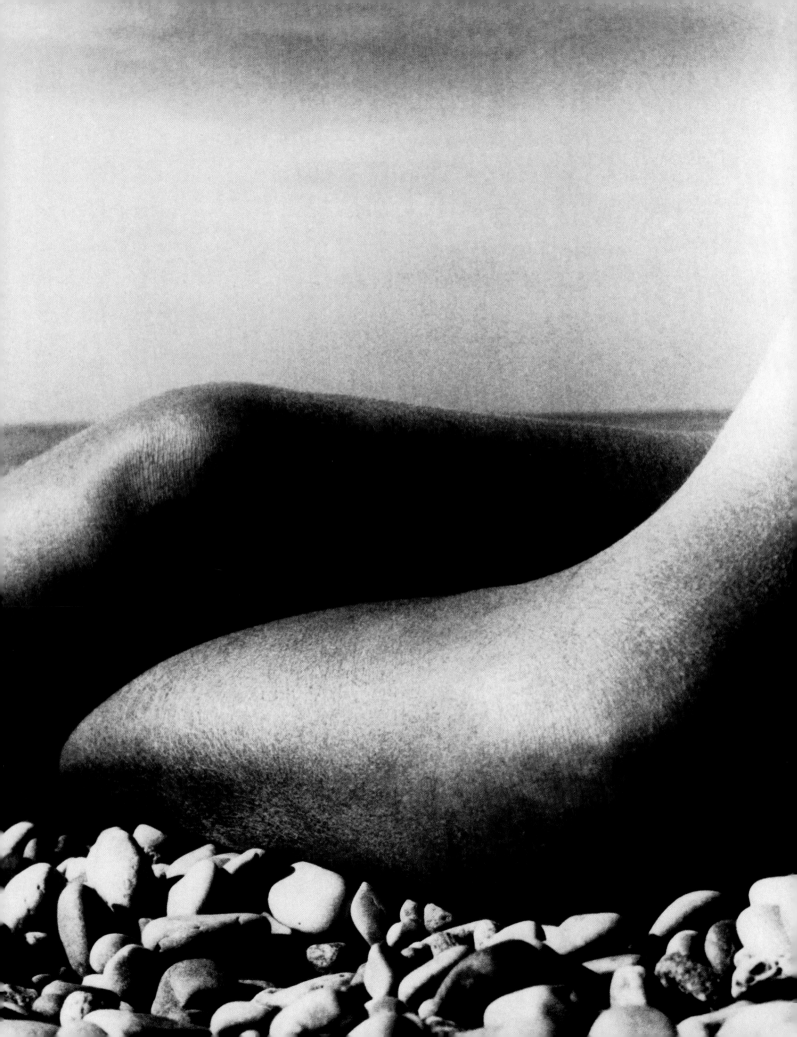

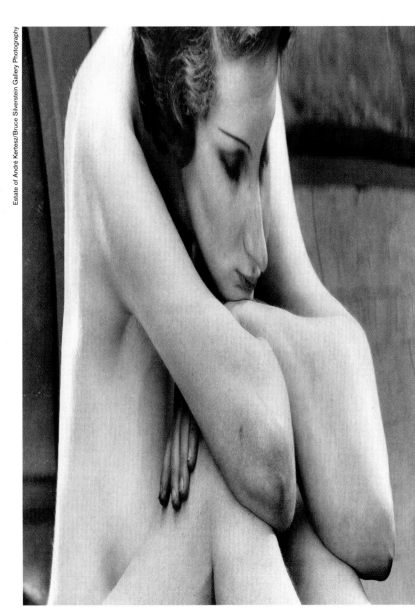

Flesh and Fantasy

The English photographer Bill Brandt dealt with a wide array of subjects, but there was at all times an element of mystery in his images—even his photojournalism. Born in 1904, he studied with the celebrated surrealist Man Ray in Paris in 1929, and they remained acquaintances for a couple of years. The specter of Man Ray would shade Brandt's career. When the picture at left was taken in 1961, he was working often with nudes, but who ever thought a model's knees could be so alluring? In the picture above, taken by André Kertesz in 1933, a different use of distortion is at work. Born in Hungary in 1894, Kertesz was an influential photographer who was part of the vital artistic community that flowered in Paris in the 1920s. He came upon distortion photography in a bizarre way. During World War I he carried his camera, which, although a worthy talisman, was unable to prevent his being wounded. He was sent to a military hospital to recuperate, and one day, while sitting around a pool with other wounded soldiers, Kertesz became intrigued by the shapes of swimmers beneath the water and began taking pictures of them. From then on, he often sought out examples of "natural distortion." For this picture, however, he employed a fun-house mirror. Despite the seemingly surreal effect, Kertesz insisted, "I am not surrealist. I am only realist . . . this is a normal realist thing that I do." And while he said he considered his fun-house images just a lark, for others they are deeply redolent of isolation, of loneliness, perhaps of despair.

Photographs by **Bill Brandt** and **André Kertesz**

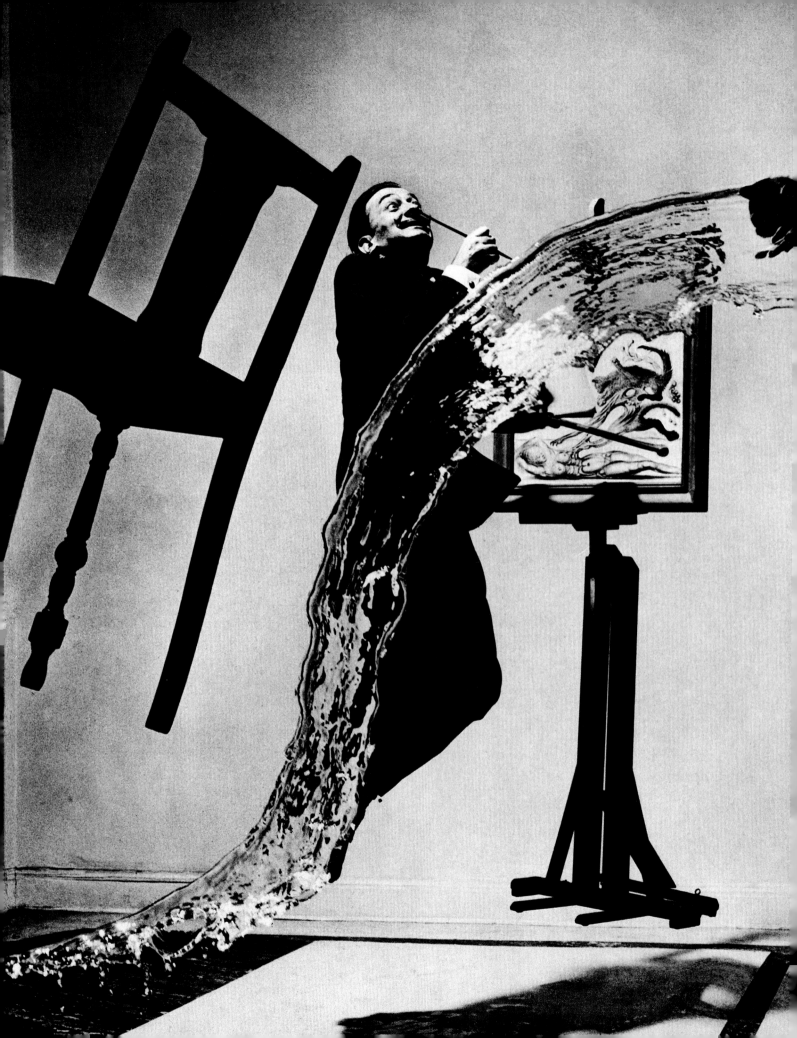

An Appropriate Portrait

We surrealists are not artists. Nor are we really scientists," Salvador Dalí once said. "We are caviar." But here, in what is, perhaps, the best-known image from his 30-year collaboration with photographer Philippe Halsman, the Spanish artist looks more like tossed salad than fish eggs. Halsman built his long and successful career on an uncanny ability to: a) get famous people to let down their guard, revealing themselves more fully; and b) capture the essence of his subject's appearance and humanity. To make this picture of Dalí in a New York studio in 1948, Halsman suspended an easel, two Dalí paintings and a stepping stool from the ceiling while his wife, Yvonne, held a chair in the air. Then, on the count of three, he had his assistants throw a trio of cats and a pail of water into the air as Dalí leapt. After each shot, Halsman would go to his darkroom, develop the film—and decide to stage the photograph yet again. "Six hours and 28 throws later, the result satisfied my striving for perfection," he said. That result, *Dalí Atomicus,* is among the most famous portraits ever taken. "Dalí likes me taking his picture because he is interested in pictures that do not simply reproduce reality," said Halsman. "Even in photos he prefers to appear outside reality."

■ Photograph by **Philippe Halsman**

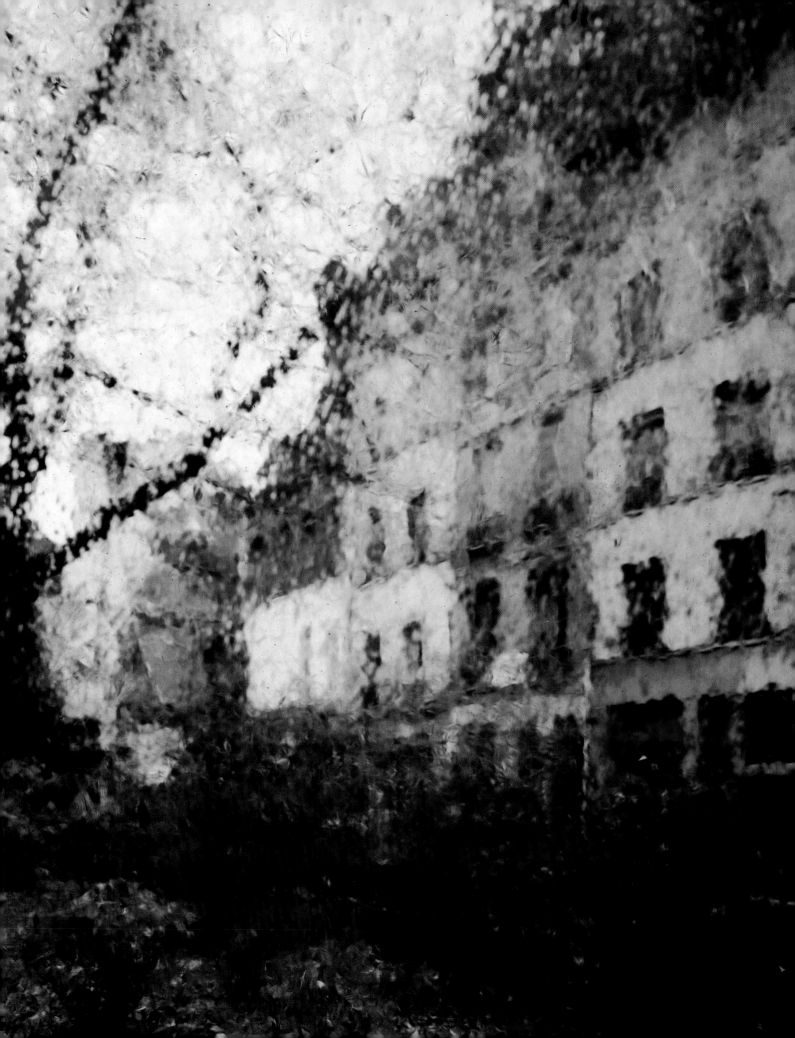

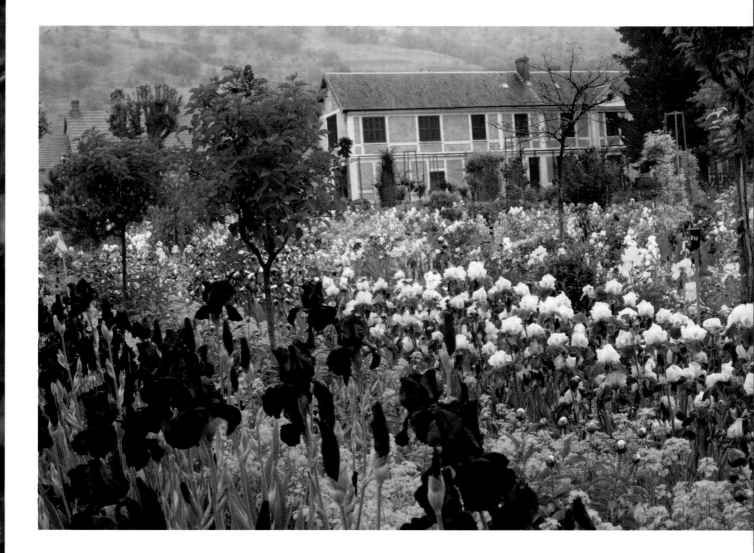

Getting the Impression

Dmitri Kessel's comfortable Ukrainian childhood was turned upside down during the Bolshevik Revolution, when Communists confiscated most of his family's possessions. Later, even his prized Brownie camera was destroyed when a soldier broke it over Dmitri's head. Drafted into the Red Army at 16, he escaped through Romania and emigrated to the United States, where he launched a 60-year career as a photographer of wars and women, mountains, mining and more. He worked hard and he worked well, yet he knew that was not always enough. "Photography can be just a matter of luck," he said. After gaining his greatest accolades for faithful renderings of famous works of art, Kessel played a joke on the genre by creating faux paintings. Looking through a windowpane full of air bubbles in Paris one day, he was inspired to become an Impressionist. He bought some bubbly glass and photographed spots around the city, including the Left Bank scene at left. Then he shared the pictures with an art expert, saying they were photographs of paintings. "Ah," intoned the expert, "Monet." Some 20 years later, after the renowned estate was restored, Kessel photographed the real thing (above): Monet's gardens at Giverny.

Photographs by **Dmitri Kessel**

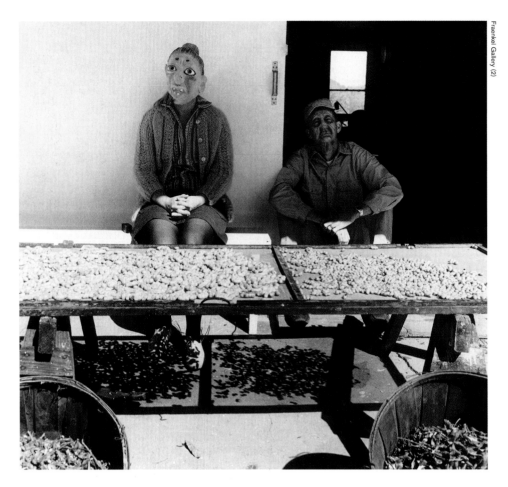

Fraenkel Gallery (2)

The Family Album

That Ralph Eugene Meatyard was born in Normal, Illinois, is at once absurd and rational. There is nothing about his work that one would consider "normal," but at the same time there is always present the ethos of Middle America. After serving in the Navy and briefly attending Williams College and Illinois Wesleyan University, he decided to become an optician and moved to Kentucky. In 1950, at the age of 25, he bought his first camera to take pictures of the first of his three children. Increasingly, he became devoted to photography, and though he attended workshops and met with veteran photographers, he was mainly self-taught. On weekends, he would take his wife, Madelyn, and the kids and motor around Lexington and its environs looking for suitable locations, which generally meant an abandoned building with a certain lighting and feel. The photo at right, taken in 1960, features sons Michael and Christopher. This eerie, gothic construct centers on a phantom-like Michael, but

the younger boy has a palpable innocence and an abiding trust in and concern for his brother. One day, Meatyard came across a store that had hundreds of masks, and he bought several of them. These masks would figure significantly in his work, as in the 64-piece series called "The Family Album of Lucybelle Crater," which was based on a character from a story by Flannery O'Connor. He began work on this project in 1970, after learning that he had cancer. The Meatyard family and a few friends were the stars of these pictures, in which every character had the name *Lucybelle Crater.* Above, that's Madelyn on the left in *Lucybelle Crater and Her Successful Peanut Farmer Friend from Port Royal, Ky., Lucybelle Crater.* Meatyard died in Lexington in 1972, leaving behind a body of work—strange, funny, mythical—that belies its weekend origins.

Photographs by **Ralph Eugene Meatyard**

22 **LIFE** THE ARTS

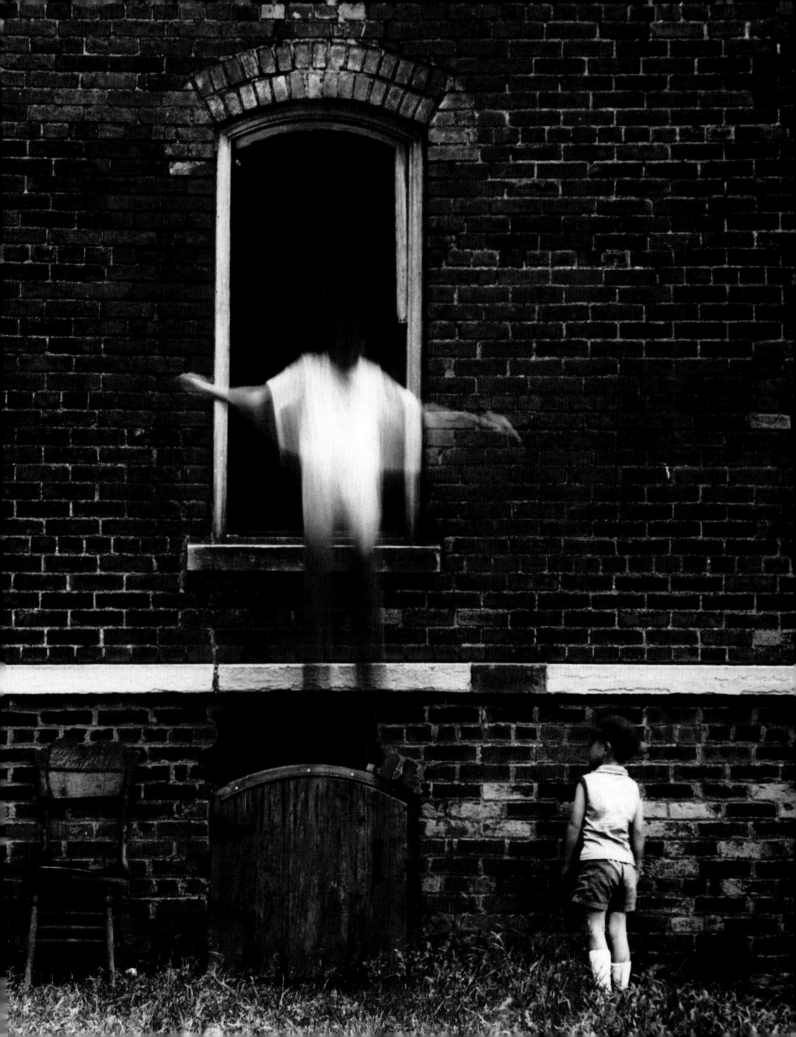

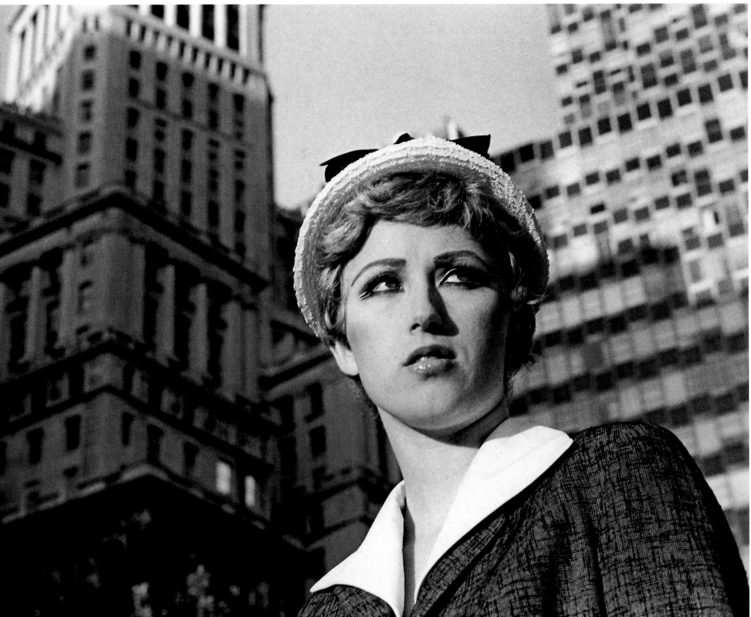

The Self As Other

In 1977, just one year out of college, Cindy Sherman began work on a devastating set of photographs that would come to be called the "Untitled Film Stills." In 1980, she produced the 69th and final entry in the series, which was acquired in toto by the Museum of Modern Art in 1995 for $1 million. Sherman appears in each of these pictures, but they are not self-portraits, at least not as normally construed. They have the uncanny appearance of stills from real films, decidedly postwar films, in which various archetypal heroines are cast in solitary, telling moments. These are dazzling, hypnotic images, wherein the dreamlike quality of cinema coalesces with Sherman's internal perceptions of clichéd stereotypes.

Numbering each photo (at right, #7; above, #21) serves to depersonalize it, but the inescapable humanity remains vivid. Because Sherman has created these pieces of art, there is necessarily some part of her in each, but what part that may be is utterly ambiguous. *Look at this, look at me,* she seems to be saying, *But no, you cannot ever come in.* Since finishing the "Stills," Sherman has produced a variety of photograph series, and in some she has continued her elegant, hypernatural self-posing. These later pictures are by turns graphic, eerie, disturbing, prurient, but always provocative.

Photographs by **Cindy Sherman**

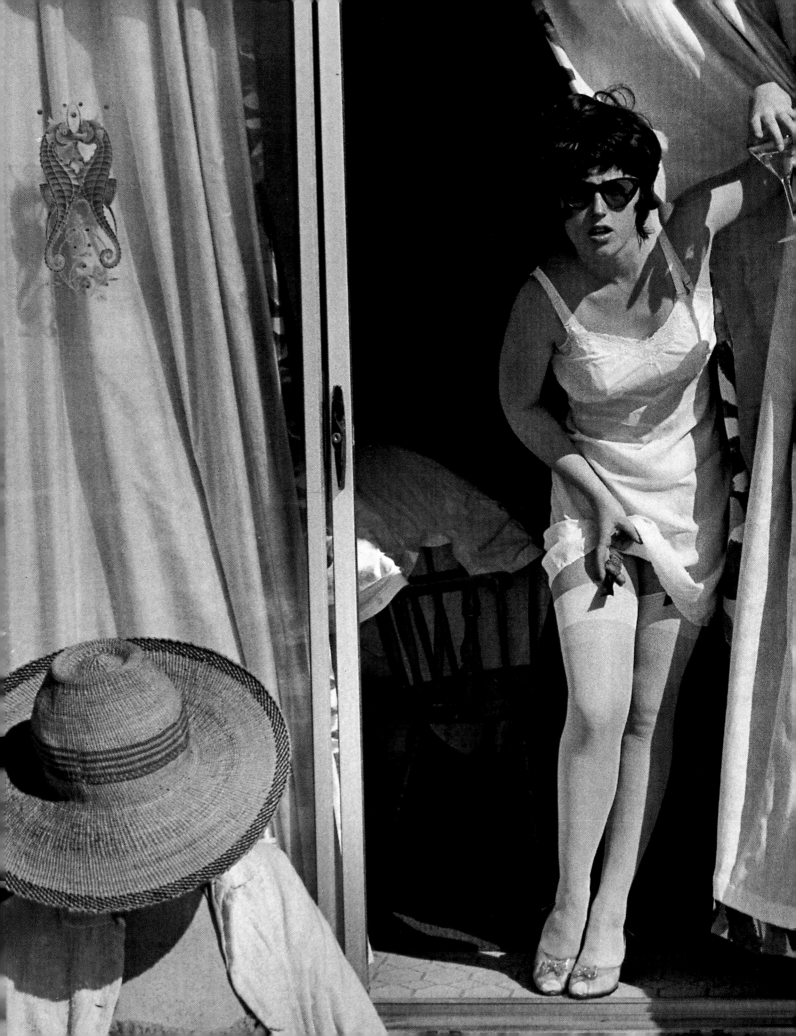

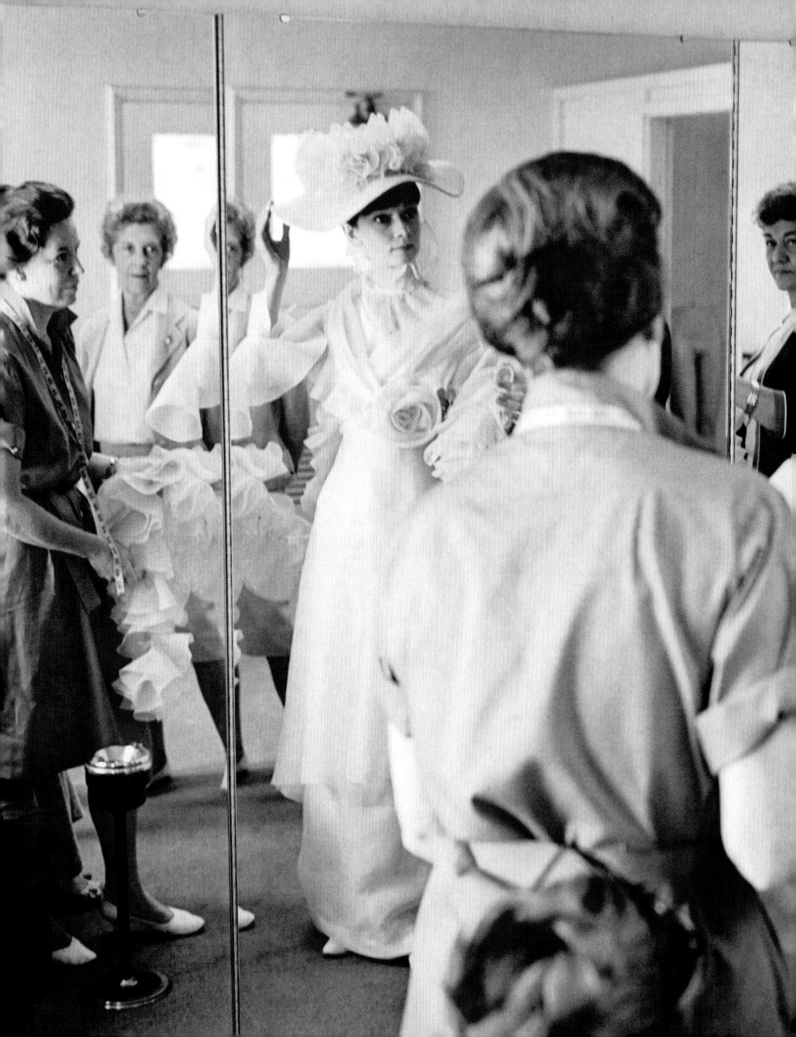

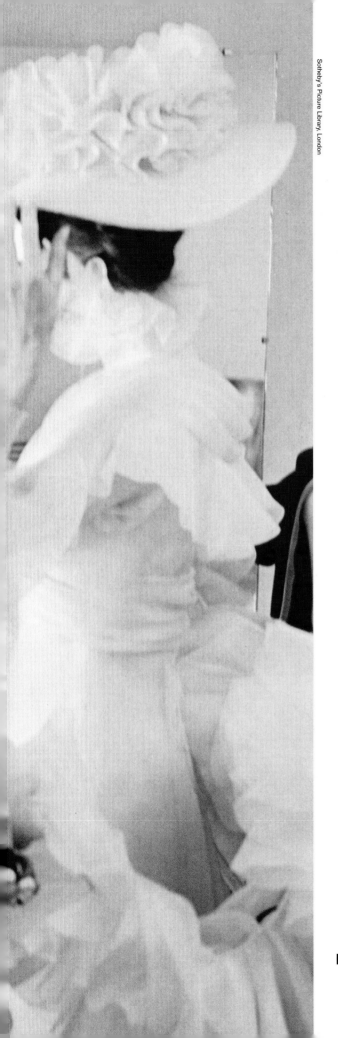

Sotheby's Picture Library, London

Camera Press/Retna

The Pursuit of Beauty

In 1907, Cecil Beaton was captivated—nay, bowled over—by the allure of glamour and the power of photography. Cecil was, at the time, three years old. Each morning, the boy would scramble into his mother's bed while she sipped tea and opened letters. As he wrote in his memoir, aptly named *Photobiography,* one morning "my eyes fell on a postcard lying in front of me . . . and the beauty of it caused my heart to leap." The card showed Lily Elsie, an Edwardian actress of note. Beaton soon began collecting picture postcards of her and other stars. Before long he wasn't just collecting photographs of fantasy and beauty, he was taking them, and he would parlay his passion for style and romance into a 50-year career as a peerless fashion photographer (at *Vogue,* for decades), an honored portraitist of royalty (in the House of Windsor and the Hills of Hollywood) and an award-winning theatrical designer. In 1963, Beaton spent 10 months designing costumes and sets for the film version of *My Fair Lady.* All of his skills and sensibilities came together now as he re-created in the sets the London of his youth, rethought every lavish costume and, meantime, made gorgeous portraits of the movie's star. Audrey Hepburn, said Beaton, was "the most interesting public embodiment of our new feminine ideal." He lived to capture such things.

■ Photographs by **Cecil Beaton**

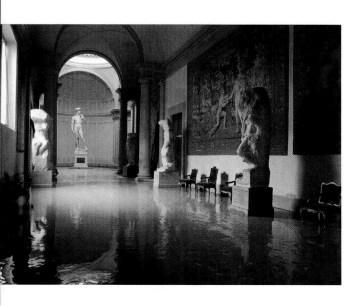

A Labor of Love

Technically, David Lees was British, but in most every other regard, he was Florentine. Born to British expatriates, he grew up in Florence and in 1945 launched his career by assisting LIFE's Fernand Bourges with color photographs of Benozzo Gozzoli's Florentine frescoes. Over the next two decades, Lees busily chronicled Italy's fashions and celebrities, its politics and parties. In November 1966, when a flood suddenly plunged Florence *sub aqua,* Lees shook off illness, hitched a ride from Pisa on a military helicopter and began to record the devastation. "Florence is my city," he wrote, "and under the mud of that flood there is a large piece of my heart." The overflow from the Arno River was everywhere, including the famous Galleria dell'Accademia (above), home to Michelangelo's *David.* Before the waters receded, conservators and restorers arrived to administer emergency treatment to works such as Taddeo Gaddi's 600-year-old frescoes of the Last Supper (right) in the refectory of the Basilica of Santa Croce. Lees tirelessly documented the delicate, painstaking work, which went on for years. Four decades later, high-water marks remain on walls and columns around Florence, but it is Lees's work—exhibited at the renowned Uffizi Gallery shortly before his death in 2004—that remains the most vivid record of the human response.

Photographs by **David Lees**

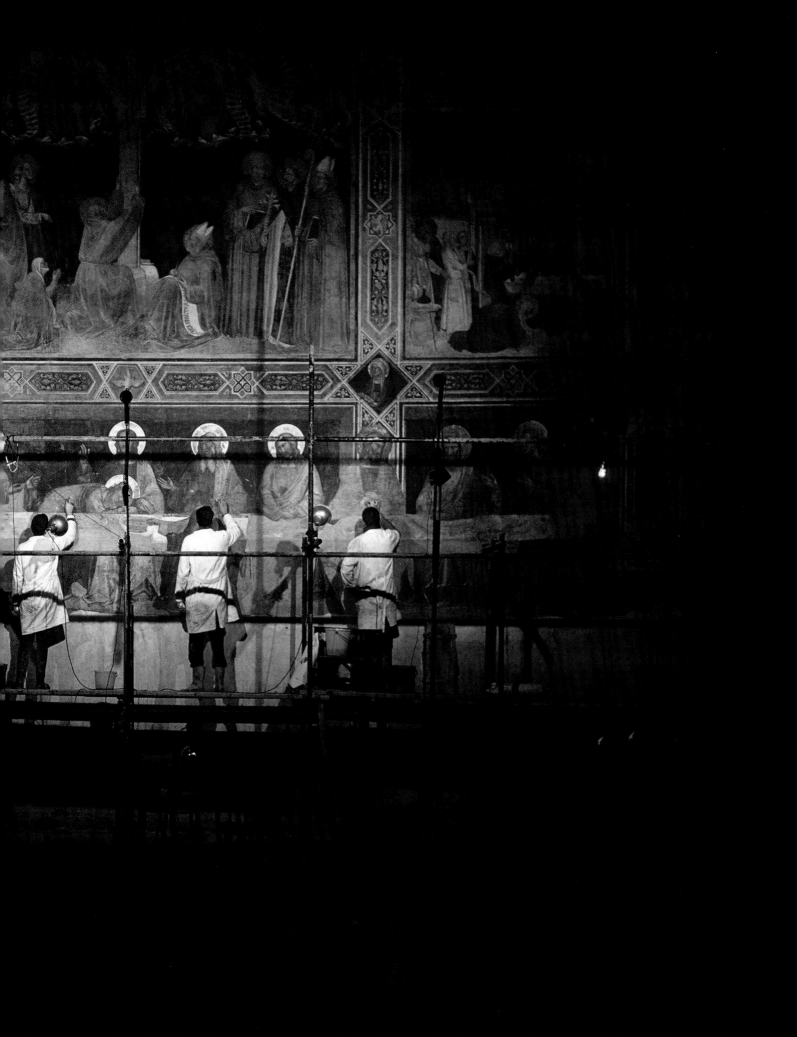

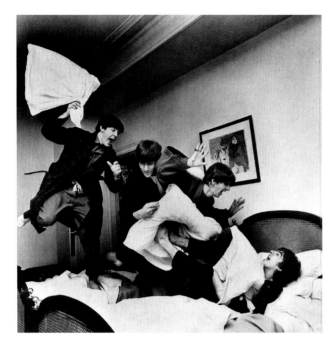

Help!

As a take-no-prisoners commando in London's Fleet Street newspaper wars, Scotsman Harry Benson was not going to let any other photographer edge him out for this story. These lads from Liverpool were sending rockets through the entertainment sky, and Benson was going to be the one to record the star bursts. Thus he became a sort of fifth Beatle, with full access to the boys at all times. On this occasion, they were all in a Paris hotel room at just after three a.m. It was 1964. The group's manager, Brian Epstein, had just come in to tell them that "I Want to Hold Your Hand" had reached No. 1 in the States, and that they would be leaving shortly for their first American tour. John, Paul, George and Ringo were already feeling wired from that evening's show, and cooped up, too, what with Epstein's security. Now the idea of going to America—the home to so many of their idols, Chuck Berry, Carl Perkins and Elvis—left them, in Benson's words, with a "violent energy . . . They needed a way to let off steam." He had witnessed their pillow fights in the past, so he suggested another go at it. As we see here, the Fab Four thought it a jolly good idea, "and it went on for a long time because they were enjoying it so much. They were excited and happy about going to America."

Photographs by **Harry Benson**

BENSON 23 1 64.

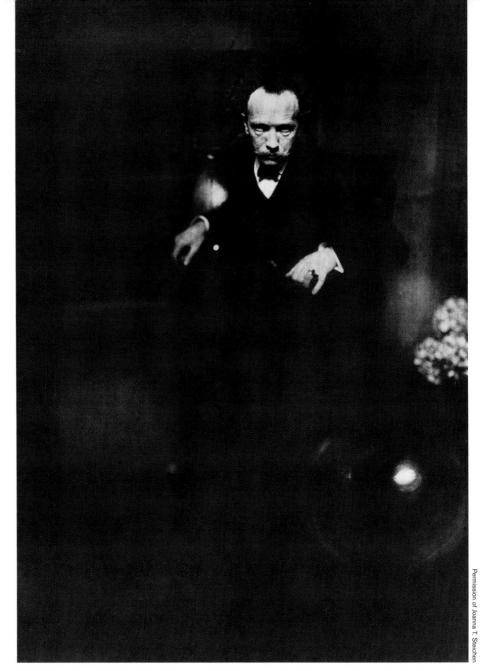

Tone Poems

Composer Richard Strauss and conductor Herbert von Karajan both took their music very seriously, but while the former was somewhat reserved, the latter fairly defined the word *intense.* "When I can no longer make music, I no longer want to be," said von Karajan, who was known as Herr Musik Diktator during his brilliant reign with the Berlin Philharmonic from 1955 to 1989. "You should not perspire when conducting," admonished Strauss in "10 Golden Rules for Conductors." Similarly, the photographers responsible for these portraits came to their work from different directions. Loomis Dean, who captured von Karajan's intensity for LIFE in Salzburg in 1964 as the maestro rehearsed—of all things—Strauss's *Elektra,* just wanted to get the shot. "That's the only satisfaction I get out of a picture: seeing it published," he said. "And I try to do everything I can do to make it amusing or interesting enough to get published." Edward Steichen, who took this picture of Strauss in 1906 and was an important player in the movement to gain acceptance for photography as an art form, had loftier goals: "The mission of photography is to explain man to man and each man to himself," he said. "And that is the most complicated thing on earth."

Photographs by **Loomis Dean** and **Edward Steichen**

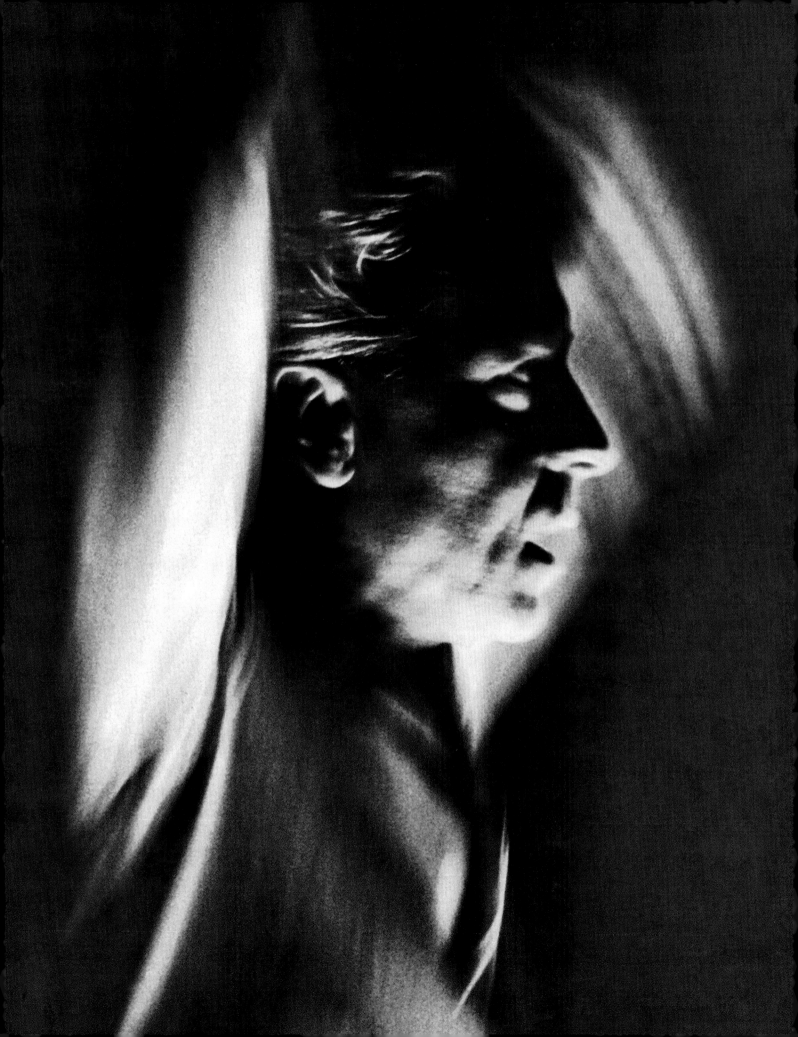

Henri Cartier-Bresson was one of the 20th century's most influential photographers, a decidedly humane and spontaneous practitioner whose Holy Grail was "the decisive moment." He was also a most idiosyncratic fellow, one whose compulsion to observe the unseen resulted in a modus operandi of anonymity. When he was prowling about with his beloved Leica, he often covered the bright metallic parts with black tape to better conceal it, and sometimes even cloaked the camera with a handkerchief. This stealth extended to his personal life as well, and even to his very self. He refused to sit for portraits: "Oh, I hate being photographed," he said to John Loengard, who was, for 14 years, LIFE's director of photography. In 1987, Loengard was with Cartier-Bresson in southern France, in Provence. The Frenchman, then approaching 80, permitted Loengard to take his picture—but only from behind. What happened was: Loengard was about to depart for the airport after his visit, when Cartier-Bresson, at his wife's urging, indulged in one of the world's most lyrical, if solitary, pastimes.

Photograph by **John Loengard**

Science
& Nature

In this 1949 photo of a uranium atom, the compact nucleus contains 92 protons (red lights) and 146 neutrons (green lights). The streaks of blue light represent some of its 92 electrons. But this "atom" was actually created by LIFE photographer Fritz Goro and others at Columbia University. For this image, Goro, called by Stephen Jay Gould "the most influential photographer that science journalism (and science, in general) has ever known," used four different lenses and incorporated 33 different exposures.

Photograph by **Fritz Goro**

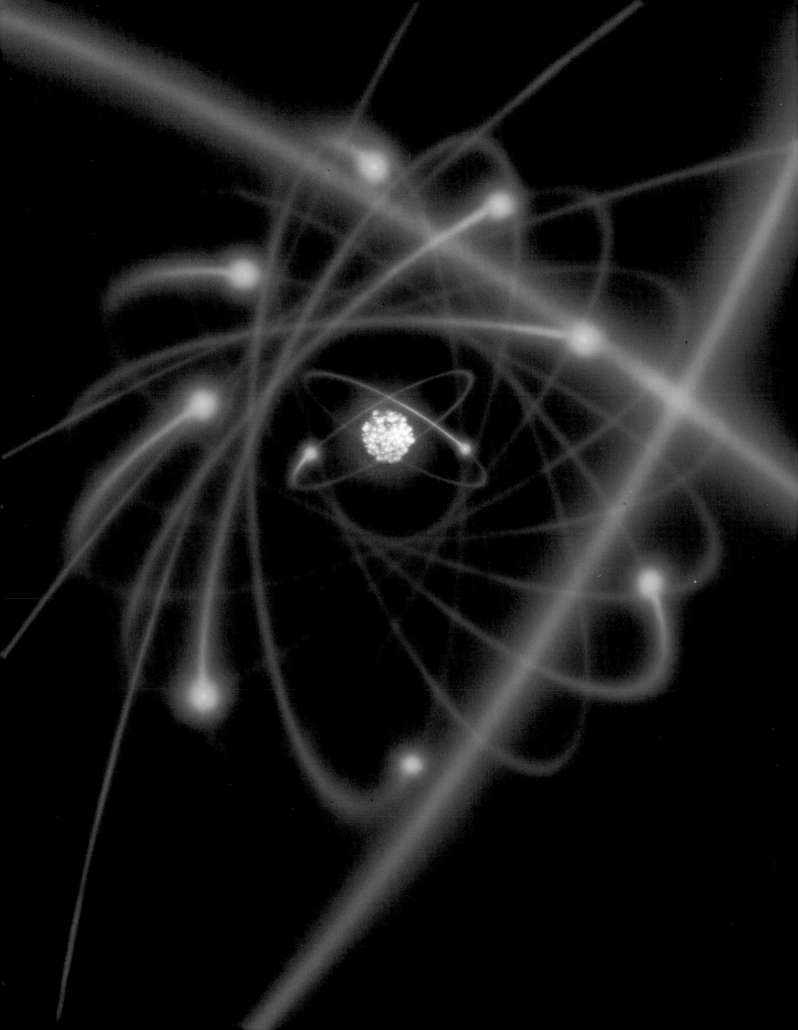

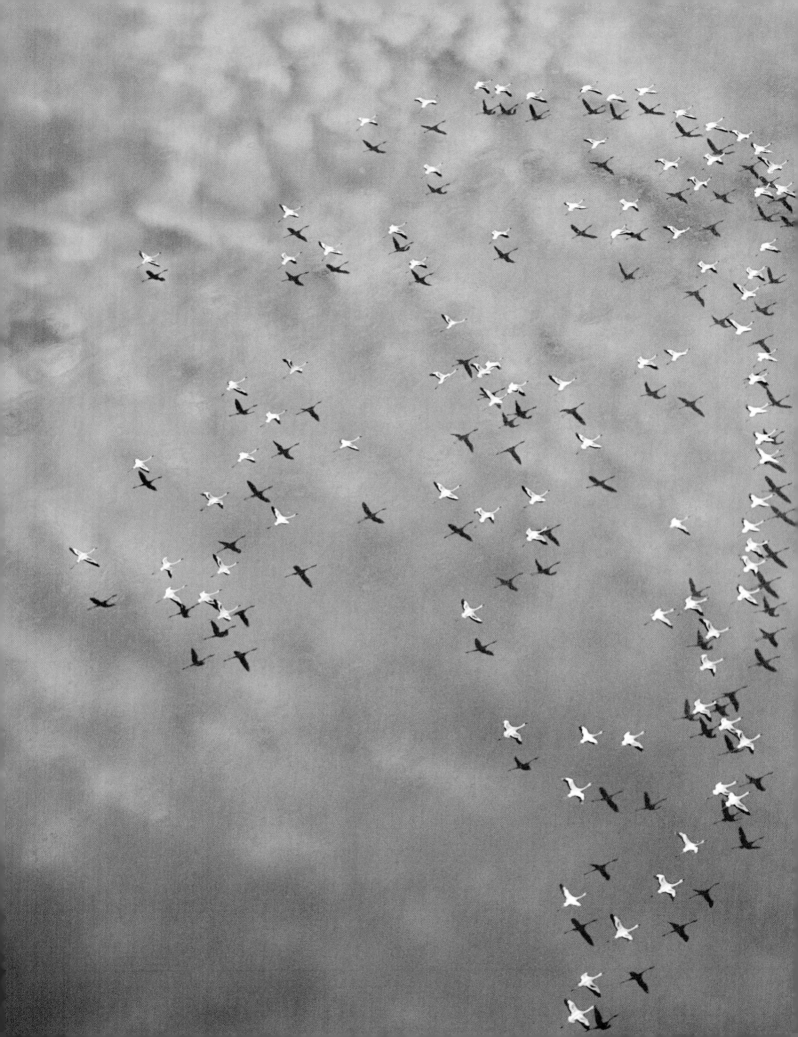

Birds of a Feather

Kenya's Rift Valley is home to several lakes that serve as homes to huge numbers of flamingos. The birds are drawn to these caustic waters, known as soda lakes because of the calcium carbonate they derive from the area's volcanic soil, for the algae and crustaceans that thrive in such an environment. These are lesser flamingos swirling about and standing in Lake Magadi. (Yes, that is water below; its mottled appearance stems from a combination of its chemical makeup and reflected clouds and birds.) At about three feet tall, lesser flamingos are the shortest of the five flamingo species, however, they form the largest flocks of any bird in the world. More than one million at a time can be found in a single group. In fact, flamingos always travel as a group, rather than singly. Art Wolfe took this picture from a very small aircraft called an ultralight. The perspective provides for a most remarkable pattern, an aspect that he frequently tries to acheive. Wolfe says that the shifting pattern and perspective were quite visually unsettling for both the pilot and himself. This picture was taken early in the morning. Later in the day, the very high temperatures create a turbulence that makes aerial photography impossible.

Photograph by **Art Wolfe**

The Serpent

Michael Melford is a master of color and texture, so it was no surprise that in 1982 he was asked to do a photo shoot of the creatures that inhabited the floor of a rainforest in Costa Rica. It was his first time in such a place, and he found it a beautiful, serene environment, but the heat, humidity and mosquitoes were another matter. What's more, although Melford had been fascinated with snakes since he was a kid, that interest was now compromised after warnings about the fer-de-lance, a deadly customer, common in the area. As he walked along on his own, the thick underbrush and vines conspired with the darkness to make Melford increasingly uneasy and photography difficult. Nevertheless, he quite enjoyed photographing an eyelash palm-pit viper, which, although poisonous, he took a liking to. That is, until he was climbing a metal girder through the thick canopy and suddenly found one three feet from his face. After that, says Melford, "as the canopy closed in on the tower above me, every vine now looked like a snake. The tower was unstable, and in my mind, I was going to die." He beat a retreat to the forest floor. The next day he met up with and photographed a fer-de-lance, which proved to be his undoing: "It was about then that I thought it might be a good idea to set up a studio at the research center, and bring the snakes to me." Thus we have this portrait of a green vine snake. Melford learned that, as a defense mechanism, it posed as a viper. So Melford would flick his hand to startle the snake, get his shot, and the creature would shortly resume its gentle ways.

Photograph by **Michael Melford**

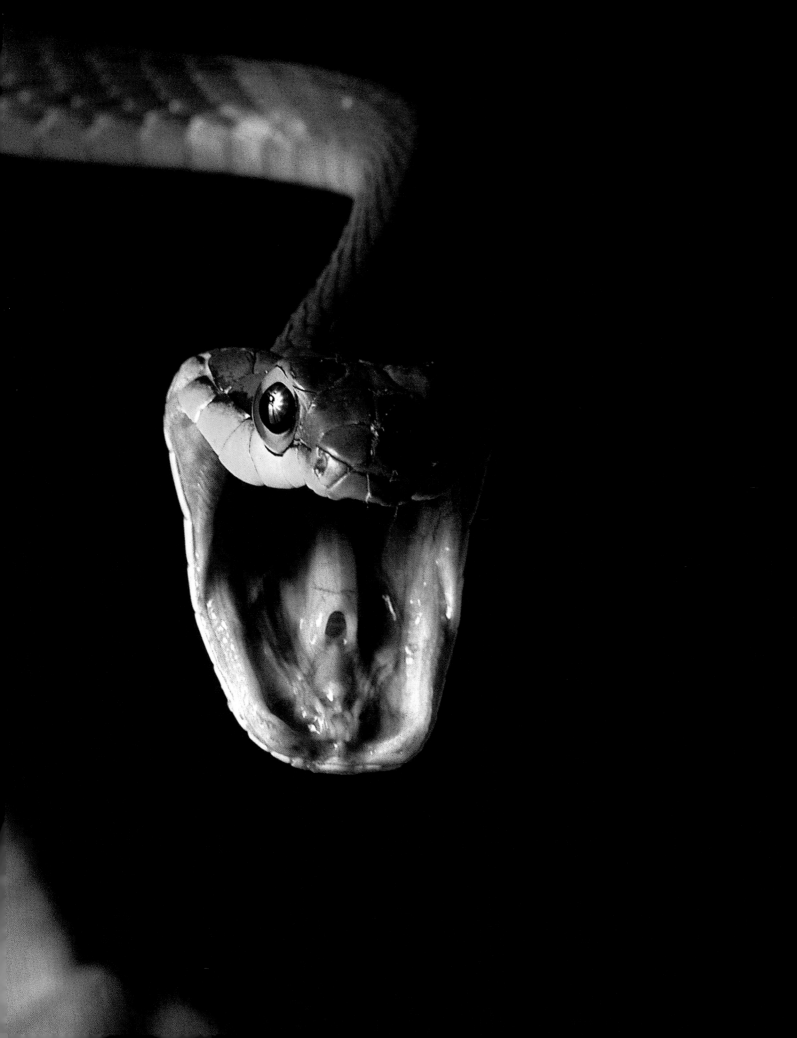

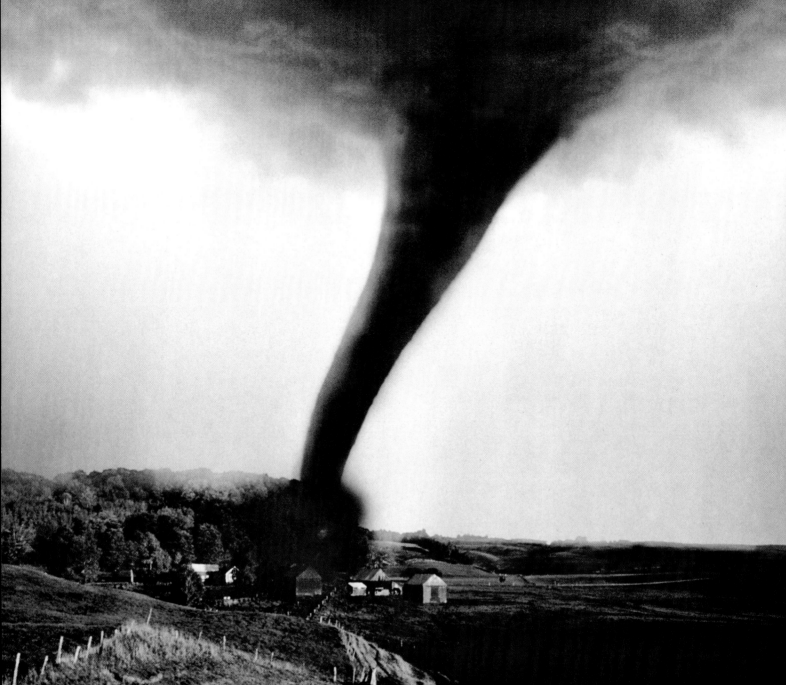

Violently rotating columns of air that can spin faster than 300 mph, tornadoes are capable of devastating damage and disaster, as any film fan—of either *Twister* (released in 1996) or *The Wizard of Oz* (1939)—can attest. They are largely an American phenomenon, with more than 1,000 reported in the U.S. each year, and every state is susceptible—although Tornado Alley, running from Texas through Missouri, is a highly vulnerable swath. Most funnel clouds are less than 100 feet wide and touch down for only seconds, but when conditions are right (or wrong), as is common from April through June along the southern High Plains, these monsters can carve a mile-wide path of destruction. On August 28, 1979, Sheila Beougher caught a tornado touching down in Gove County, Kansas (opposite). Some years later, prompted by a demand for terrifying tornado images in the wake of *Twister*'s popularity, Jim Zuckerman decided to improve upon Mother Nature for the image on this page. Using Photoshop software, he combined dark clouds from a photograph he had taken in Indiana with a picture he had shot of a Vermont farm. Then he changed the morning light of the Vermont scene to match the Indiana image, drew a funnel cloud, and placed imported bits of image from the land, house and barn at the base of the funnel to look like objects being blown about.

Photographs by **Jim Zuckerman** and **Sheila Beougher**

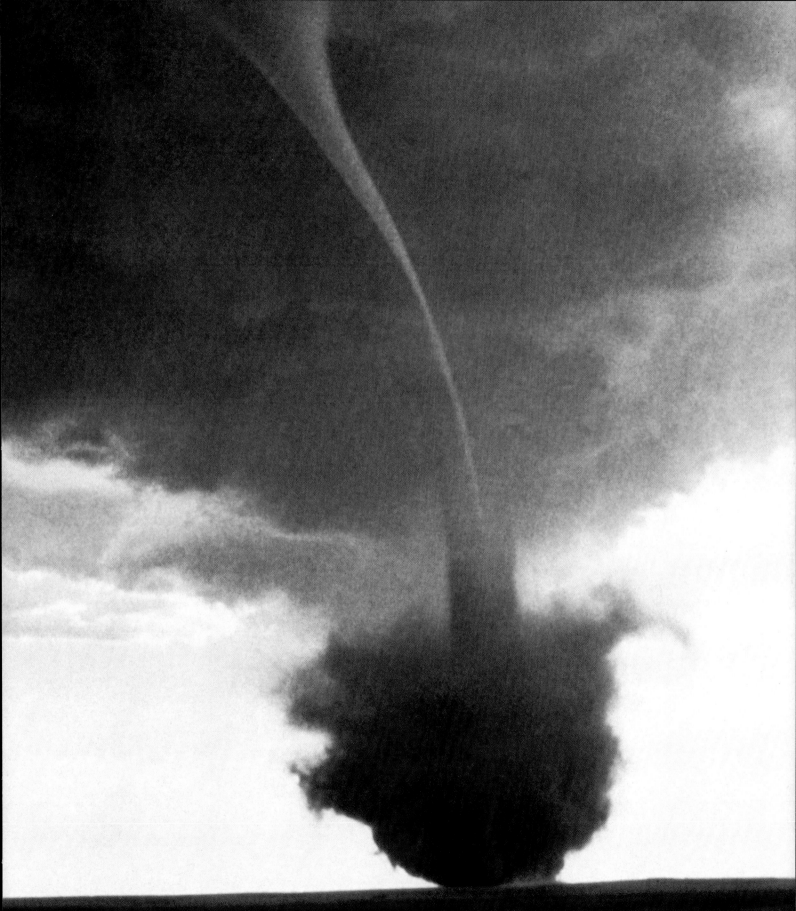

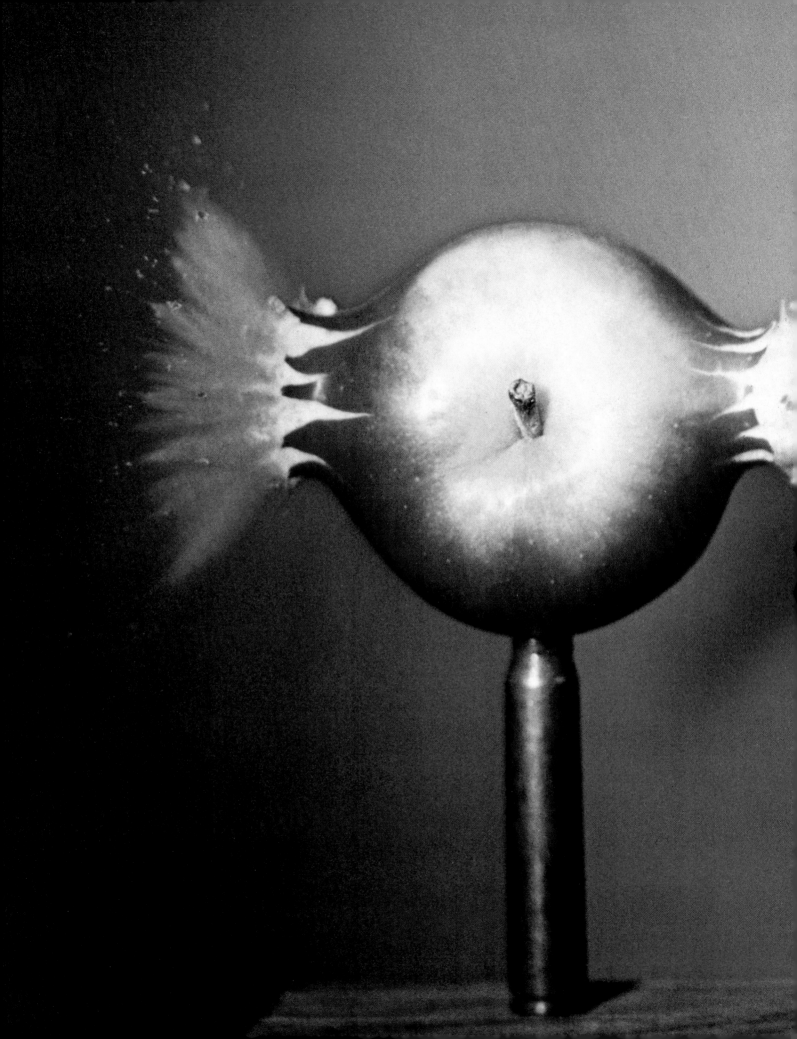

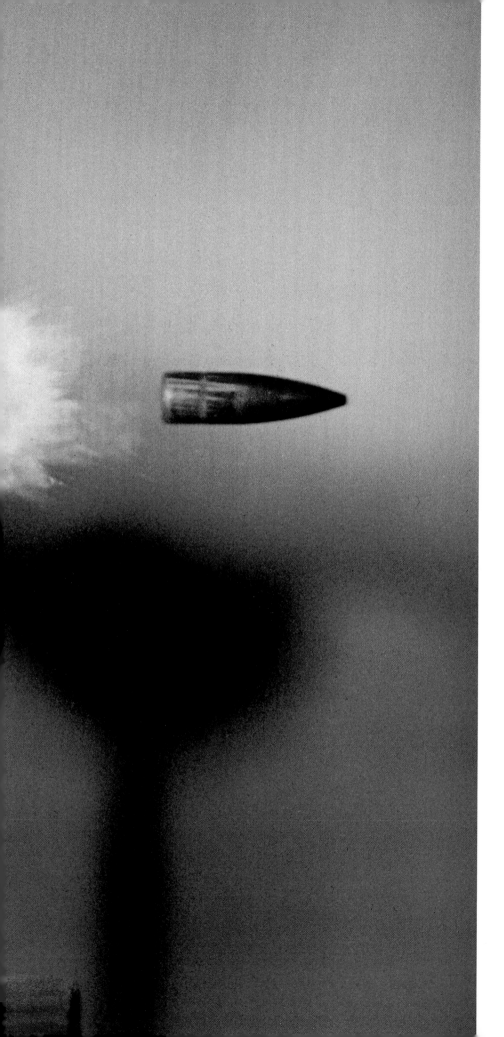

Seeing the Unseen

Before 1931, the fastest speed at which a stop-action photo could be taken was about one thousandth of a second. Then a 28-year-old graduate student of electrical engineering at MIT concocted the high-speed electronic flash, or stroboscope. Harold Edgerton's photos were memorable, artistic renderings that simultaneously validated scientific theories. In fact, his strobe opened up a whole new field of knowledge about high-speed phenomena. He used this 1964 photo, *Shooting the Apple,* to accompany a lecture at MIT called "How to Make Applesauce." The picture shows a .30-caliber bullet traveling at 2,800 feet per second as it pierces an apple balanced on a cartridge. The flash exposure that produced the image lasted one third of a millionth of a second. In the next instant the apple will explode, but this captured moment helped Edgerton illustrate laws of physics. For the layperson, though, there is only the wonderment from seeing the profound similarity between the entry and the exit of the bullet.

■ Photograph by **Harold Edgerton**

The Waiting Game

This is a portrait of patience. For 16 days, photographer Steve Bloom sat in a small boat off the coast of Cape Town, South Africa, waiting. He crouched low to improve the angle of the shot he was after and pressed his eye against the viewfinder of his camera for long periods at a stretch, lest he miss the split-second event he hoped to record. Trolling off his boat, at the end of a length of twine, was a seal decoy, designed to lure the object of his desire: a great white shark. The terrifying "star" of the classic nail-biter *Jaws* and unwelcome headliners in the real world for their rare but intense attacks on humans, great whites locate their prey with their acute sense of smell—they can detect one drop of blood in a hundred quarts of water—and their ability to sense minute electrical discharges from other animals. They sometimes jump completely out of the water to sink some of their 3,000 teeth into supper. On the 16th day of Bloom's stakeout, it finally happened: A shark ripped through the surface of the water, launching its huge body into the air, breaching the waves and snagging the seal. "When the shark finally burst out of the water," said Bloom later, "it was over so quickly that as the sea settled in its wake, I wondered if I was dreaming."

Photograph by **Steve Bloom**

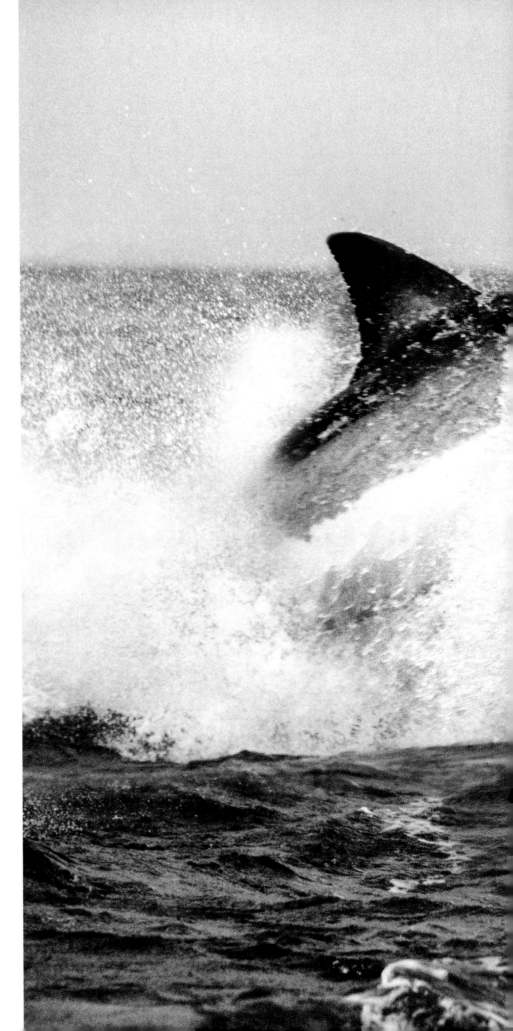

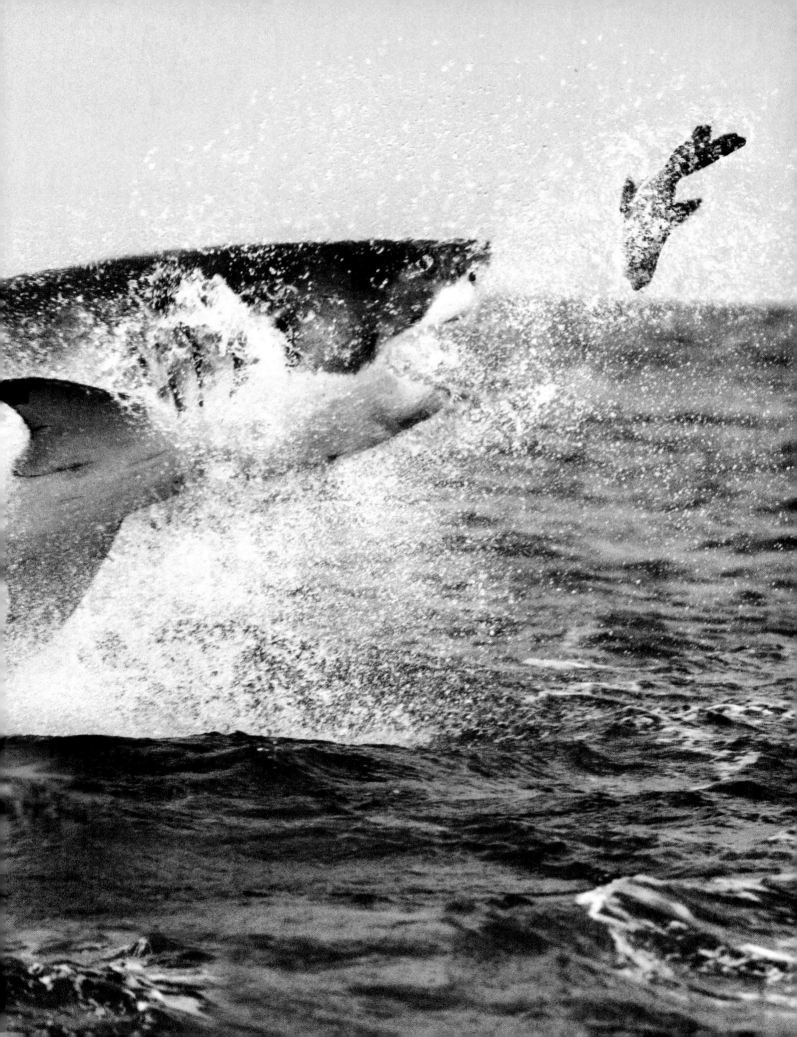

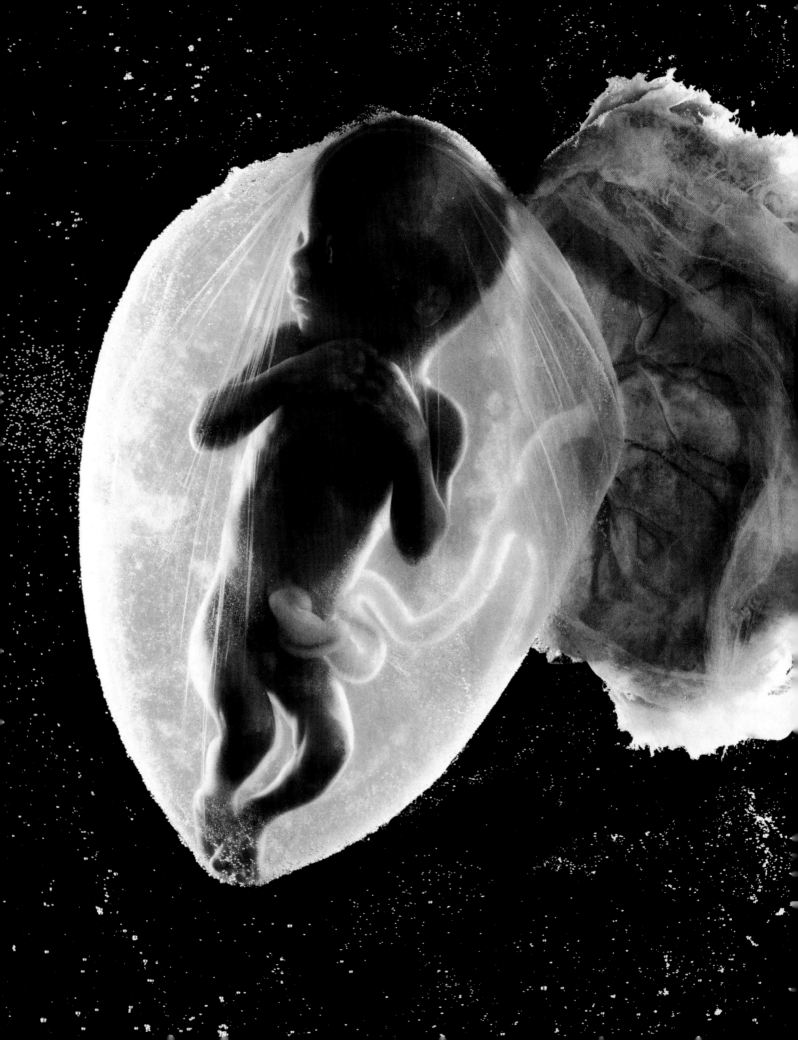

E very day is like his first day on earth. He is the most enthusiastic person I've ever met," says LIFE's director of photography, Barbara Baker Burrows, of Lennart Nilsson. She has ample reason to know, having worked with him, and been a close friend, for nearly four decades. Nilsson's grand curiosity ignited early; at five years old he was already a studious collector of flowers and plants, and by age 12 he was photographing them. Then, in 1951, when he was 29, he happened past a row of bottles in a lab that held two-week-old fetuses. His life was forever changed: "In that same second I knew I would concentrate on the early development of the human." For years this new enthusiasm, his slakeless wonder and a rare talent for photography fed off one another, culminating in a 1965 LIFE picture essay, "Drama of Life Before Birth." Part of that piece was the famous image at left of a living 18-week-old fetus and placenta. The Swedish lensman was suddenly a star, but this did nothing to sway his anointed direction of discovery, as one can see from his bravura 1990 image of sperm forcing its way into an ovum (below). Working with an electron microscope that can magnify a cell hundreds of thousands of times, he photographed the human egg cell, then safely returned it to the fertility clinic from which he borrowed it. In much the same way, Nilsson has summoned the secrets of life, revealed them to us, then given them, and us, safe transit.

■ Photographs by **Lennart Nilsson**

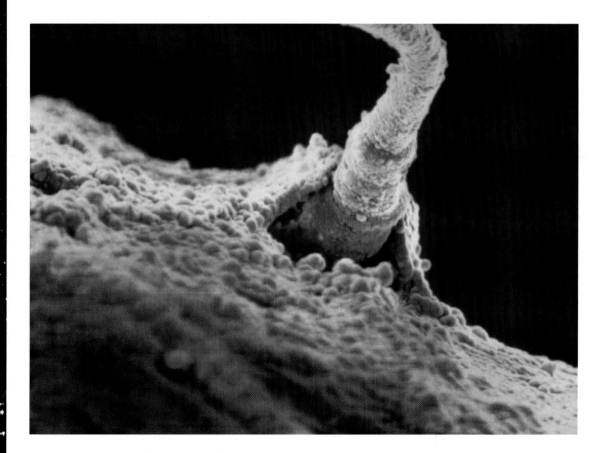

A Deadly Foe

Having made his name as a photographic master of the miracle of conception and birth, Lennart Nilsson more recently has devoted himself to the fight against that tireless assailant of life: disease. Working at the Swedish Institute for Infectious Disease Control, at the Karolinska Institute, in Stockholm, this national hero has produced an assemblage of photographs that are pictorially beautiful, yet at the same time, by their very existence, deeply chilling. Nilsson has clearly succeeded at his goal of making an image of the vaccinia virus—a close relative of smallpox—as sharp as possible. Here, a little more than 24 hours have passed since the virus landed on a cell membrane. The cell is now dying. The blue globules on the cellular surface are viruses ready to infect new cells. This viral reproduction process can be ruthless. Nilsson is hopeful that his new work will provide scientists with some insight into the war against invasive diseases. "The virus," he says, "is the worst terrorist we have."

Photograph by **Lennart Nilsson**

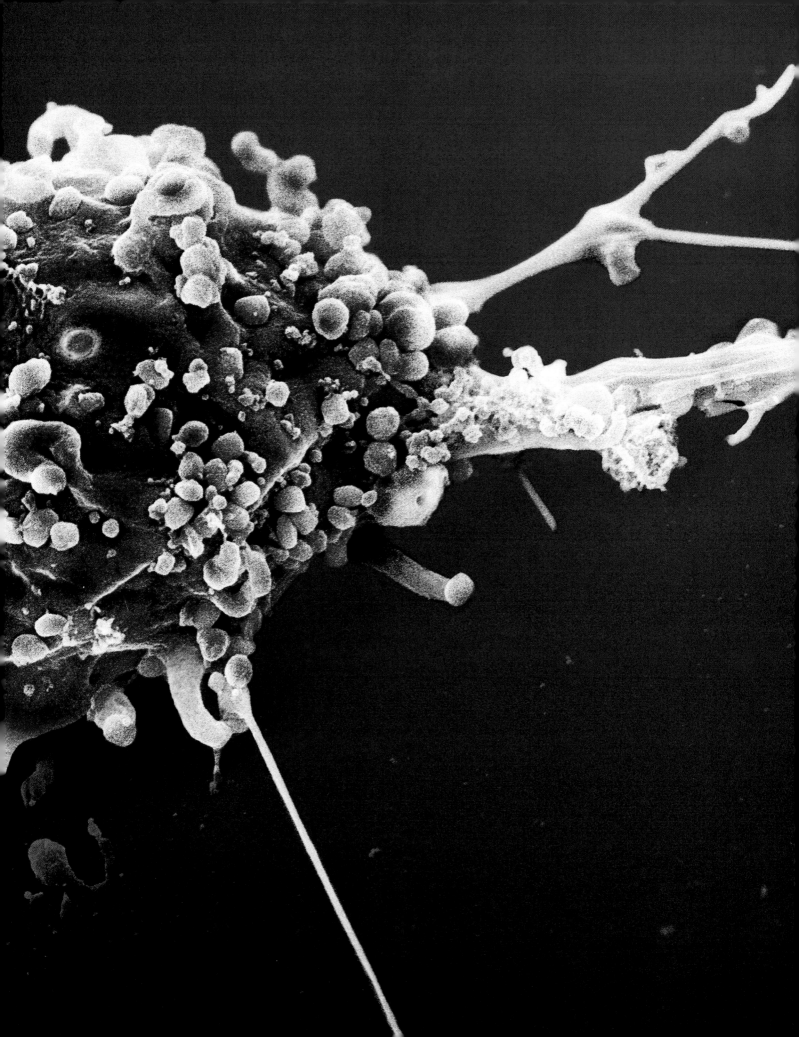

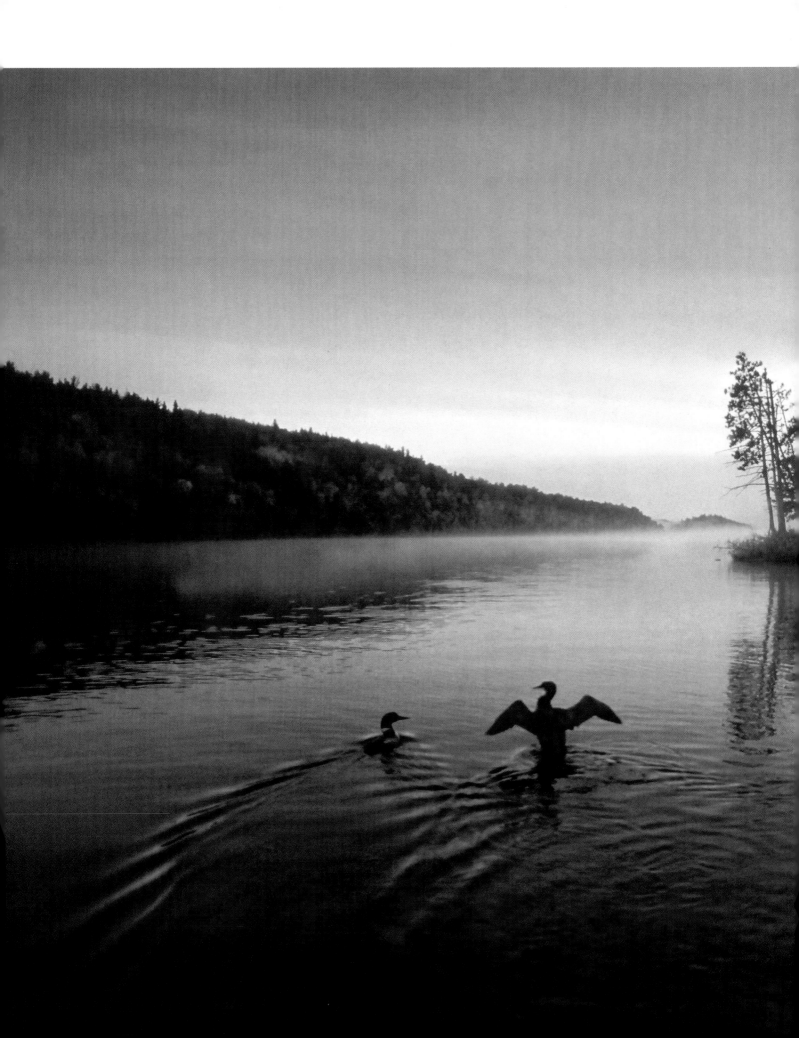

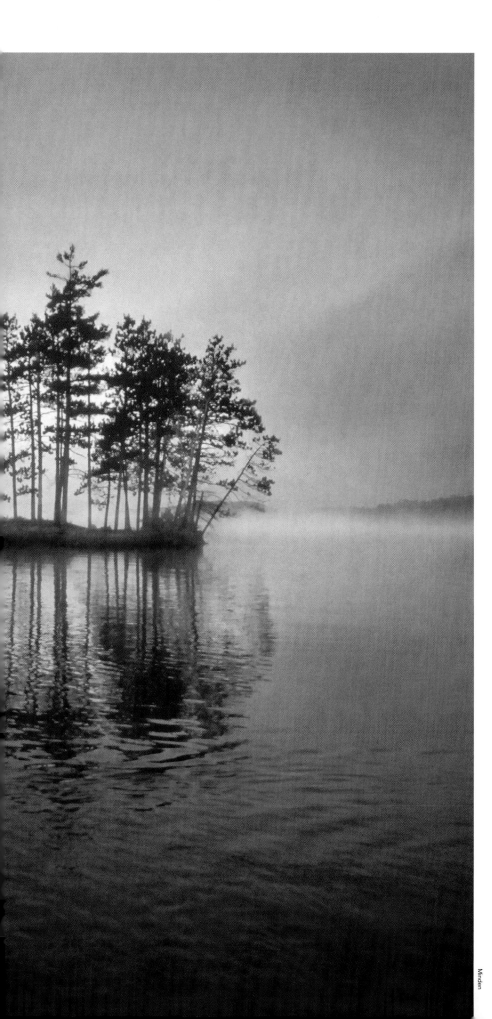

Thanks

In 1994, Jim Brandenburg gave himself a terrible assignment: For 90 days—from the autumnal equinox until the winter solstice—he would allow himself to take only one photograph per day. In an era of motor-driven shutters and "thousand-roll" stories, this was an awesome task for the *National Geographic* veteran. "I had to break out of the pattern my photography was stuck in, felt compelled to let go of life's clutter and a world lit by computer screens instead of the sun," he later wrote. "I wanted to wander the forest again, to see what was over the next rise, to follow animal tracks in the snow with the eyes of a boy." Early on the morning of October 2, 10 days into the assignment, Brandenburg was paddling a canoe on Moose Lake, in Minnesota, when he came upon a young loon that had a fishhook caught in its beak, with 10 feet of fishing line wrapped around it. Brandenburg caught up to the loon, grabbed it, untangled the line and placed the bird back in the water. Then he stood up in his canoe and lifted his camera to his eye. "I watched as it swam off to a nervous and protective parent," Brandenburg wrote. "Then the young one stopped, turned toward me and, as I released the shutter, flapped its wings as if in gratitude."

■ Photograph by **Jim Brandenburg**

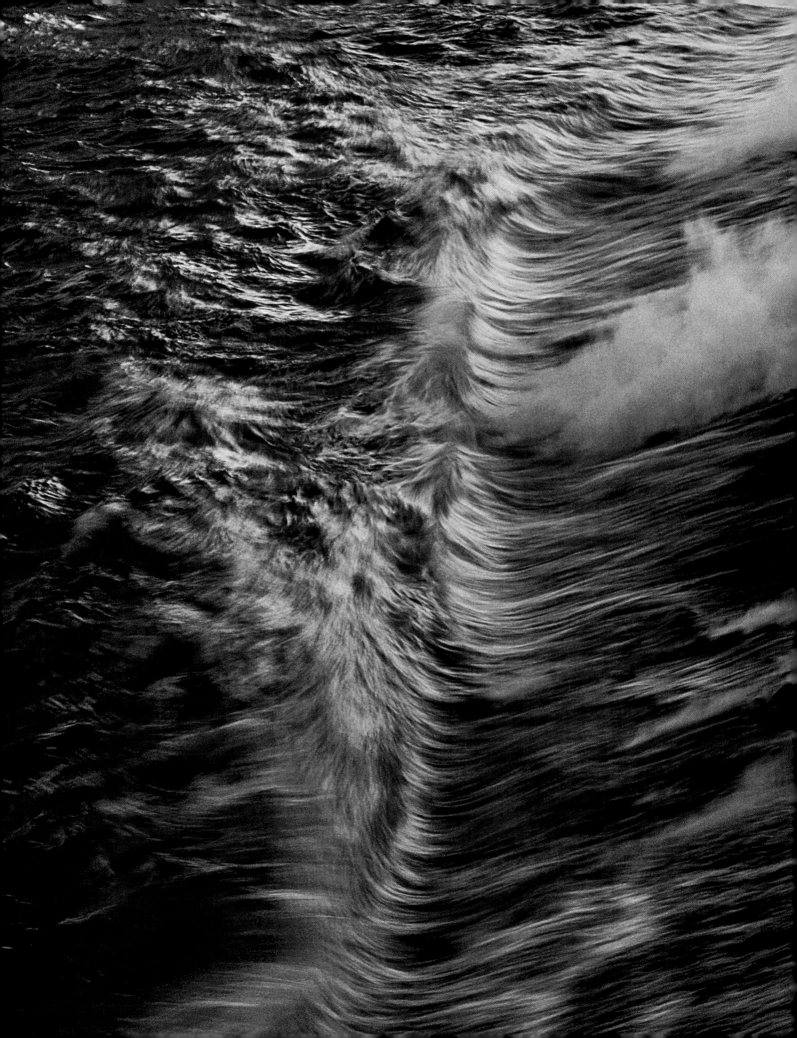

A Study in Liquidity

Lava is molten rock that issues from the earth's surface at temperatures commonly ranging from 1300° to 2200°F. And although it can flow quite rapidly, its viscosity, typically, is at least 100,000 times greater than water. This picture of a lava flow was taken at Hawaii Volcanoes National Park. To get it, Art Wolfe spent three days photographing an eruption of the Kilauea Volcano. Reaching this vantage point meant Wolfe had to traverse large lava fields generating such heat that, had he paused even for a moment, it would have melted the soles of his boots and singed his body hair. Further, he sometimes had to don a gas mask because he encountered plumes of sulfurous gases that were hazardous to breathe–and also potentially dangerous to the front elements of camera lenses. All of this led to an experience that Wolfe described as "both exciting and surreal." That description also applies quite nicely to this time exposure of lava entering the ocean.

■ Photograph by **Art Wolfe**

An Isolated Inspiration

Ansel Adams is, of course, one of photography's most celebrated practitioners, and he secured his place in the pantheon with superb renderings of nature on a vast scale. But as we see here, he was also entirely adept at the closeup study. This picture was taken circa 1932, when Adams was about 30. He was in San Francisco, and his mother had brought him a pale pink rose from the garden. At the time, many photographers felt that their work should correspond to examples from other art forms. Adams said that he had never before seen a painting of a single flower, had never seen Georgia O'Keeffe's portraits of flowers. "I believe that this picture was an isolated inspiration," said Adams in his *Examples: The Making of 40 Photographs,* "free of any association in art that I knew about. It was simply a beautiful object with a sympathetic background and agreeable light." And how was this achieved? "The north light from the window was marvelous for the translucent petals of the rose, but I could not find a suitable background. Everything I tried— bowls, pillows, stacked books and so on—was unsatisfactory. I finally remembered a piece of weathered plywood, picked up at nearby Baker Beach as wave-worn driftwood . . . The relationship of the plywood design to the petal shapes was fortunate, and I lost no time completing the picture."

■ Photograph by **Ansel Adams**

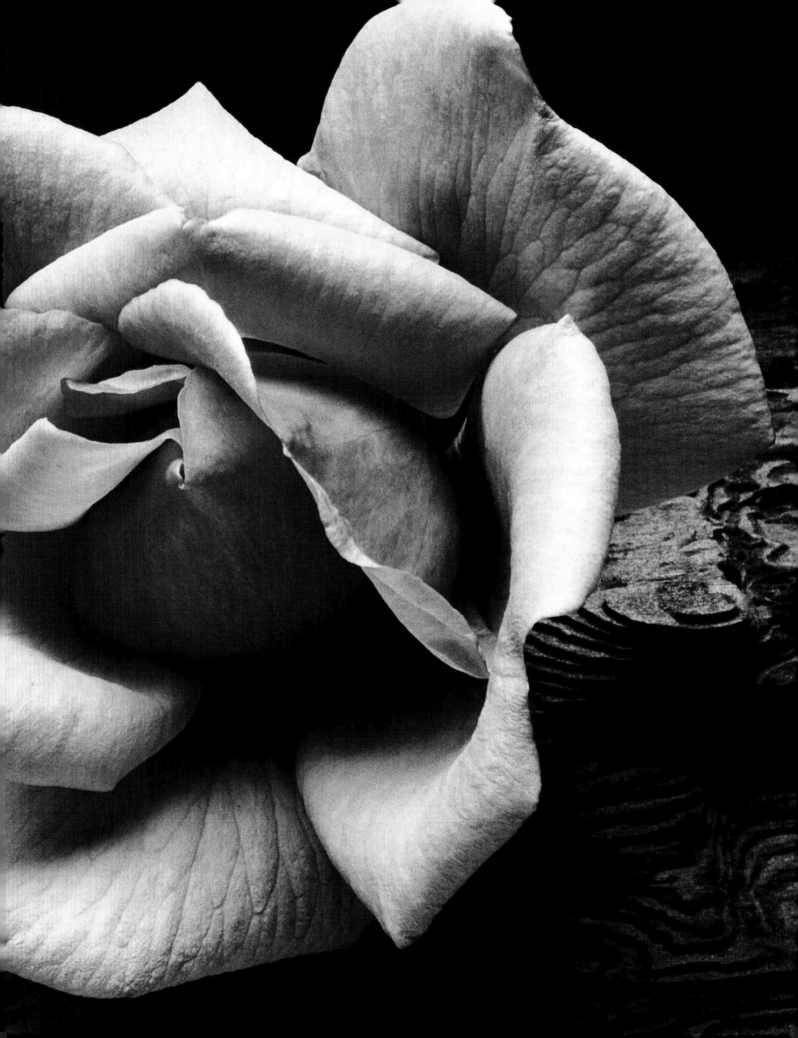

Portrait of an Era

Seconds after nine a.m. on Able Day, July 1, 1946, a B-29 plane aimed an atomic bomb, about the same size as the one that had been dropped a year earlier on Nagasaki, at a point a few hundred feet above the red-painted battleship *Nevada,* one of a cluster of defunct ships that were part of a joint Army-Navy project called Operation Crossroads. The goal was to gauge the effects that nuclear weapons might have on American naval vessels. One craft two miles away burst into flames; in all, eight ships were sunk or badly damaged. The test, like others to come, was held at Bikini, a remote atoll in the central Pacific Ocean; the 166 residents had been evacuated and relocated. The magnitude of Crossroads is suggested by the attendant developments: There were a dozen 75-foot-high steel towers built to house cameras and recording instruments for the hundreds of scientists and technicians. Around these towers sprouted officers' and enlisted men's clubs for the many military personnel involved in the test. Because so little was known about nuclear blasts at this point, there was considerable apprehension in some quarters regarding the dangers of the experiment. But here it is, the first peacetime A-bomb.

Photograph by **U.S. Joint Task Force**

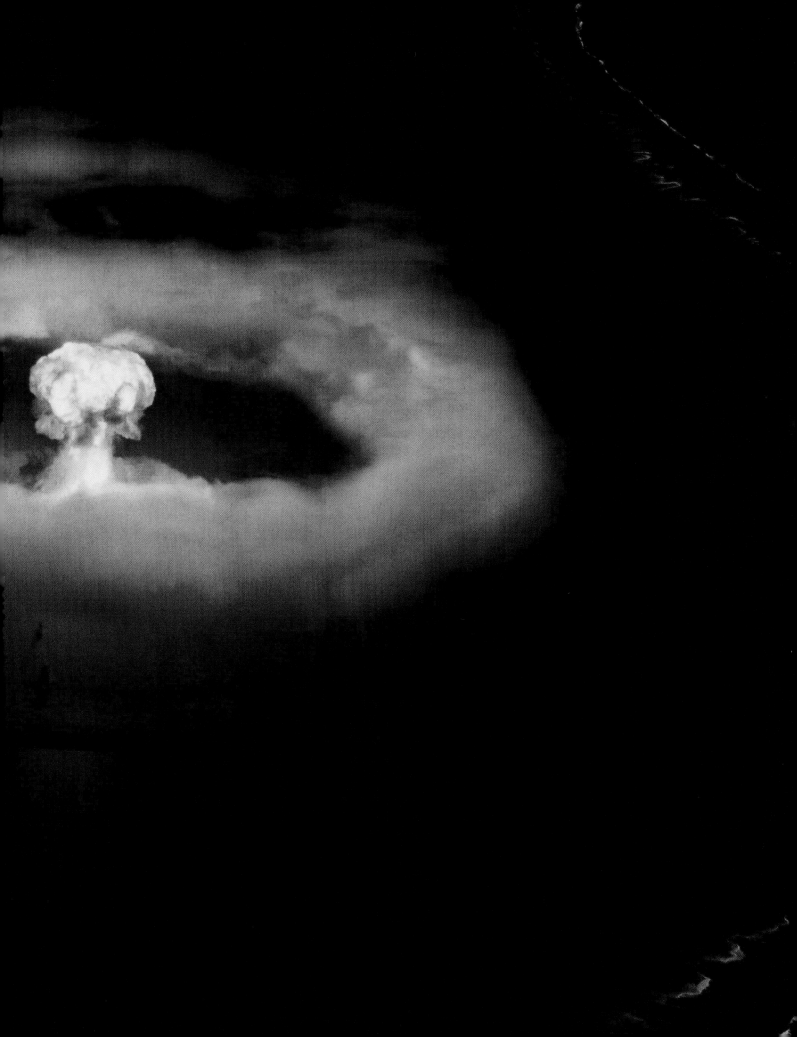

Skyshow

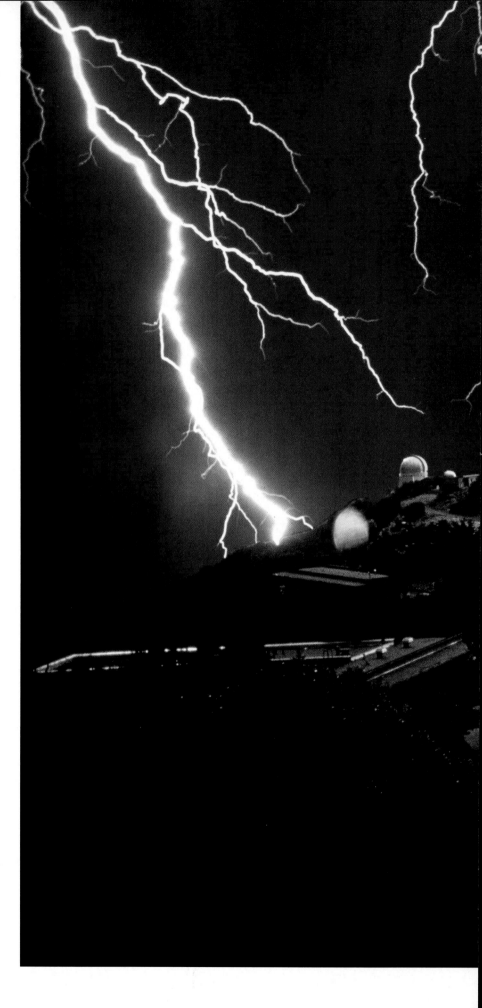

If you've ever had it crack anywhere near you, you know how terrifying it can be. But without question, lightning is also one of nature's most fantastic extravaganzas. It often appears to pierce the sky for seconds at a time, yet each strike lasts only for a tiny part of a second. The temperature generated by lightning may reach 50,000°F, and the sudden heating along the bolt makes surrounding air expand at supersonic speeds, thereby creating thunder. Here, at Kitt Peak National Observatory in Sells, Ariz., is a splendid example of this atmospheric wonder. The bolts themselves are only an inch or two thick, but their vividness makes them appear much bigger. As for the ones at left and right, they aren't actually larger than the others, they merely appear so because they are closer to the camera and are overexposing the film.

Photograph by **Gary Ladd**

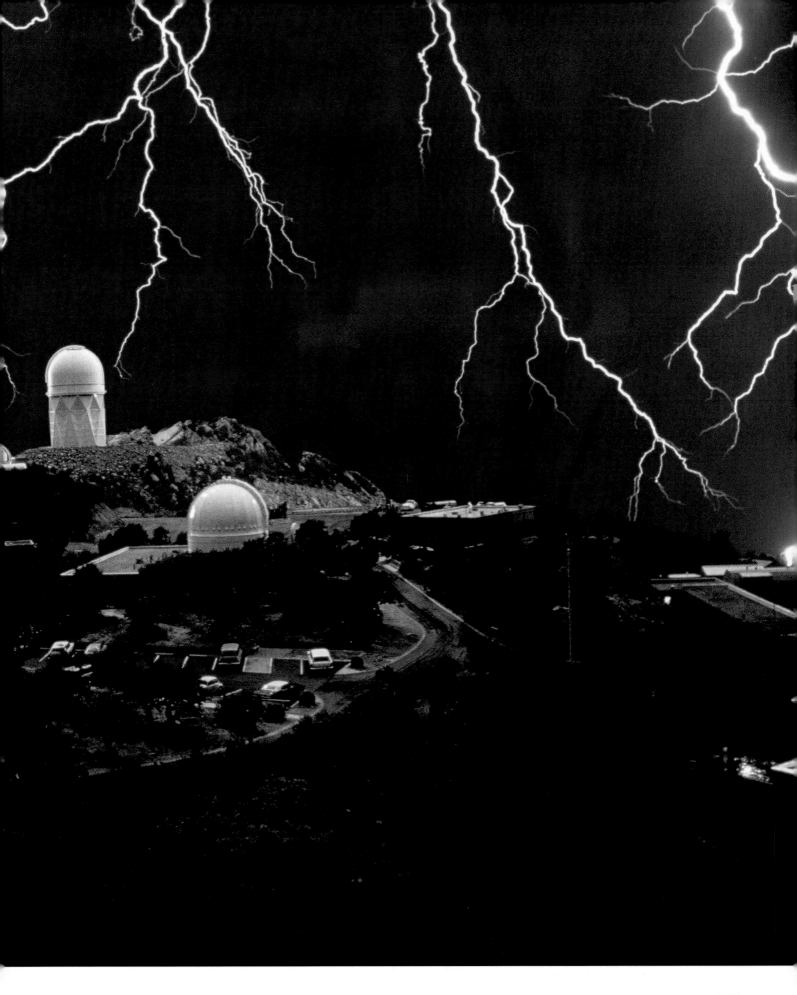

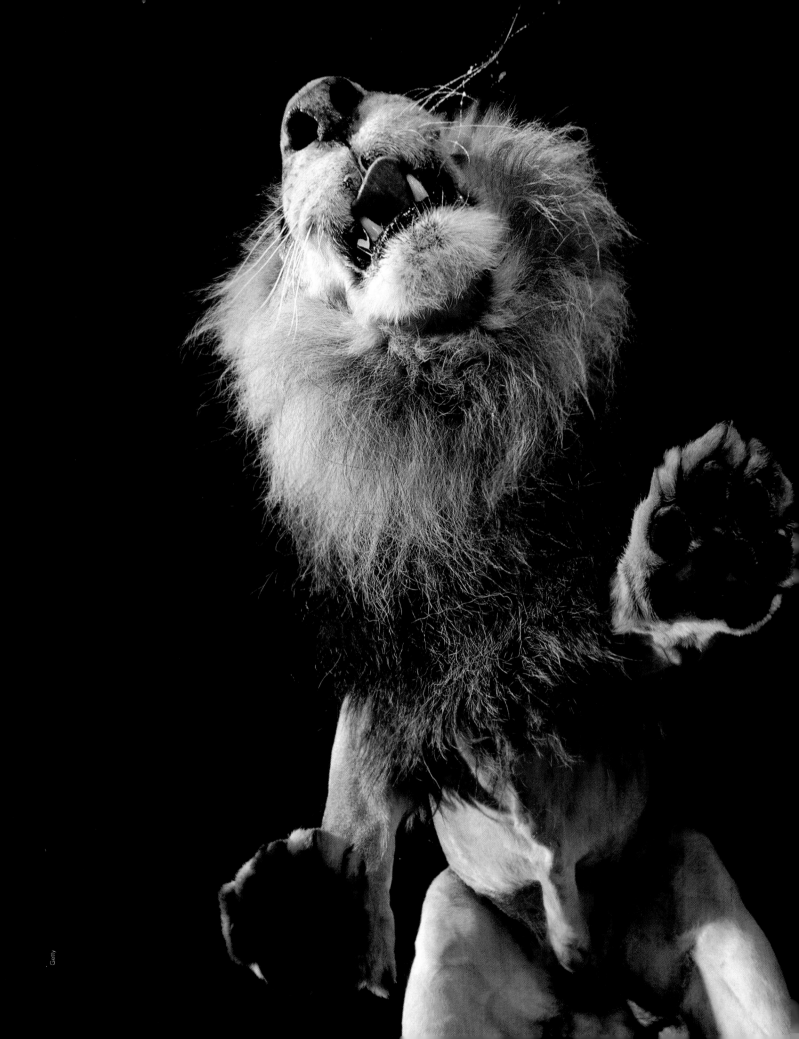

The mighty lion has stirred the imaginations—and nightmares—of people through the ages, and for very good reason. After all, even today lions kill some 300 people a year. And yet, this is a most handsome creature, with its flowing lines and powerful paws that can crack the skull of a bull. Of course, the mane of the male is quite simply one of nature's great achievements. But the King of Beasts is among the world's most photographed creatures. So how to get a picture of this big cat that is entirely different? In 1994, James Balog had an excellent idea for a viewpoint very few have seen—and survived. He mounted a four-by-eight-foot slab of clear Plexiglas onto a seven-foot-tall base and . . . voilà! Simba as we've never seen him before! Or, at least, 10-year-old Sudan, the focus of this regal shoot.

Photograph by **James Balog**

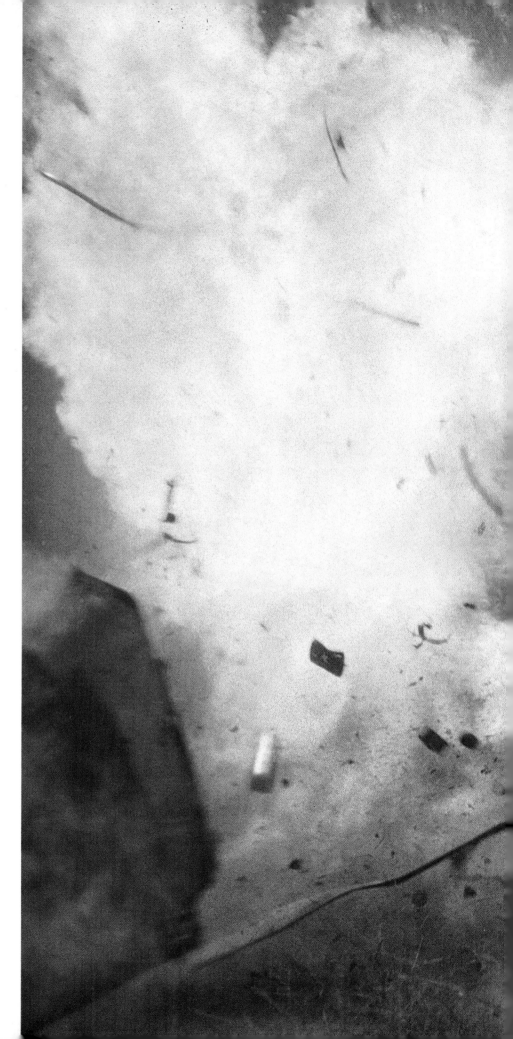

Boom, Boom

A dozen years before the September 11 attacks, airline security was an issue of growing concern in the global consciousness. On December 21, 1988, Pan Am Flight 103 exploded over Lockerbie, Scotland, killing all 259 aboard and 11 people on the ground. The cause: A homemade bomb consisting of a battery, an electronic timing device and less than a pound of plastique—a powerful, putty-like explosive invented by the British during World War II. Several months later, for a LIFE article on airport security entitled "The Next Bomb," photographer and scientist Alexander Tsiaras did an experiment. With the help of Bureau of Alcohol, Tobacco, Firearms and Explosives officials, he photographed the detonation of 1.5 pounds of plastique—twice. On a 20-acre tarmac in South Carolina, a car was filled with gasoline and blown up. The results were dramatic, but not quite dramatic enough. "So they pushed another car to the edge of the tarmac, near the woods, and did it again," recalled Tsiaras. The second blast (seen here) sent the car's roof 100 feet into the air. The wind was blowing too, resulting in a small forest fire, which was quickly controlled. Tsiaras's camera was destroyed, as he had expected it would be, by the heat and pressure, but the film survived.

Photograph by **Alexander Tsiaras**

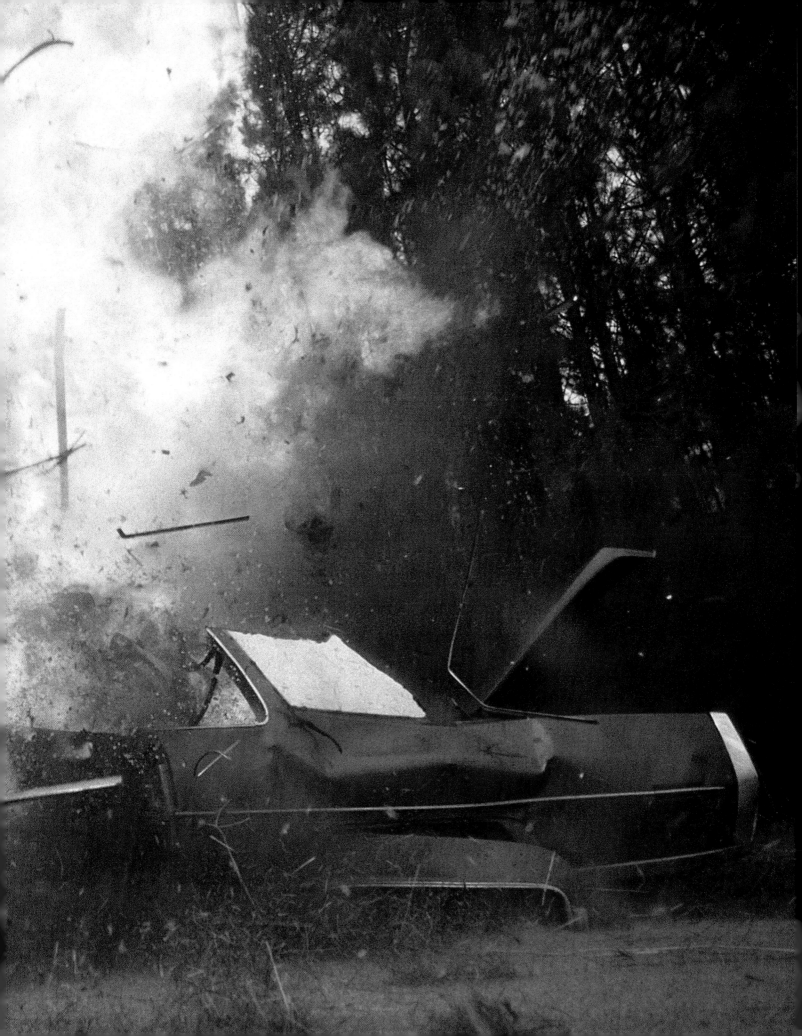

Precision Provided

Some images change the way we look at the world. This one changed the way scientists look at the universe. Taken in 2003 by the Wilkinson Microwave Anisotropy Probe (WMAP) satellite, this picture answered questions that have bedeviled cosmologists for ages. WMAP traveled a million miles from Earth to study the most ancient light in existence and told us this: The cosmos is

13.7 billion years old (give or take a couple of hundred million years); the first stars began burning about 200 million years after the Big Bang; and the universe is composed of 4 percent ordinary atoms, 23 percent "dark matter," and 73 percent "dark energy." And although the last two remain extremely mysterious to even the most learned cosmologist, the breakthrough was, so to speak,

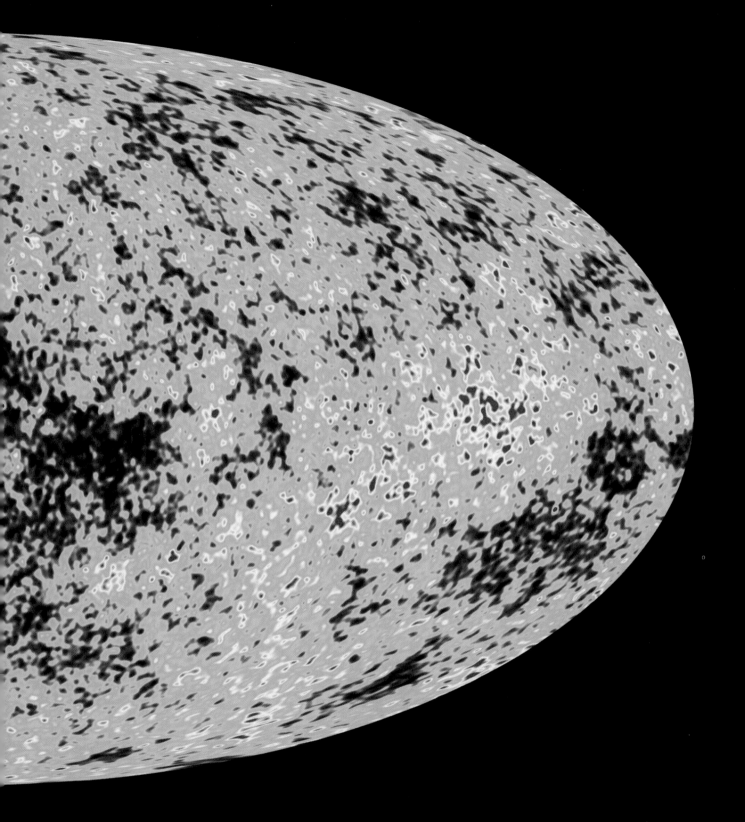

earth shattering. Previously, physicists' estimates of when stars first shone ranged from 100 million to a billion years after the Big Bang occurred. "This is a rite of passage for cosmology, from speculation to precision science," said an astrophysicist at the Institute for Advanced Study in Princeton, N.J. Seen here in the WMAP image above is a color-coded pattern reflecting what are tiny temperature differences—sometimes a millionth of a degree—within the evenly dispersed microwave light that bathes the universe. The microwaves recorded by WMAP reveal the structure of the universe 379,000 years after the Big Bang. This is, then, one of the first baby pictures of our universe.

Photograph from **WMAP/NASA**

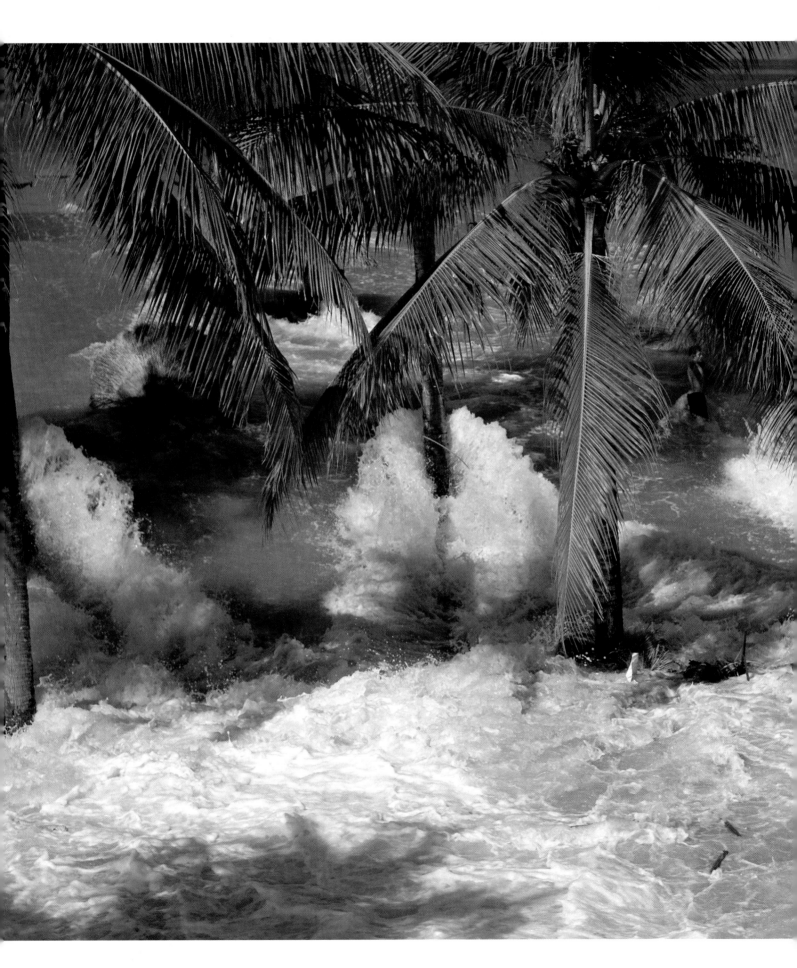

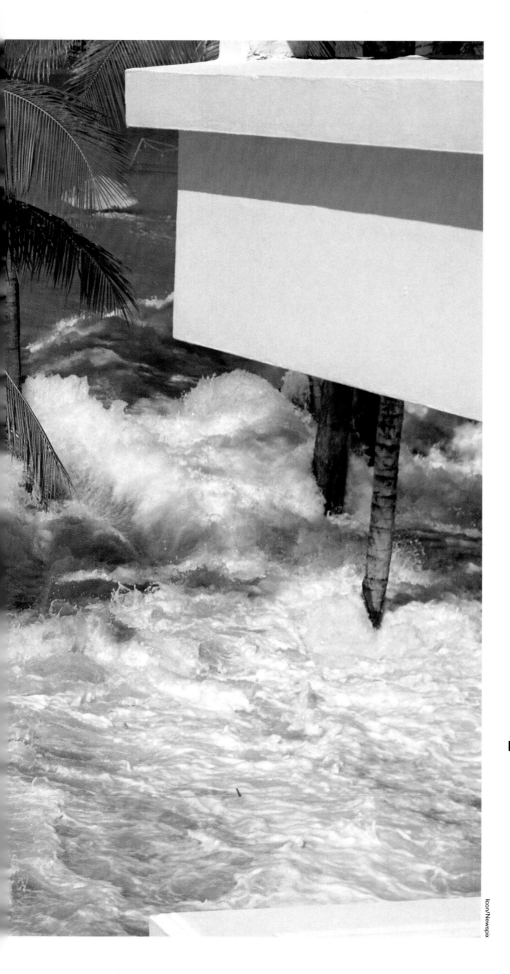

Icon/Newspix

Positive Thinking

Rarely has the world been more vividly reminded of nature's power than on December 26, 2004, when a tsunami wreaked havoc from Sumatra to Somalia. An estimated 200,000 people from 11 nations died; another 140,000 were still missing five weeks later. Those of us many miles away who saw the carnage on television and in the press—thanks to photographs like this—could only imagine the terror inspired by the unstoppable mass of water. Ironically, when this picture was taken in Phuket, Thailand, neither the shooter nor his subject feared for his life. The German photographer Hellmut Issels was in the region working on a book about Indonesia's Balinese dancers. He had just finished breakfast when people started returning from the beach with news of an earthquake, and a "small wave." Issels was sure that a tsunami was on its way. He ran to his hotel room, grabbed his camera and stationed himself on the second floor of an exterior staircase. After the third huge swell had crashed ashore, he spotted Supat Gatemanee, a 19-year-old waiter, clinging to a grass roof for dear life—or so it seemed. But Gatemanee had already survived two waves and the initial fear that he would perish, and now, "I wasn't worried. I knew I'd survive." Issels later said he felt the same. Luckily, both men were right.

Photograph by **Hellmut Issels**

Art Meets Science

Alexander Tsiaras comes to the nexus of art and science by both nature and nurture. His early training was as an artist and sculptor, and, as a young man, he also worked in photojournalism (see "Boom, Boom," page 64). Then, during a visit with his brother, an ophthalmologist at the University of Pennsylvania, he looked on as eye surgery was performed. "It was like an early Salvador Dalí film," Tsiaras said, "real bizarre and a mixture of drama and science." Intrigued, he taught himself math and physics and began to blend medical technology with his artistic sensibility and photographic ingenuity. Using software he developed with colleagues at his company, Anatomical Travelogue, Tsiaras adds light and color for eye-popping depictions of the body's interior—what he calls "scientific visualization." The process can take half an hour—or it can take days. For this image, Tsiaras took a spiral, whole-body CT image from a 360-degree body scan, digitally stripped it down to the skeleton and merged it with a filmed performance of a dance move. "My responsibility as scientist and journalist is to provide accurate information," says Tsiaras. "My desire as artist is to make the images beautiful."

Photograph by **Alexander Tsiaras**

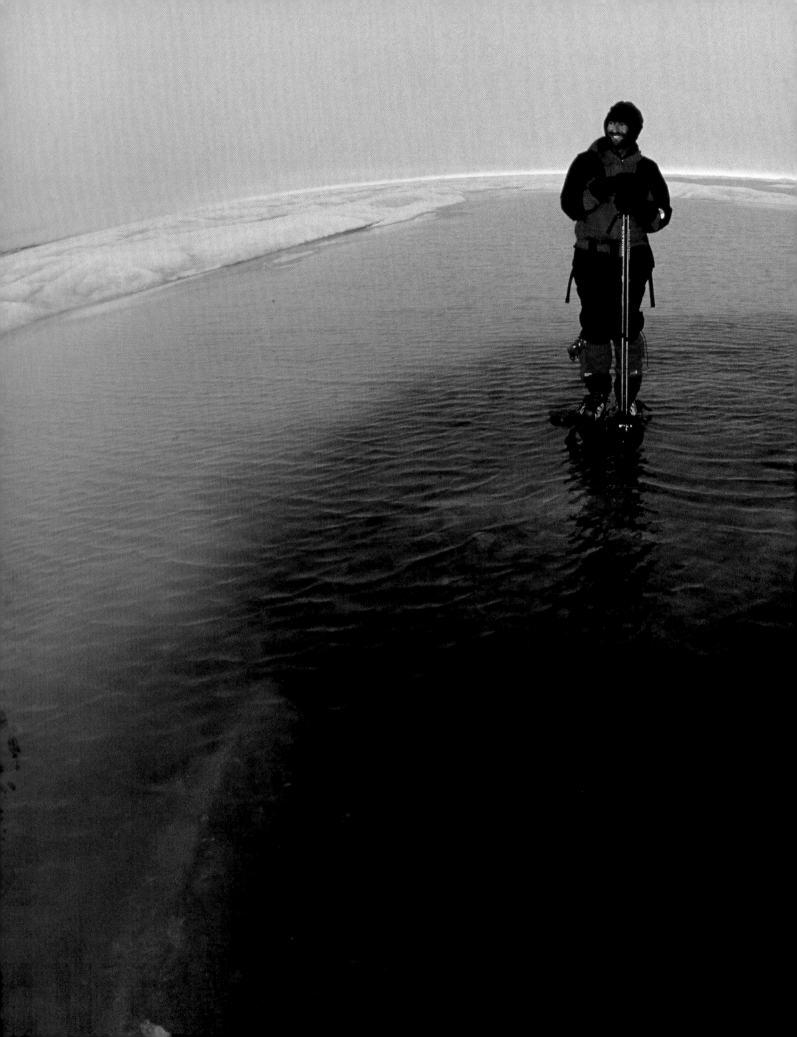

You're the Top?

More than a century ago, Robert E. Peary mushed his way to Cape Morris Jessup in Greenland and believed he had reached the northernmost landmass on earth, beyond which lay only ice and ocean. Since then a handful of small islands off the coast of Greenland have been accorded the status of "top of the world." In July 1996, photographer Galen Rowell and nine others struck out for Oodaaq Island, a tiny place that had been identified by a Danish helicopter survey group in 1978. Rowell, who pioneered a special brand of participatory wilderness photography, and his companions flew 1,200 miles from Iceland to North Pearyland, over mountains, glaciers and sea ice, then had to trek for 13 hours by rubber raft and snowshoe before arriving at their destination. Despite wearing double boots, gaiters and two pairs of socks with plastic garbage bags over them, Rowell suffered a touch of frostbite. Yet he couldn't help but laugh as he took this shot of mathematician Bob Palais standing atop the one little bit of land that was, they thought, Oodaaq. "This is an island?" Rowell wrote. "This is our great goal?" This tiny patch of land—designated "ATOW1996"—while sometimes above sea level, was not, in fact, Oodaaq. But it *is* thought to be the top of the world . . . at least for the time being.

■ Photograph by **Galen Rowell**

War

Danger is everywhere as these Marines move past an enemy corpse in August 1950. U.S. forces had recently begun fighting in the Korean War, and both of these Marines would be dead within a couple of days. The man who took this picture, David Douglas Duncan, himself a Marine and a veteran of World War II, would prove to be the preeminent photographer of the war. Said Duncan: "I wanted to show the way men live and die when they know death is among them."

Photograph by **David Douglas Duncan**

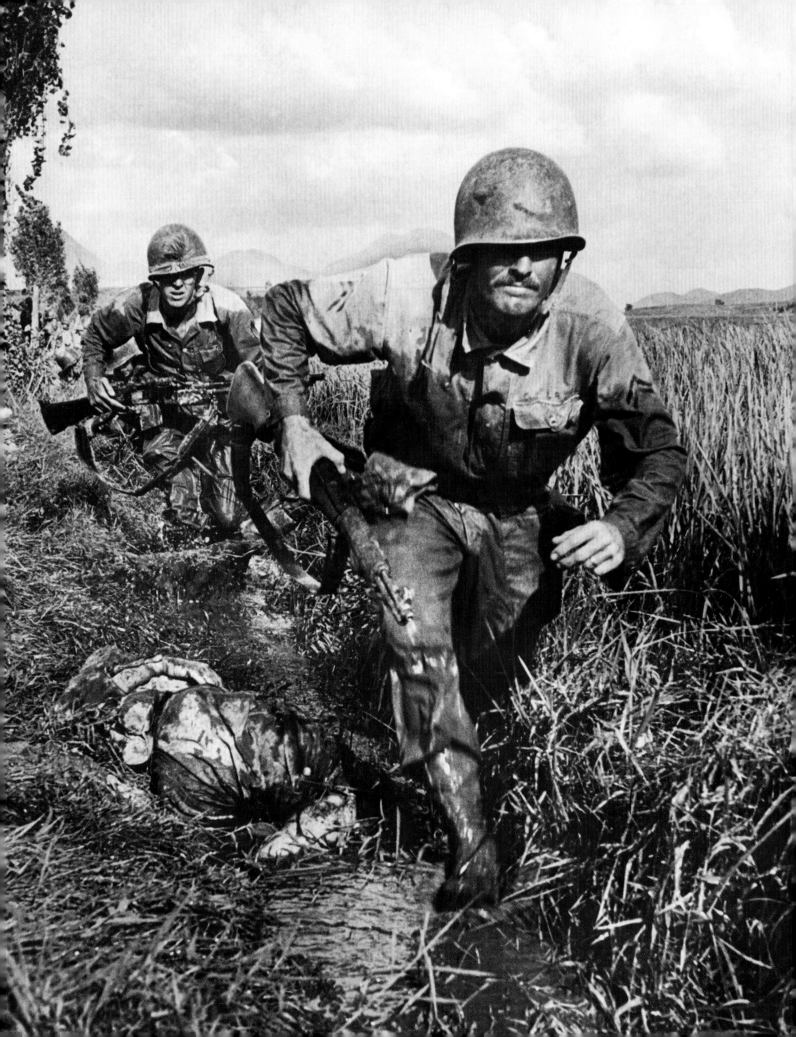

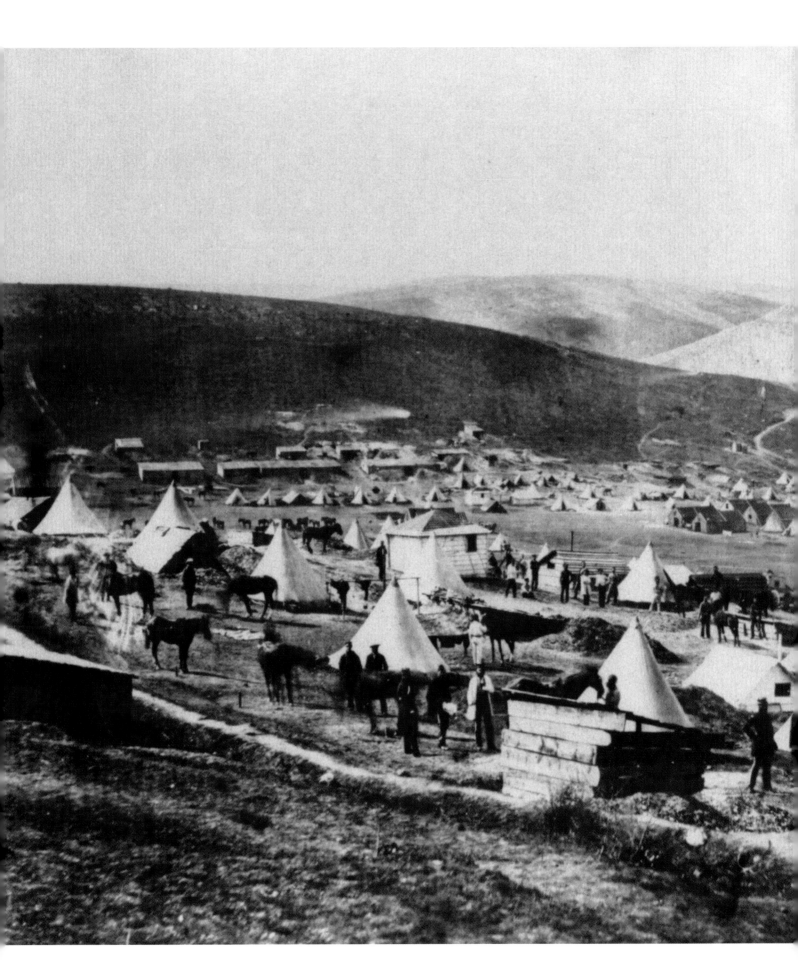

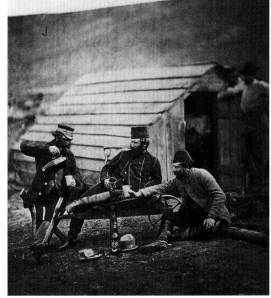

The War of the Poses

With Great Britain engaged in the Crimean War, a former solicitor named Roger Fenton set sail in 1855 on an assignment from a print dealer to cover the conflict. Fenton had taken up the camera a few years earlier and before long become a frequent portraitist of the royal family; thus it was that he also traveled in an official capacity. The Crimea was a bruising affair, and Fenton saw more than his share of bloodshed. Yet, although he took 350 photos there—creating the first substantive photographic record of a war—the images were notable for stately grandeur rather than any palpable depiction of the true nature of battle. Why? It's not entirely certain. One factor was that very lengthy exposure times made action shots impossible. And, of course, his royal patrons weren't eager to reveal to their subjects the plight of the British soldier. (This was, after all, the site of the Charge of the Light Brigade.) Further, Fenton hoped to reap postwar profits from sales of the photos, and pictures of carnage wouldn't have much appeal. In any case, his time-delay photo showing Fenton and two aides enjoying relative luxury in an uncivilized arena (above), bears the ironic title *Hardships of Camp Life.* This isn't really war, Fenton is saying, this is not the real thing.

■ Photographs by **Roger Fenton**

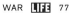

Inside the Civil War

There was but one official army photographer during the Civil War, and his name was Andrew J. Russell. The erstwhile painter was serving as a captain in a New York regiment when he was detached in 1863 to document the building of military railroads. This took Russell near Fredericksburg, Va., the general locale for several important battles. It was here that Russell began taking 132 pictures of combat zones, reflecting the way soldiers themselves saw the war. His cameras were unable to depict action, but he was there in the thick of things. Here, members of the 15th New York Engineers bivouac on the Confederate side of the Rappahannock River in preparation for an assault. It has been speculated that some of the Civil War images attributed to Mathew Brady or to his cameramen—Brady himself didn't actually take pictures in the field—may in reality be Russell's work. After the war, Russell was hired by the Union Pacific to record the laying of track across the nation. On May 10, 1869, he took one of the century's best-known pictures, the driving of the Golden Spike, as the East and West Coasts of the United States were finally connected by railway.

◼ Photograph by **Andrew J. Russell**

Record of an Execution

It was 100° just after one p.m. on July 7, 1865, in the yard near the Old Penitentiary in Washington, D.C. On a scaffold erected the day before by the hangman, Capt. Christian Rath, three men and one woman await their fate. George Atzerodt, David Herold, Lewis Paine and Mary Surratt have been found guilty in the conspiracy to assassinate President Lincoln, and they will shortly hang. The prayers are over, and Captain Rath, in a white coat, is adjusting the noose around Herold's neck. Below the scaffold, soldiers wait to kick out the supports of the trap doors. One of the soldiers, a victim of the long wait and the heat, clings to a supporting plank. A single photographer was authorized to document this historic event, Alexander Gardner, a native of Scotland who had come to America a decade earlier, and taken up work as a portrait photographer for Mathew Brady. Gardner shot for Brady in the first years of the Civil War, then, when Brady refused to give him public credit, he went to work on his own. Gardner took two of the war's most famous pictures, *President Lincoln on the Battlefield of Antietam* and *The Home of a Rebel Sharpshooter*. The latter is of note because Gardner got to Gettysburg two days after the battle ended, dragged a dead Confederate soldier 30 yards to a rifle position, then set him next to a weapon that would never have been used by a real sharpshooter. Nevertheless, the phonied-up image lives on as an icon.

Photograph by **Alexander Gardner**

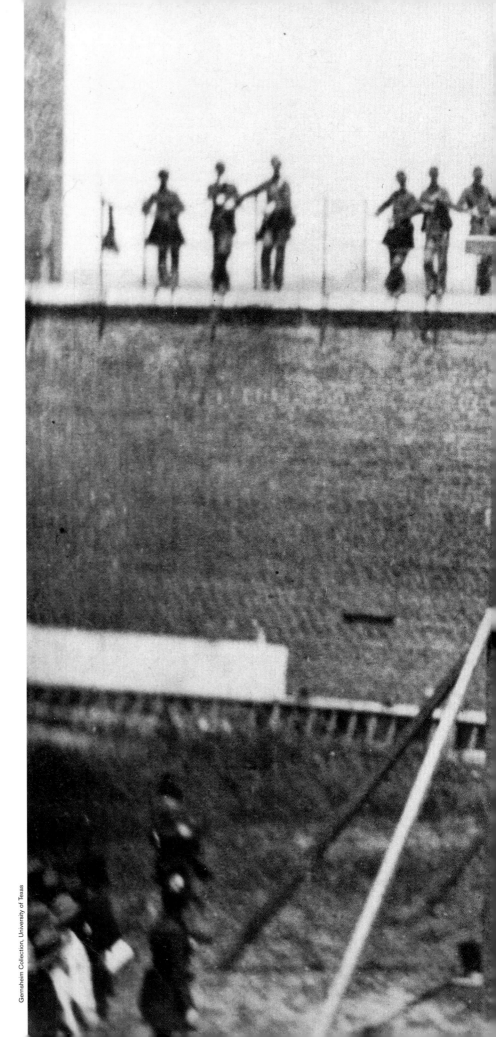

Gernsheim Collection, University of Texas

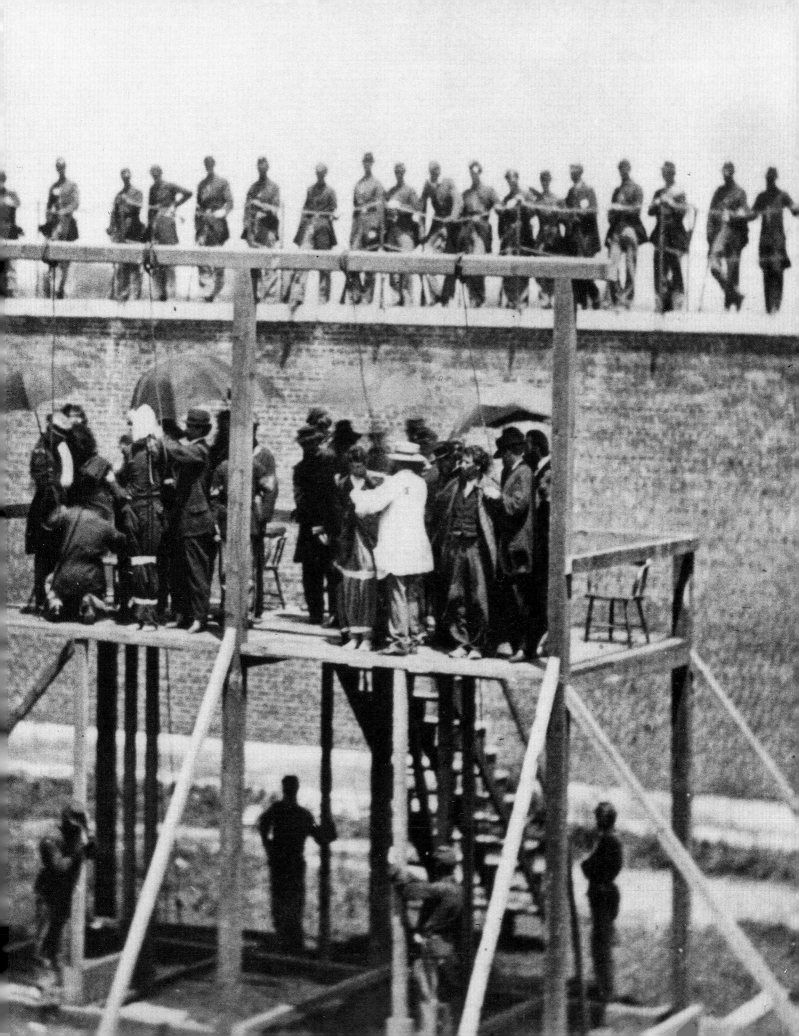

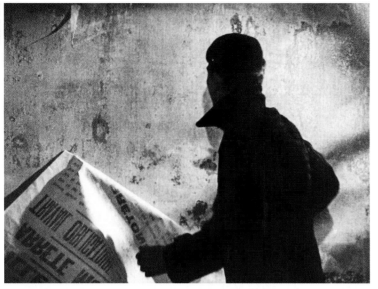

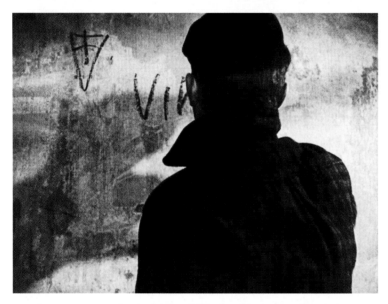

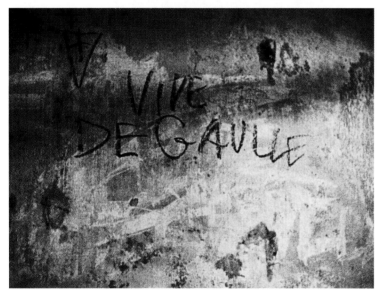

Cameras of Resolve

Living under the boot of an occupying force is one of the basest conditions that can befall a human being. World War II was no exception, as the Nazis proved particularly brutal oppressors. In such cases, the first signs of civil disobedience usually take a clandestine form. Graffiti is popular. In the picture sequence at left, a French Resistance photographer documents the courage of an ordinary citizen as he tears down a German propaganda poster and replaces it with a cry for Charles de Gaulle, the exiled leader of the Free French. Also included is that group's symbol, the double-barred cross of Lorraine set within the V for victory. Opposite, a Dutch woman keeps a wary guard as her companion, a photographer for the underground press, uses a hidden camera to take a picture through a hole in her bag. For any of these people, to have been caught would have meant torture or death.

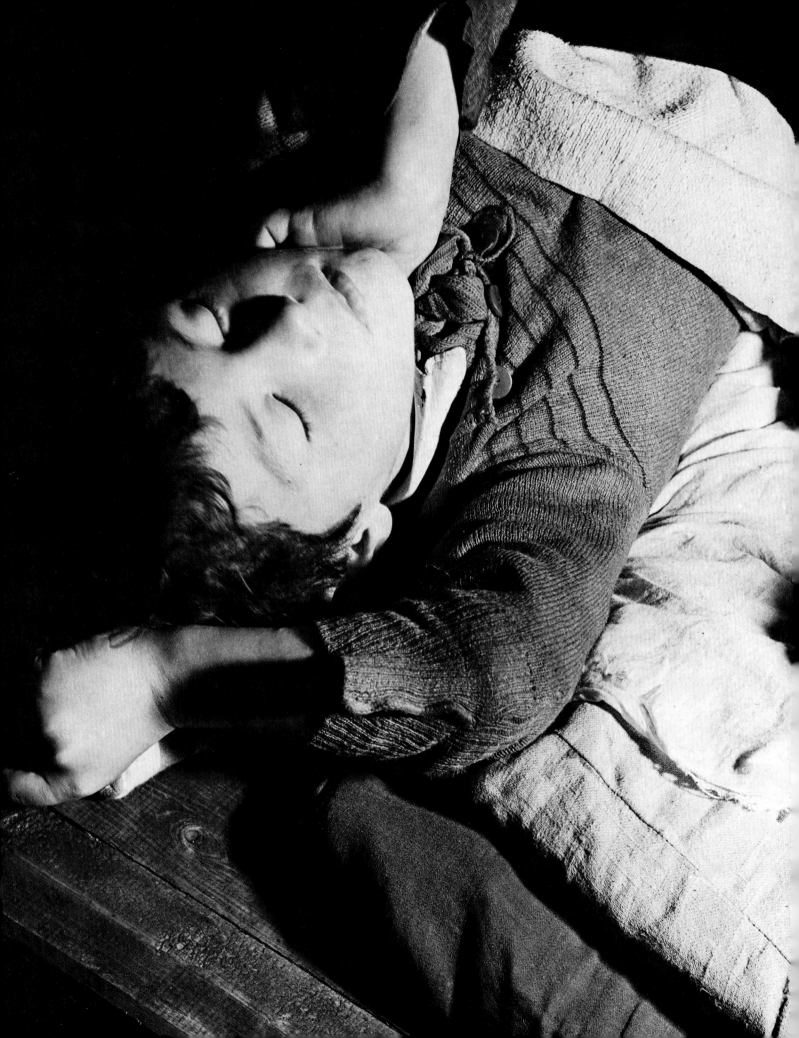

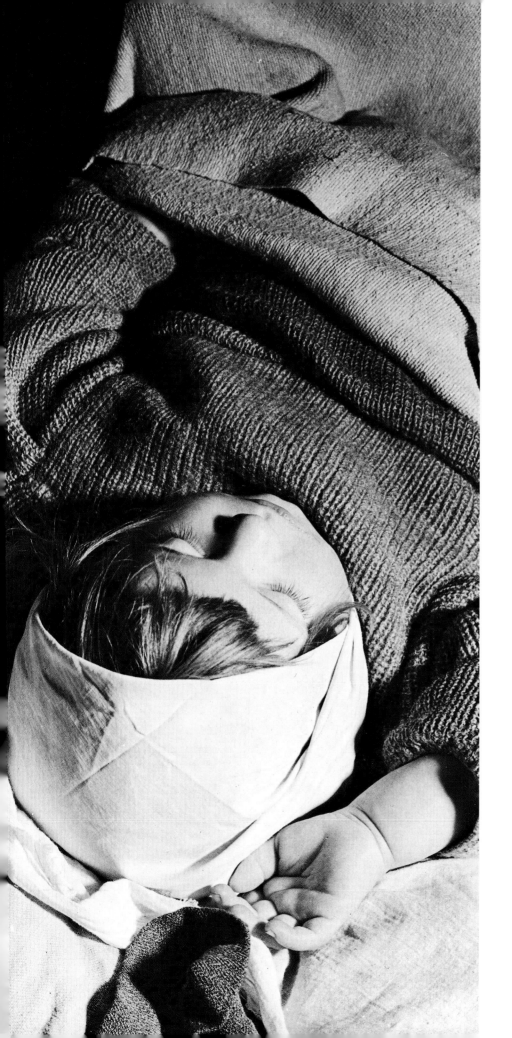

Connections

When Margaret Bourke-White arrived in Moscow in May 1941, she was ready for war, even if the Soviets were not. She had 600 pounds of equipment, including five cameras, 22 lenses, 3,000 flashbulbs and four developing tanks, all of which the legendary LIFE staffer got into the U.S.S.R. despite a ban on foreign photographers. Eleven years earlier, Bourke-White had outwaited the Soviet *nyets* to gain access to, and take nearly 3,000 photos of, the nation's industrial and social awakenings. Her work on that and two other early-'30s trips had earned the respect of Soviet officials. One month after she arrived in 1941, Germany invaded the Soviet Union. Bourke-White was the only foreign photographer on hand to record the nightly firestorms that assaulted the capital. From the first attack, she and all Muscovites were ordered to the subways. These were their bomb shelters, and women and children, especially, set up camp, as with these sleeping children in the Mayakovsky station. During later air raids, Bourke-White took photos from the U.S. embassy or her hotel. From a rooftop perch, she would note when the salvos were drawing near, then set her shutter to time exposure and smoothly slip to safety indoors. Getting the photos was one problem; getting them out of the country another. But Maggie was up to the challenge. Later that summer, after a meeting with Josef Stalin, American envoy Harry Hopkins, an old Bourke-White crony, carried her film out in a diplomatic pouch.

Photograph by **Margaret Bourke-White**

Stratospheric Sorrow

W"ar is, above all, grief," wrote Soviet photographer Dmitri Baltermants, who spent World War II documenting death and destruction—otherwise beyond belief—for the Red Army's newspaper and the official Soviet daily, *Izvestia.* Ironically, it took 20 years and a bit of photo-fiddling for Baltermants's most vivid portrait of grief to be seen. More than 20 million Soviets lost their lives in the war, including 176,000 on the Kerch Peninsula when the Nazis overran the Crimea in 1941 and '42. Close behind the German Army came the Einsatzgruppen, mobile units that ultimately murdered at least 1.25 million Jews and other Soviet nationals. Sometime around December 1, 1941, Einsatzgruppe D, led by Otto Ohlendorf (later tried and hanged at Nuremberg), rounded up and murdered 7,000 Kerchian Jews, leaving them scattered on killing fields. Baltermants's haunting image of grieving survivors searching for loved ones was, however, suppressed by Soviet censors who preferred images that would boost national morale. When the photograph finally surfaced in the 1960s, it quickly began to attract attention and is now a very well-known photograph. But it was not the same as the original shot. It had acquired a more ominous sky. When he printed it this time around, Baltermants added the lowering clouds from another photo—perhaps to hide a defect on the negative, perhaps to increase the drama . . . perhaps both.

■ Photograph by **Dmitri Baltermants**

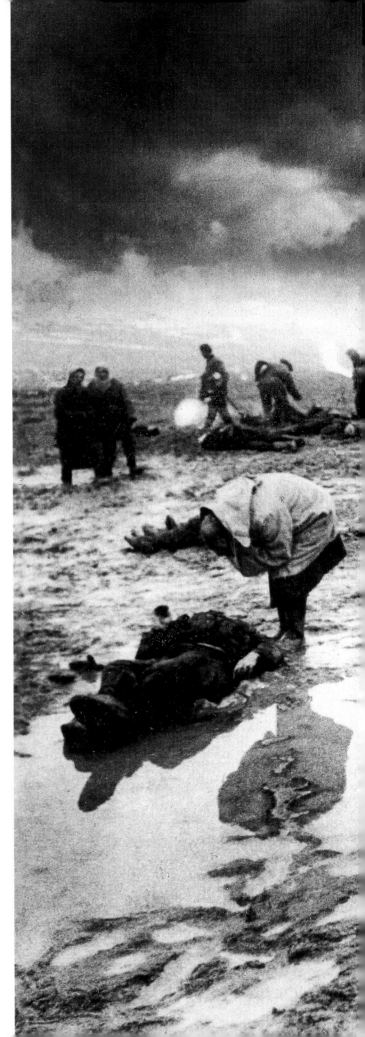

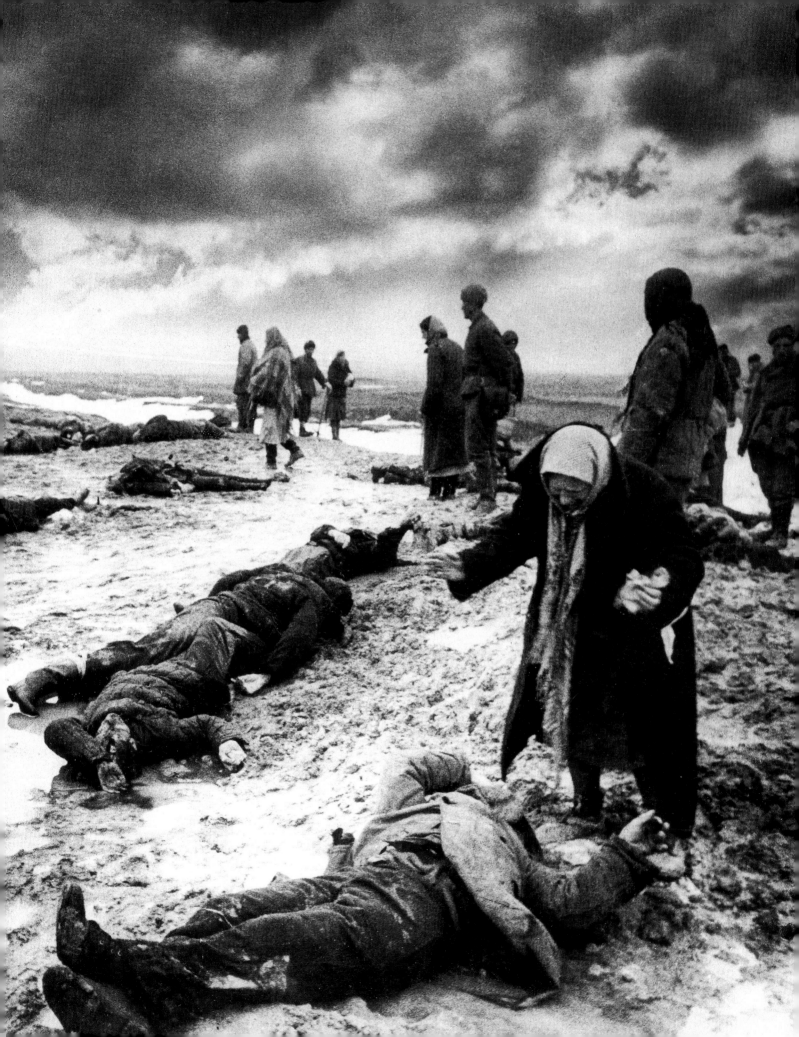

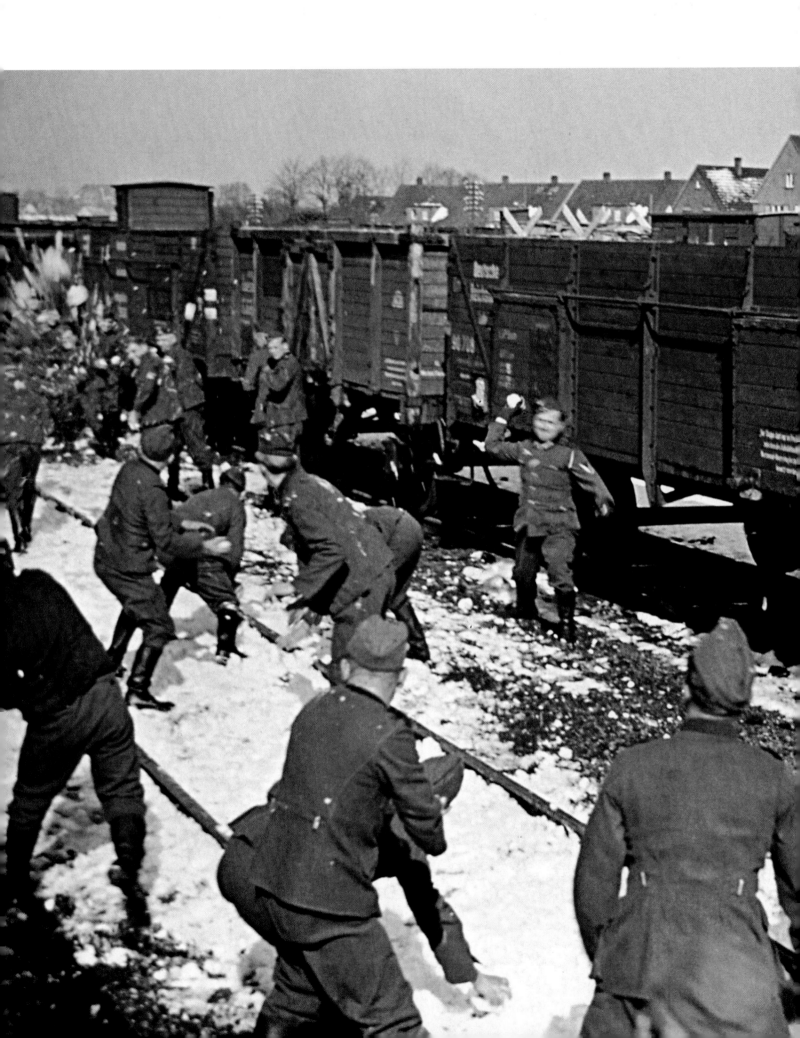

For His Eyes Only

One of the strangest tales in the annals of photography is that of Hugo Jaeger. Born in Munich in 1900, he was 14 when he received the only gift he ever got from his parents: a camera. He took to it immediately, and in WWI served as a very young photographer at the front. After the war, he joined a fascist group that proved to be an incubator for the Nazi party, but continued with his camera, developing an interest in color and stereo pictures. In 1930 he befriended Martin Bormann, who would become a powerful figure in the Third Reich. Six years later in Berlin, Bormann introduced Jaeger to Adolf Hitler, who was impressed with both Jaeger's ideology and his photography. Although at first Hitler didn't like Jaeger's color work ("a poor technical imitation of nature," he opined), the clarity of the images soon won him over so that the Führer told Jaeger to stick with color: "Be totally rock-hard convinced that German industry and science will steadily perfect it." Hitler gave Jaeger a pass that essentially allowed him to go wherever he wanted to take his pictures. On weekends, he was often invited to Hitler's home to show his slides to guests. Ironically, Jaeger's sharp-eyed work was never used as propaganda, which is a real surprise. Witness this 1944 shot of German soldiers horsing around while awaiting deployment in France. Things were rapidly growing bleak in Germany, and this unposed portrayal of high morale would have done wonders on the home front. Instead, Jaeger's work served only to entertain Hitler and his private circle. Jaeger hid his work till after the war, then in the late 1950s he sold it to *Look* and, in 1965, to LIFE.

■ Photograph by **Hugo Jaeger**

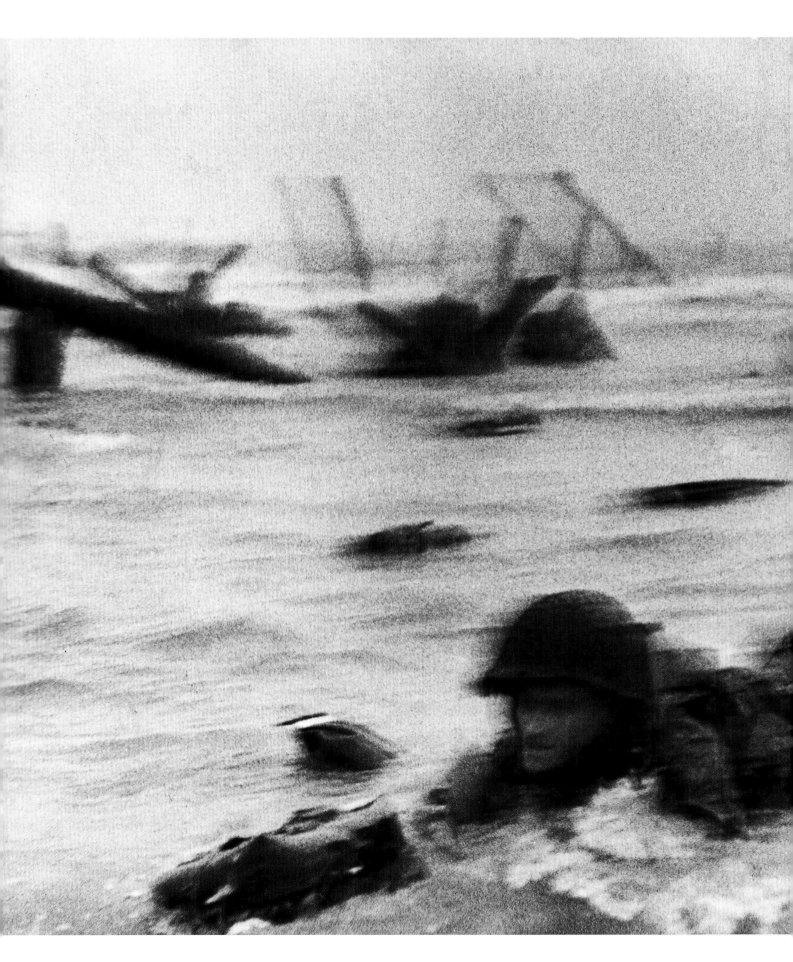

In His Element

One of history's premier photojournalists, Robert Capa was at his finest when depicting the torments of war. And he always closely adhered to his own dictate: "If your pictures aren't good enough, you're not close enough." Consequently, Capa rode in with the first Allied soldiers to hit the Omaha beachfront, one of the fiercest places to be on June 6, 1944, D-Day. But even with a master such as Capa, sometimes fate intervenes in a final picture. He went through four rolls of film that day, but a photo assistant in London, racked by deadline pressures, ruined all but 11 of the shots. And even those 11 were altered by heat, or perhaps in the furor of the day, Capa himself exposed them to water. In any case, the images that survive capture the bewildering chaos of combat as well as any pictures ever taken.

■ Photograph by **Robert Capa**

Returning

A few months after the Japanese attack on Pearl Harbor, President Franklin D. Roosevelt ordered Gen. Douglas MacArthur, who was in charge of the Army in the Far East, to evacuate the overrun Philippines for Australia. MacArthur famously vowed in March 1942, "I shall return." In October 1944, to great fanfare, he did return, and this picture is widely used to commemorate that event. Except that this photo was actually taken three months later, when Carl Mydans recorded the general's entry onto a different beach in the Philippines. It has been said that MacArthur himself preferred this image: more commanding mien, and all that. (He doubtless also preferred it as it's often seen—without the bare-chested soldier at right and/or the photographer at left.) The Mydans-Philippines story itself is fascinating. He and his wife, Shelley, had been captured and held as POWs for nearly two years before being repatriated in an exchange. Less than a month after the picture below was taken, one of MacArthur's officers had Mydans sent in with the first tanks to liberate Santo Tomás prison, where Carl had been a prisoner. These two men, civilians Lee Rogers and John C. Todd, were among 31 others with whom Mydans had shared a room. The duo had lost 131 pounds during their confinement.

■ Photographs by **Carl Mydans**

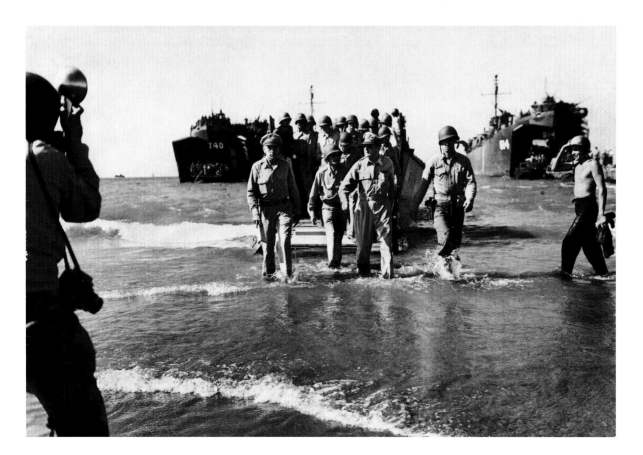

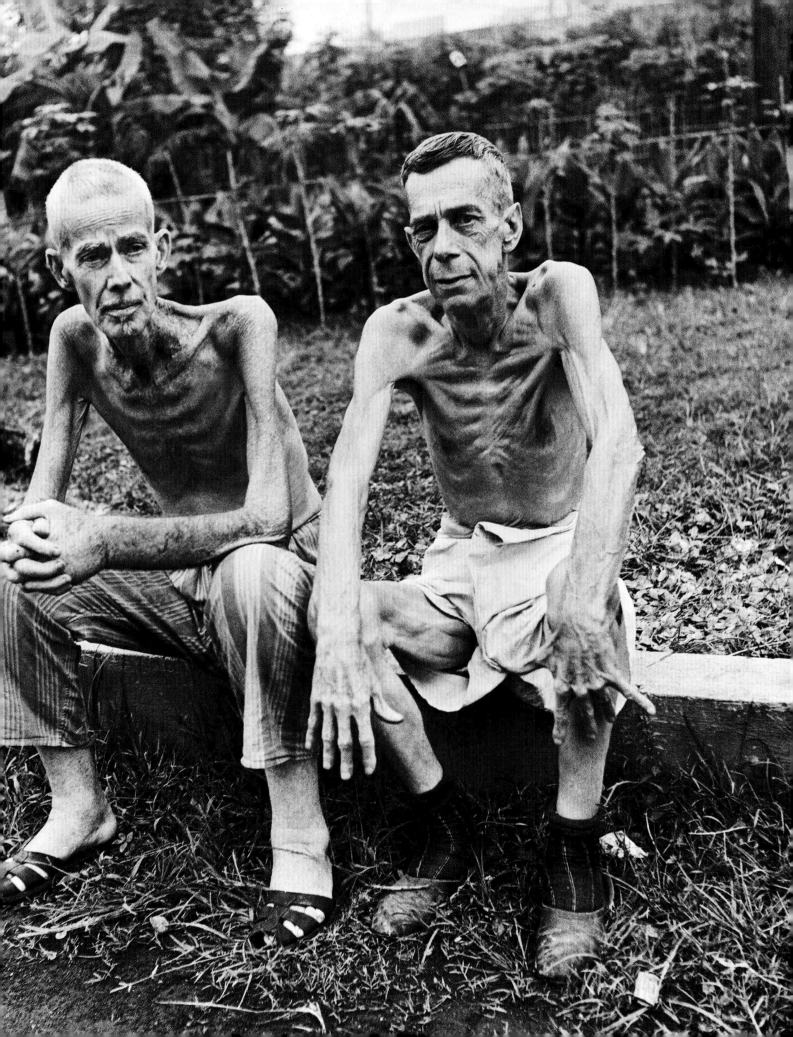

The Walking Dead

At 8:15 a.m. on August 6, 1945, 32-year-old Yoshito Matsushige had finished breakfast and was preparing to leave for his job as a newspaper photographer when suddenly "the world around me turned bright white." Matsushige was but a mile and a half from the hypocenter of the atomic bomb explosion at Hiroshima. Although the blast rent the walls of his home, he was only slightly injured. By instinct he grabbed his camera, and during the next few hours he wandered dazedly through the streets of the city. For a long time, he could not bring himself to take a picture of the flowing nightmare that surrounded him. Finally, however, the need to record the event overcame him. "I clearly remember how the viewfinder was clouded over with my tears." Here, at the Miyuki Bridge, he found a group of burn victims. "What did these people . . . think of me as I recorded this scene in photographs? . . . Sensing that hundreds saw me as a coldhearted, uncompassionate wretch, it was all I could do to click the shutter twice." Then Matsushige moved on, helplessly drawn to one macabre scene after another. "I don't pride myself on it, but it's a small consolation that I was able to take at least five pictures." The people in this photo all likely died of radiation poisoning.

Photograph by **Yoshito Matsushige**

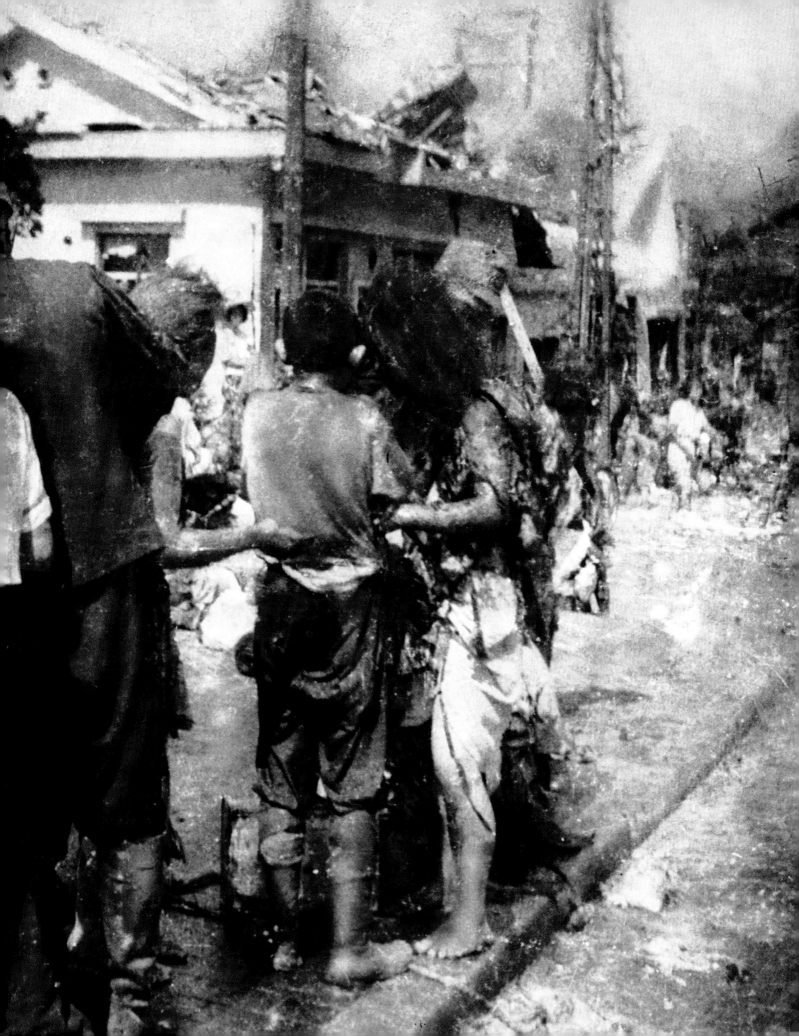

Where There's a Will . . .

Larry Burrows was, of course, the photographic bard of the Vietnam War. And, as with any real artist, he gave completely of himself to get results. This meant not letting little things stand in his way . . . little things like the United States Air Force. In 1966, Burrows wanted to capture the AC-47 gunship in action. The plane was a real workhorse over there. It had been used in WWII and Korea for transport and the like, but in Vietnam three side-firing guns were added, capable of 6,000 rounds a minute. Because these miniguns were fixed, the craft had to be tilted to aim at a target. To get this shot, Burrows persuaded the Air Force to remove half of the plane's rear door, then he strapped himself in, leaned outside and got this sizzling shot of tracer fire.

Photograph by **Larry Burrows**

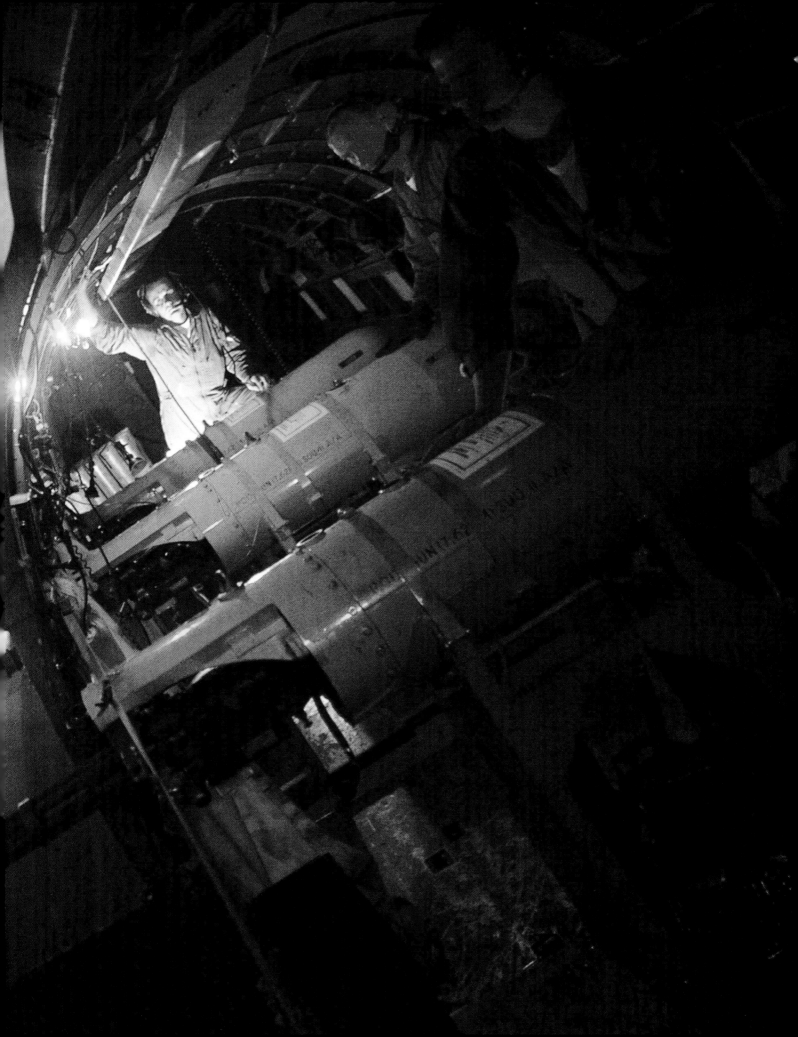

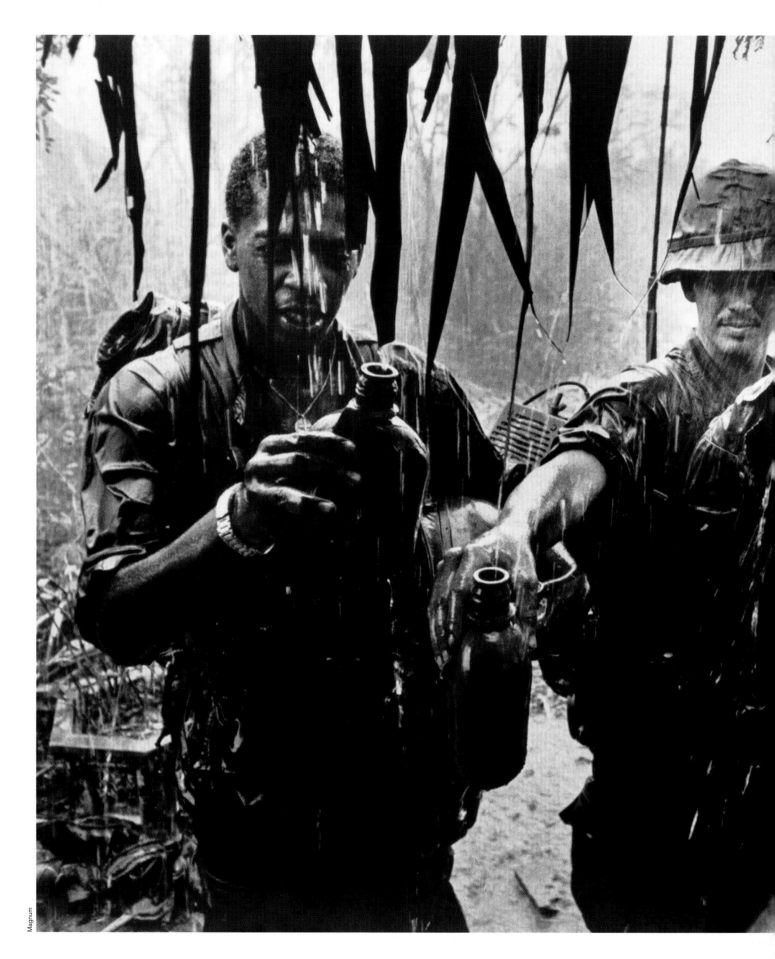

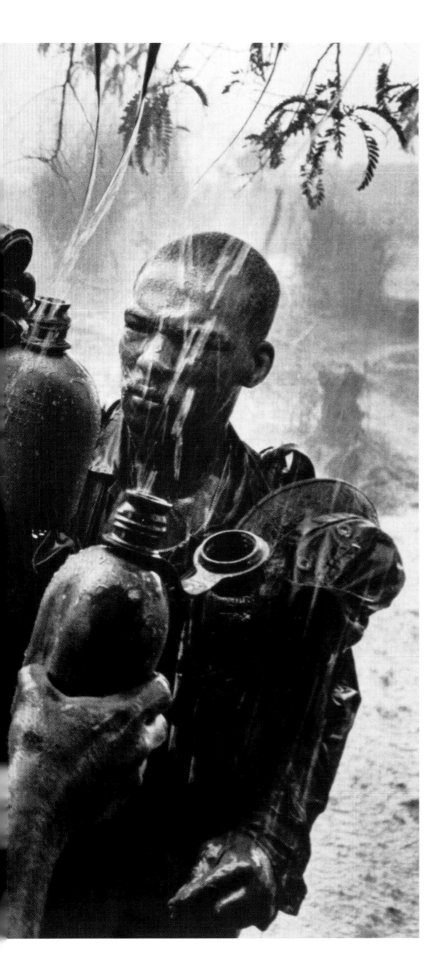

Nectar from Above

The Welsh photographer Philip Jones Griffith gained his greatest notice for 1971's *Vietnam, Inc.,* a book that helped crystallize public opinion against the war—and got him banished from South Vietnam. Time and again, Griffith looked beyond the "soldiers running up and down hills firing at each other," which he regarded as boring compared with the cultural upheaval in the land. On a steamy day in 1968, he was with the U.S. Army 9th Infantry Division in the countryside east of Saigon when the monsoon came. ("The worst thing, after lead [a bullet], is water," says Griffith. "It ruins cameras.") Tired of drinking the heavily chlorinated army-issue water, these GIs shrugged off concerns about getting sopping wet—even though the awful sogginess could stay with them for days—in favor of the chance to collect fresh H_2O as it cascaded from the roof of a hut. "You had to wait at least three minutes for the rain to wash the dust off everything," Griffith explains, "but then it was the most wonderful water you ever tasted. You could bottle it and sell it."

■ Photograph by **Philip Jones Griffith**

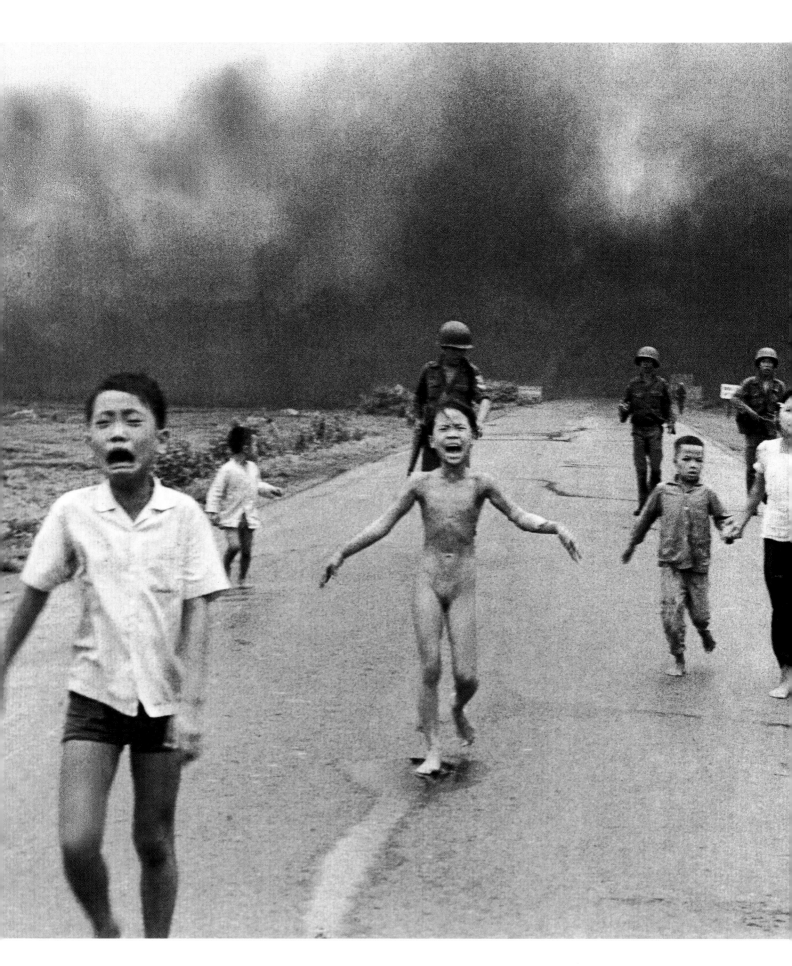

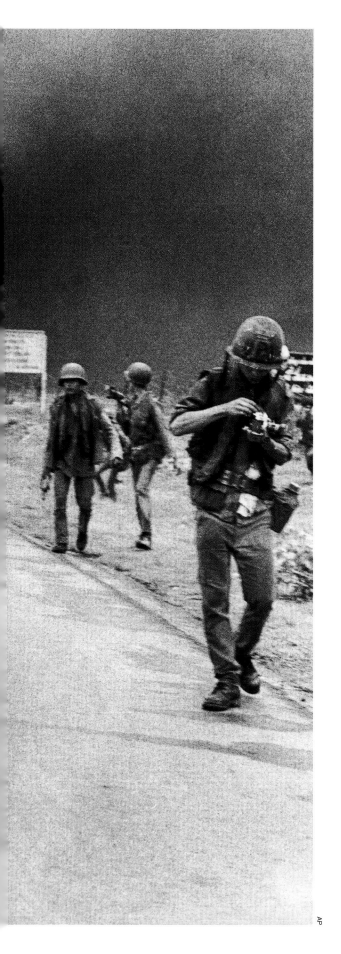

He Saw a Signal

It is, perhaps, the most memorable photograph to emerge from the Vietnam War—or maybe even any war. The image of nine-year-old Kim Phuc running, naked and screaming, down a road in Vietnam is seared into our brains like the napalm that charred her left arm and back. Associated Press photographer Huynh Cong "Nick" Ut had spent the morning of June 8, 1972, taking pictures at Trang Bang village, where there had been fighting for three days. He was getting ready to return to Saigon when he saw a South Vietnamese soldier drop a yellow smoke bomb. "That's a signal," Ut thought, and picked up his camera and began shooting. Moments later, a South Vietnamese Skyraider dropped four napalm bombs on the village. "When the bomb exploded, we didn't know anybody had died or was injured," recalls Ut. Then people started charging out of the town. Ut heard a child screaming, *"Nong qua! Nong qua!"* ("Too hot! Too hot!") and turned to see Phuc, who had pulled off her burning, napalm-soaked clothes. She yelled to her brother (on her right) that she was dying. "I was very young," Ut says. "I knew I had a good photo, but I didn't know what a historic photo was." When Phuc reached Ut, and he saw that her skin was coming off, he put down his camera. "I didn't want to take any more pictures." Ut took her and other injured children to a hospital and then made his return to Saigon.

■ Photograph by **Nick Ut**

To Honor the Fallen

Working the night shift at Kuwait International Airport in early 2004, 50-year-old Tami Silicio had seen more than a few coffins come through bound for Dover (Del.) Air Force Base, the largest U.S. military mortuary. Her job with Maytag Aircraft, a Defense Department contractor charged with shipping supplies to and from Iraq, entailed paperwork and loading cargo . . . cargo that included the dead. Silicio knew the pain of losing a child: Her oldest son had died of a brain tumor at age 19. Surely it was the mother in her that reacted on April 7. As colleagues secured the 21 flag-draped coffins that filled the fuselage of one C-5, the Everett, Wash., resident pulled out her Nikon Coolpix digital camera and snapped a picture. She wanted to "let the parents know their children weren't thrown around like a piece of cargo, that they, instead, were treated with the utmost respect and dignity." Silicio sent the picture to a friend, and 11 days later it appeared on the front page of *The Seattle Times.* Within days, Maytag fired both Silicio and her husband, David Landry, because they had "violated Department of Defense and company policies." Any photographs or news coverage of the transport of dead servicemen and women had been banned by the Pentagon. "I took that photo from my heart," Silicio told her friend when it appeared she might be fired. "I don't care if they send me home or if I have to work for $9 an hour the rest of my life to pay my mortgage."

■ Photograph by **Tami Silicio**

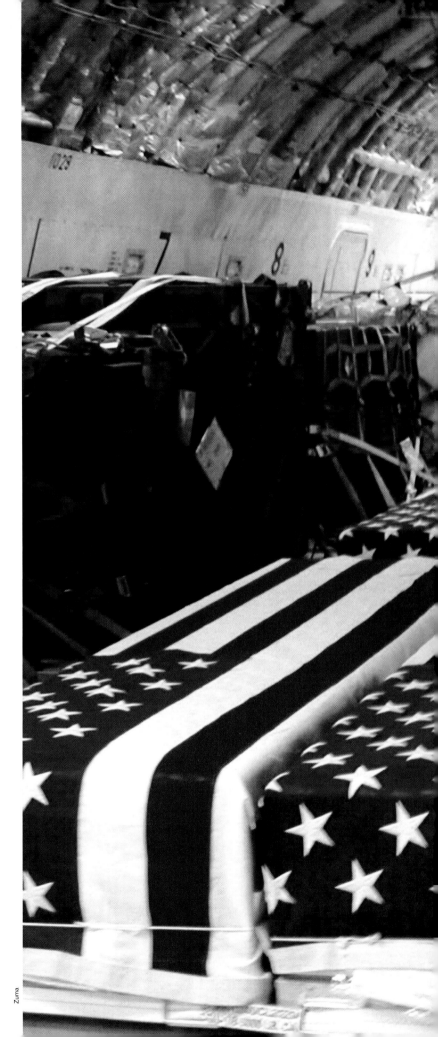

Zuma

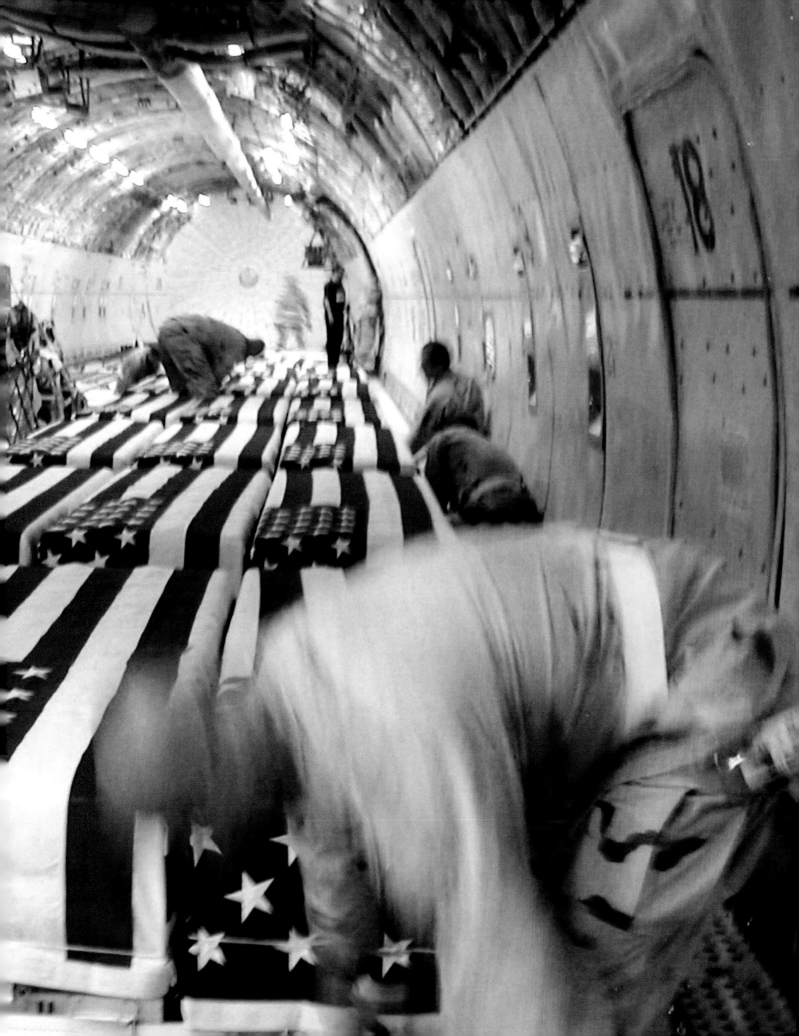

Sport

Only a very hardy, and fearless, breed of adventurer is drawn to the Antarctic—the bottom of the world. Simply getting there is a trek unto itself. Then, on site, the gear and clothing can be overwhelming. For a photographer, there is much, much more equipment to contend with, and unwieldy factors to take into consideration. Norbert Wu, who is renowned for his underwater images, has spent a good deal of time in the Antarctic. Here, Wu reveals a veteran mountaineer making his way through a particularly ominous fissure in the ice, known as a crevasse.

Photograph by **Norbert Wu**

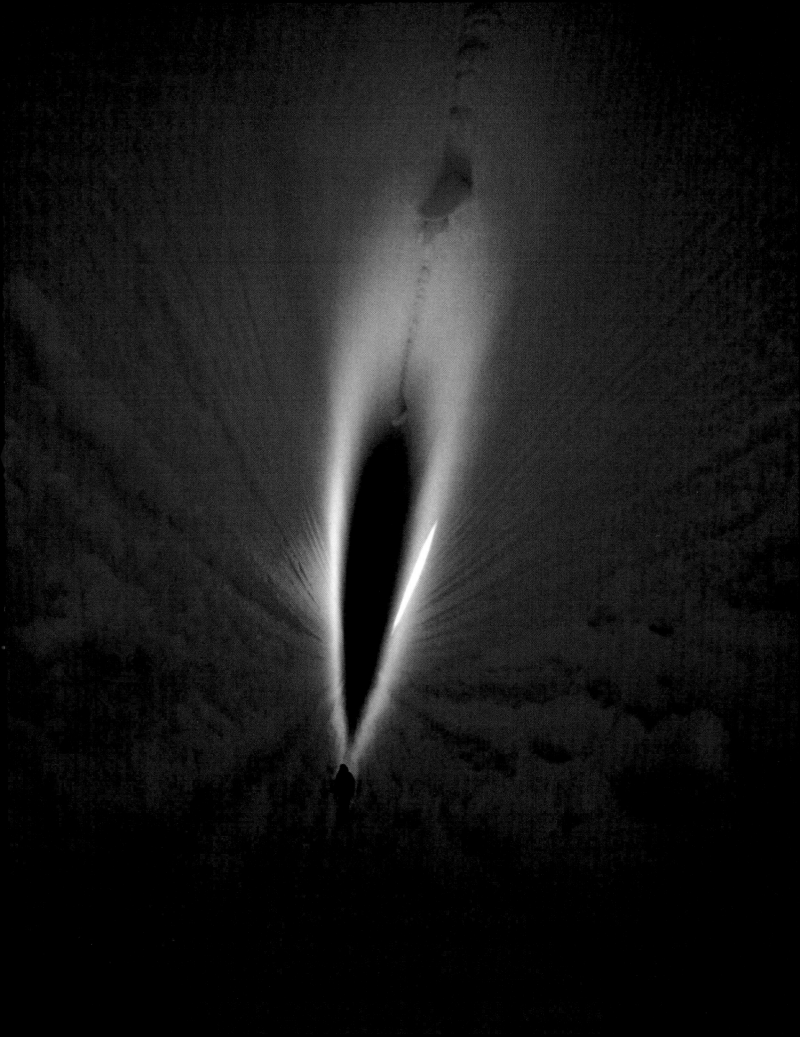

A Picture of Time

Reconciling time and motion is at the heart of sports photography. When athletes and animals are tearing by at heart-thumping speeds, a still camera well employed can freeze that pounding action. A TV producer, meanwhile, is able to parse the race endlessly, with instant replay, slo-mo, closeups and the like. Somewhere in between, with most arresting results, comes slit photography. The technique—substituting a vertical slit for the usual shutter, and zipping a strip of film past the slit at the same speed as the subject of the photo—records what happens in one spot over a period of time. Photographers have experimented with slit cameras since the late 1800s, and, in 1948, the device was used for the first time to adjudicate Olympic photo finishes. But it was a New Zealander who made his name as a combat photographer and then fell into sports photography who turned the technique into an art. George Silk began experimenting in the late 1950s with high-speed electronic flash, panoramic cameras and slits. At the 1960 Olympic trials in Palo Alto, Calif., he captured this startling image of hurdlers Willie May, Hayes Jones and Lee Calhoun by modifying the camera so that the slit shutter stayed open for a few seconds. Forty-four years later, *Sports Illustrated* photographer Bill Frakes uses an updated version of Silk's technique to record Smarty Jones's runaway win in the Kentucky Derby. Frakes, who graduated from law school only to realize that journalism was his true calling, finds sports a perfect subject because, he says, "I enjoy the technical challenges. Things happen very quickly, and often just once."

Photographs by **George Silk** and **Bill Frakes**

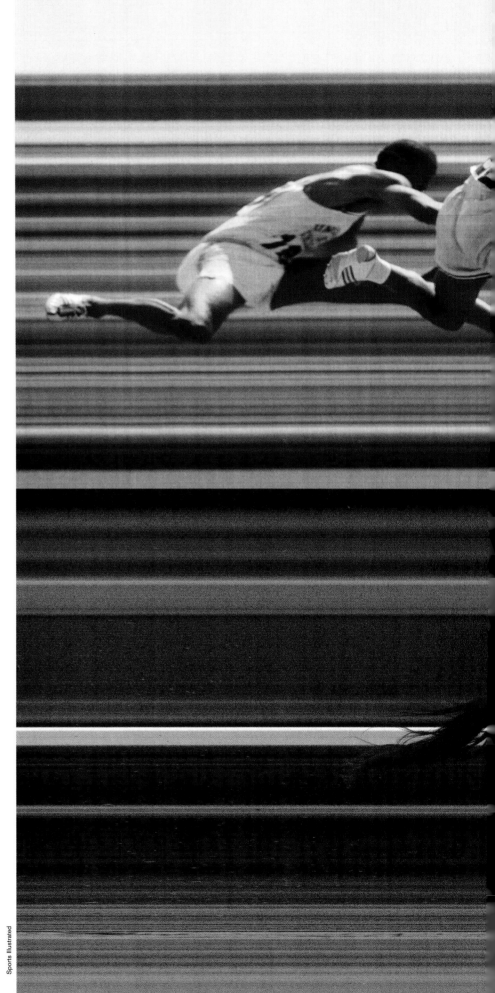

Sports Illustrated

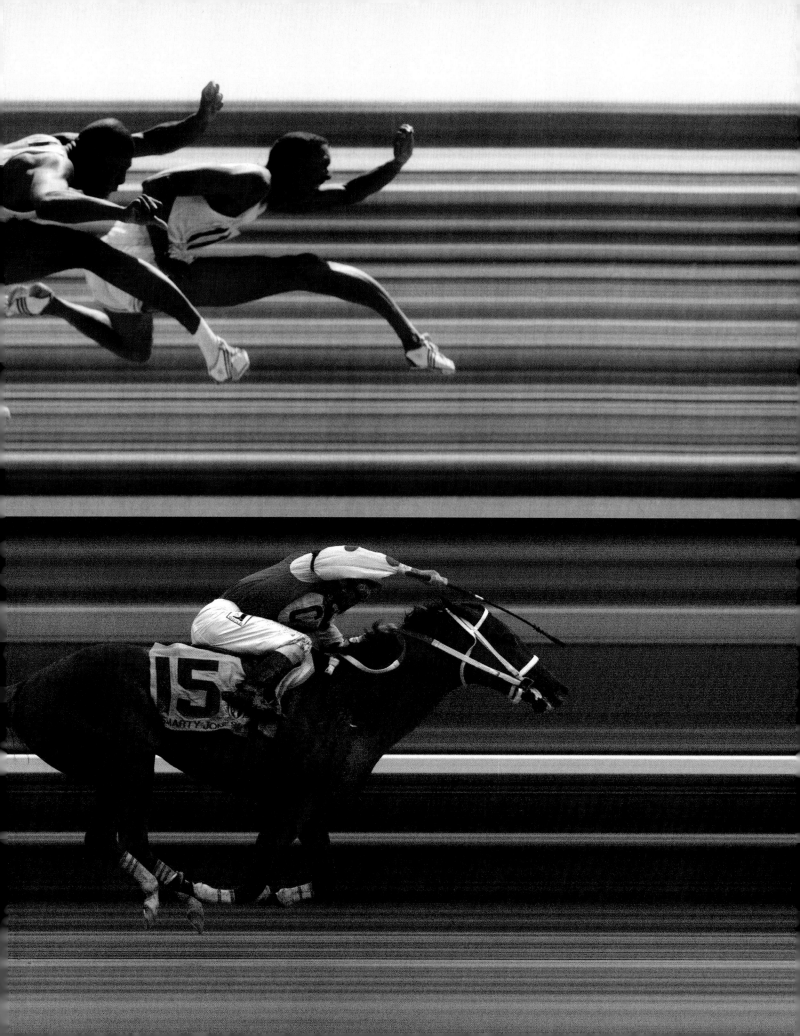

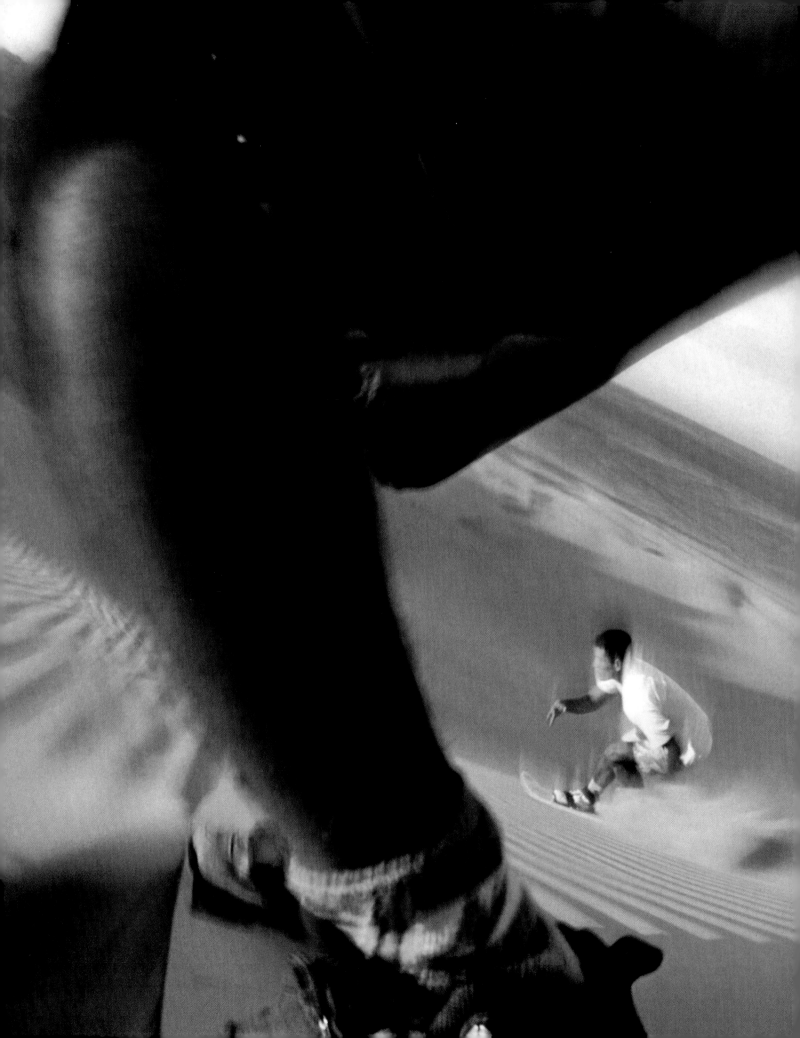

Sand Blast

The breakneck pace and raw thrills of "extreme" sports have proved increasingly irresistible to many young Americans. Because these pursuits are well suited to television, and as America is in the habit of exporting its culture around the globe, it makes sense that kids in Peru who have seen snowboard videos adapted that sport to their local terrain. Here, in southwestern Peru's Ica Desert, two lads are dashing down a 500-foot-high dune on sandboards. Unfortunately, everything about sandboarding, invented in emulation of snowboarding, makes it a difficult endeavor to capture in closeup, but photographer Olivier Renck was just the man for the job. Born in the French Alps, he has mountain biked, paraglided, BASE jumped and was, at one time, a professional speed skier. Renck attached a wide-angle camera to the back of a sandboard and used a slow shutter speed to pick up the sand flying around ("Just like powder snow," said Renck). To protect against the bedeviling effects of sand on the camera, he covered it in plastic wrap that he bought at a food store. Renck then got on a sandboard himself and followed about a hundred feet behind the boys, and triggered the camera with a remote control. "At the end of the ride, I didn't know if I had got the shot, but for sure, that day, the three of us shared a very unique moment."

■ Photograph by **Olivier Renck**

The View from On High

In 1896, a gold prospector dubbed it Mount McKinley after William (who hadn't even been elected president yet), but to Alaskan natives it has always been Denali—The High One. To Brad Washburn—mountaineer, scientist, cartographer and photographer—it is one more conquered peak. Washburn, who scaled Mont Blanc, Monte Rosa and the Matterhorn by age 16, ascended the 20,320-foot McKinley three times, including in 1951, when his crew pioneered the West Buttress Route that changed the climb forever. Only 76 people had attempted McKinley before that year. In the 50 years following, nearly 25,000 tried—and about half succeeded. Years earlier, Washburn had made the first photographic flights over the Alaska Range; he made three flights in 1936 and three more over the next few years, including one in 1938, when he took this photo. After removing the plane door, he sat cross-legged, secured by ropes, breathing bottled oxygen and wielding a 53-pound monster of a camera that used rolls of film 120 feet long and 9.5 inches wide. The pictures he got were awe-inspiring, part of a body of work that, said one photographic-arts scholar, resembled images "Ansel Adams would have made if he'd had a flying carpet." For Washburn, photography was yet another challenge. "When people climb big mountains, there are always excuses as to why the photos didn't come out . . . It was too cold, it was too windy, I was exhausted, there wasn't enough oxygen . . . I said to myself, 'I think it would be fascinating to try not to make excuses, to take large-format pictures in difficult circumstances and somehow or other make them come out.'"

Photograph by **Brad Washburn**

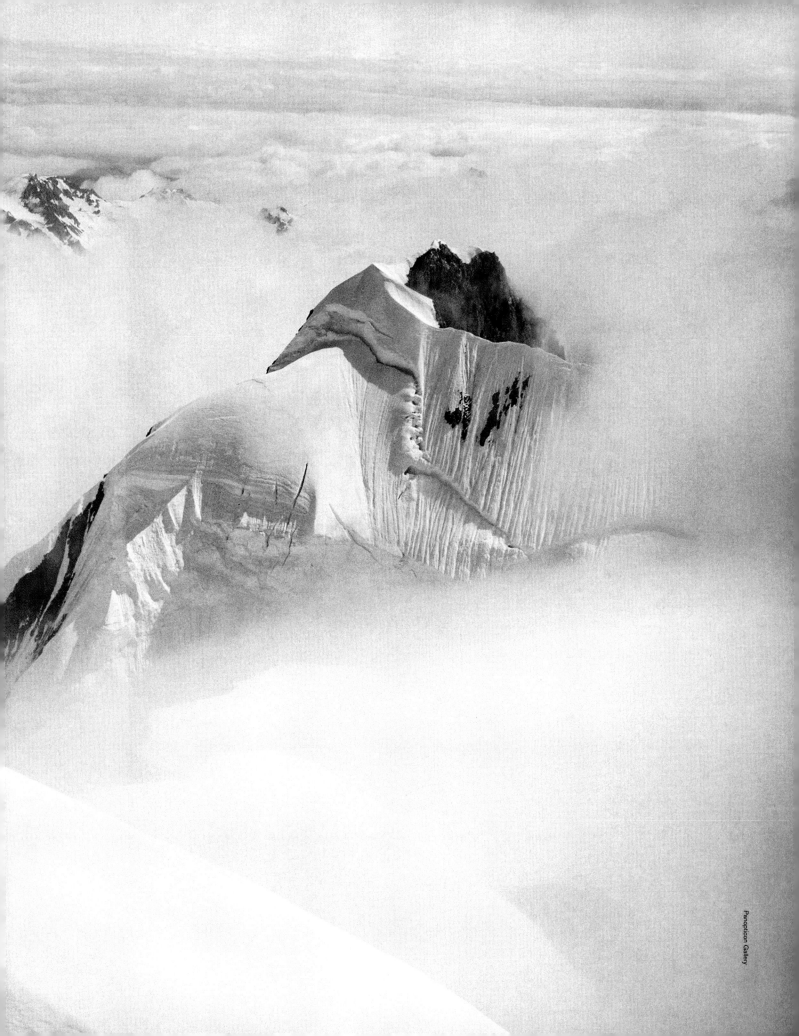

A Brace of Statesmanly Sportsmen

Angling and gymnastics are two very fine sporting pursuits, but whether they were intended to be pursued in the manner and method presented here is certainly open to debate. Tito (born Josip Broz), seen at right in 1949 with a rather undersized prize from the sea, ran Yugoslavia from 1953 to 1980. When Tito was a resistance leader fighting out of a mountain stronghold in World War II, John Phillips, who took this picture, had spent a lot of time with him, and a sort of intimacy ensued. Above: Born David Gruen in Poland, he adopted the biblical name Ben-Gurion while working as a farmer in Palestine early in the 20th century. In 1948 he would, of course, become the first prime minister of Israel, and ultimately be revered as the "Father of the Nation." Paul Goldman took this unlikely photo in September 1957, and although a number of people recalled the image, it was nowhere to be found until a few years ago when David Rubinger, a former colleague of Goldman's and *Time* photographer, tracked it down with the help of Goldman's daughter. From the 1940s to the '60s, Goldman was one of Israel's foremost photographers, and very well acquainted with Ben-Gurion. In fact, they were together on November 29, 1947, when the United Nations approved the formation of a Jewish and an Arab state. That very same day, Goldman's wife gave birth to a baby daughter. It was Ben-Gurion who suggested they name her Medina, which is Hebrew for *state*. It was Medina who helped unearth this photo, which had been stashed away in an old box above her kitchen.

Photographs by **Paul Goldman** and **John Phillips**

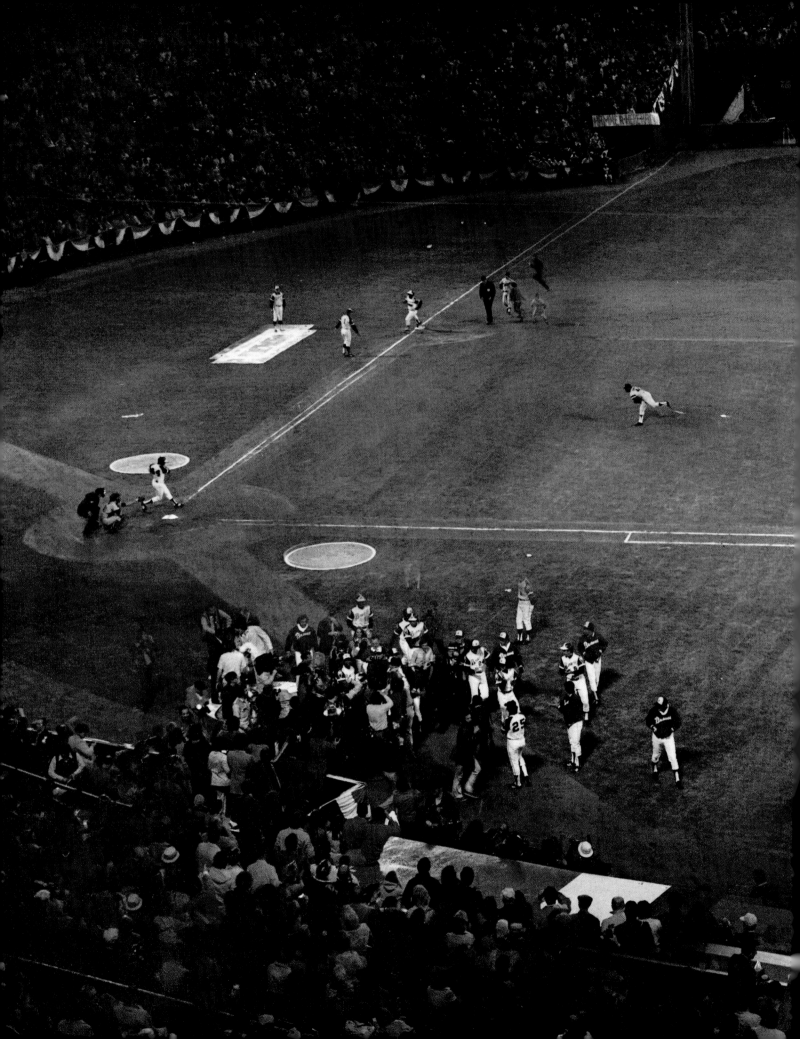

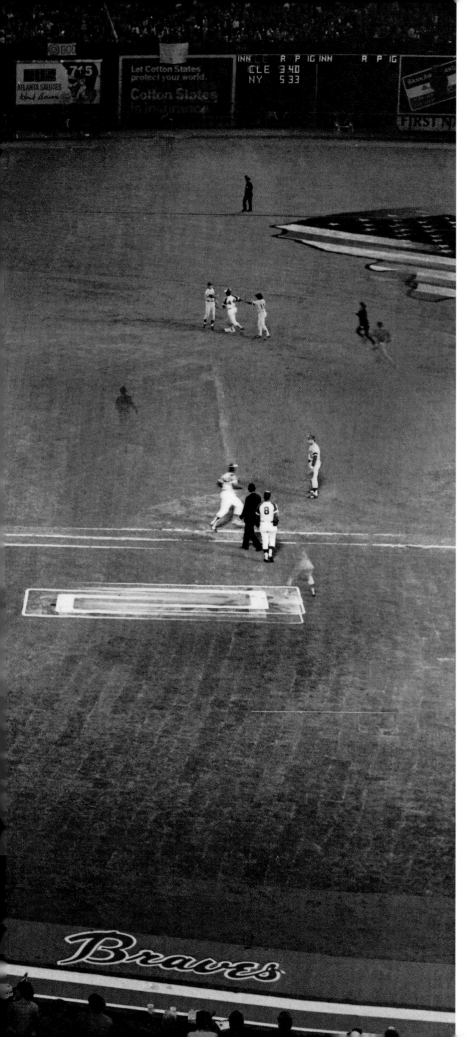

Touching All the Bases

On April 8, 1974, Henry Aaron put an end to his dramatic pursuit of Babe Ruth's all-time home-run record when he smote his 715th round-tripper. LIFE photographers Ralph Morse and Henry Groskinsky were ready. The two had devised a setup in which they aimed the lens of a camera through a glass plate covered by black cardboard. As Aaron batted and then ran, pieces of the cardboard masking were removed bit by bit, exposing Hammerin' Hank at each base and in front of the Braves's dugout. Morse, who had already scored in the sports world with his iconic image of Jackie Robinson rounding third, manned the camera. Groskinsky, who excelled at solving technical challenges, stripped away the masking. "Ralph and I had to be completely coordinated, working as one," says Groskinsky. They were entirely focused on their exercise, not on the event itself. Groskinsky remembers: "If you had had photographers who cared about baseball, it never would have worked." Close examination of the image reveals some surprises: The two men who ran onto the field to join Aaron's historic circuit made it into the photograph (they are red- and black-clad blurs at third base), but the home-plate celebration that stopped the game for 10 minutes did not. Morse and Groskinsky didn't expose any film during the little party because they had already gotten their shot of Aaron at the plate when he was batting.

Photograph by **Ralph Morse and Henry Groskinsky**

Cycles, Smoke and Sand

It was one of those nutty weeks at LIFE when nothing in the world was happening," says photographer Bill Eppridge. The year was 1971. "It just so happened that they had this annual cross-country race out across the Mojave Desert. This was long before they realized that it was ripping the desert up, just tearing it up." So, Bill and a colleague went out there and met with the organizers, who wanted to know where they were going to shoot from. Said Eppridge, "Let's get a chopper." The organizers didn't like this, thought it would make too much noise. Eppridge told them not to worry, then went right out and did what he wanted to do. "I got hold of a pilot who flew in Nam . . . always liked to give them the business . . . they did so much for us." Before very long they were hovering, not particularly high up in the air, as the 650 riders readied for the start. "[We were] sitting on top of them . . . the gun goes off, and I shot everything that moved."

■ Photograph by **Bill Eppridge**

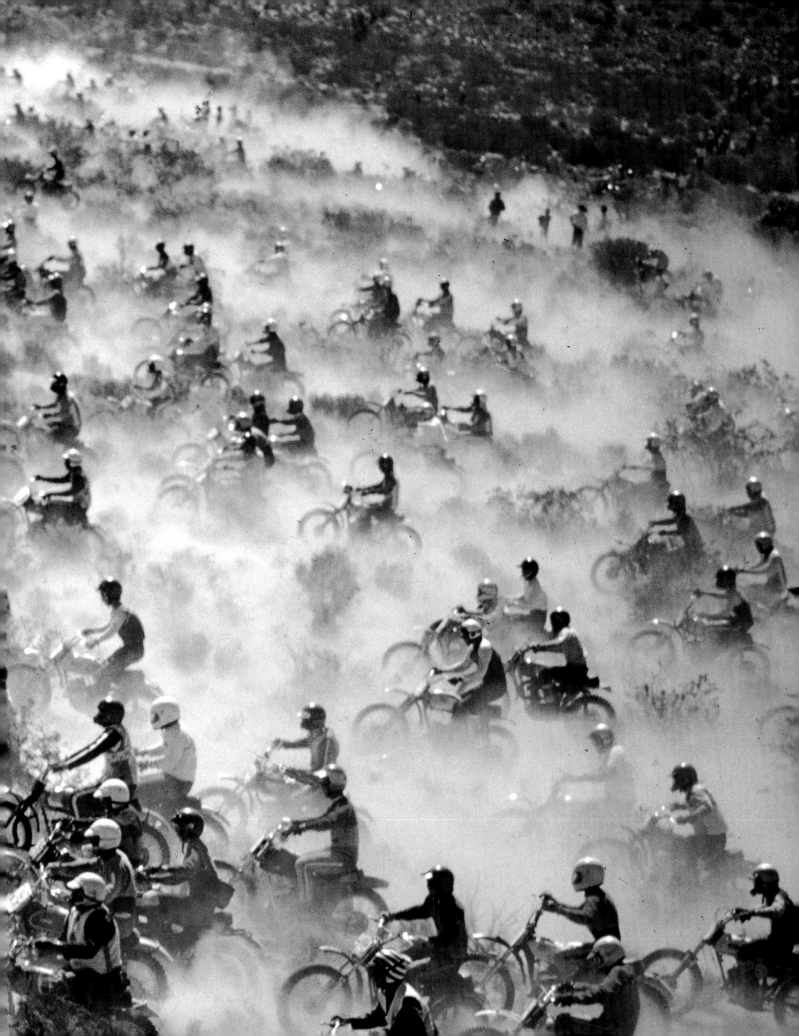

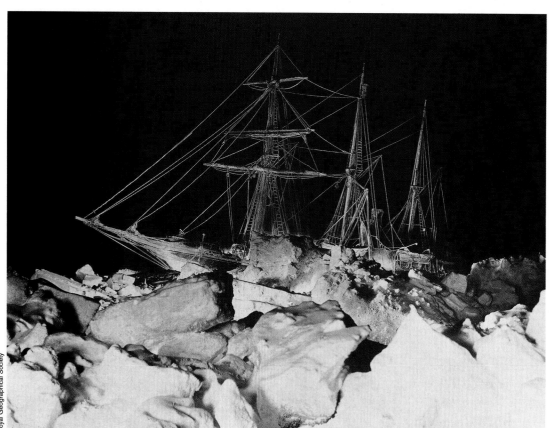

Trapped

In August 1914, Ernest Shackleton and 27 other men with a thirst for doing what no one else had done before embarked on what would become perhaps the most storied tale of survival ever: They were going to cross the Antarctic on foot. For 12,000 miles the *Endurance* sailed, then pushed through pack ice for another thousand when, not even 100 miles from its destination, the schooner was held fast in a mass of jagged ice. Photographer Frank Hurley was on the expedition. According to a shipmate, Hurley was "a warrior with his camera [who] would go anywhere or do anything to get a picture." Hurley created 500 plate-glass negatives, but was able to save only 120. To get this poetic nighttime shot, he laid out 20 flashes on the ice. These sportsmen never did make their walk across the continent, but the story of their travail and rescue has been regaled in more than a dozen books. It is enough to say that it was an unparalleled journey and that, incredibly, all 28 men aboard survived. In 1991, husband and wife Erich and Heide Wilts were taking pictures in Antarctica when their 50-foot *Freydis* (right) was besieged by storms and they, too, became trapped in ice. The German couple broke into a nearby observation station on the cruelly if aptly named Deception Island and were forced to use it as a shelter for five months until rescuers arrived by helicopter.

■ Photographs by **Frank Hurley** and **Erich and Heide Wilts**

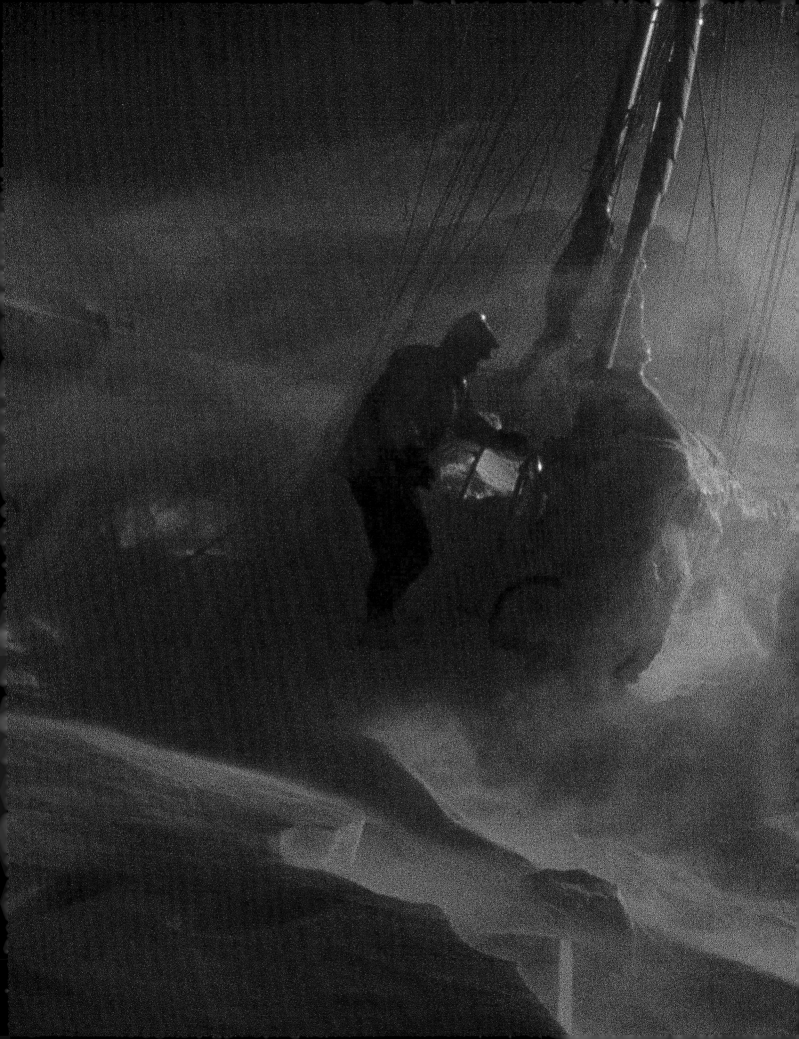

Eye to the Sky

It can take different kinds of exertions to get a fantastic photograph. On August 24, 1963, Charles Trainor didn't have to scale a mountain or don a flak jacket to get this groundbreaking photo of John Pennel's record-breaking pole vault. But the *Miami News* staffer had to persuade officials at a Coral Gables track-and-field meet to let him place his camera right next to the pole plant. This was not at all easy, as the officials were highly dubious. It probably wasn't easy, either, for Trainor to risk his equipment. Also, fish-eye lenses, which achieve extremely wide angles of view by substituting a cylindrical perspective for the typical rectangle, were still novel and quite pricey. One misstep by a vaulter could wreck man or machine—or both. Pennel, for his part, was unfazed by the experiment, and focused on the vault. "I think 17 feet is within my reach," he had told a reporter the week before. Competing for tiny Northeast Louisiana State College, he broke the 17-foot barrier—and his own world record—with a vault of 17 feet, $3/4$ inches. Pennel set world records again in 1966 and '69 before retiring but failed to medal at either the 1964 or '68 Olympics. Trainor went on to become the chief photographer at the *News*. And the fish-eye became a favorite of photographers the world over.

■ Photograph by **Charles Trainor**

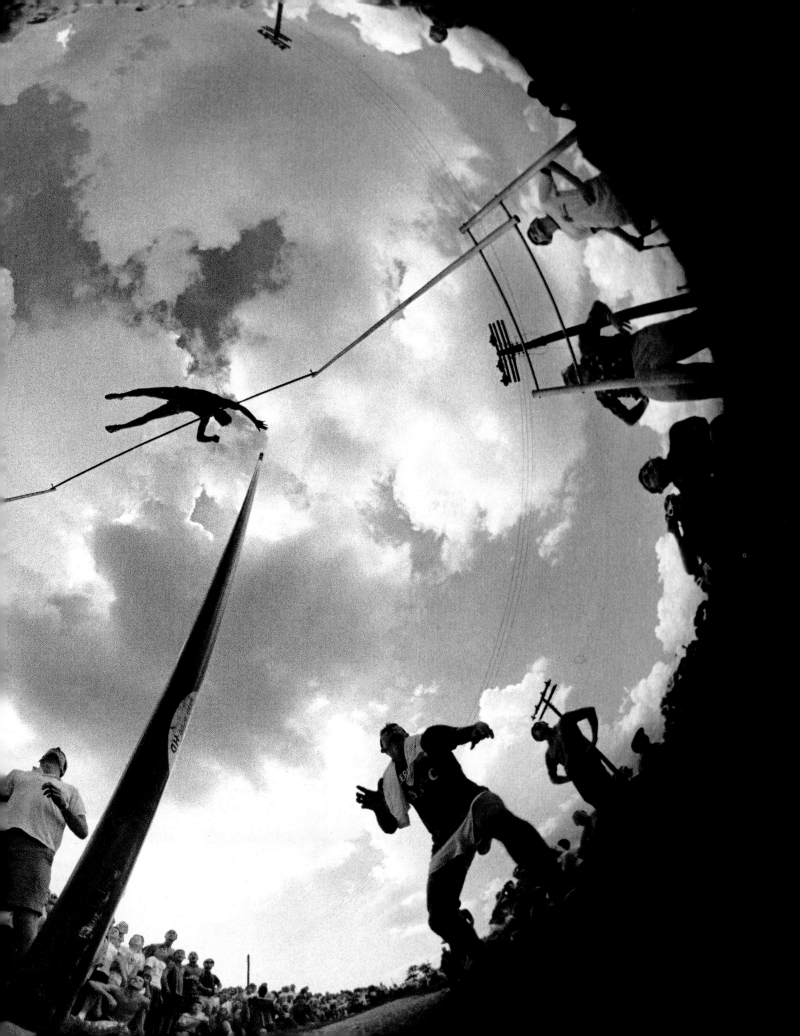

It's a Wrap

Off the south coast of Tahiti lies a razor-sharp coral reef that catches the super swells of the Antarctic Ocean and turns them into a surfer's nirvana. Teahupoo, as the wave is called, is not only one of the biggest, baddest rides around, it is also–according to photographer Tim McKenna–the most photogenic wave on earth. "The coral reef creates a perfect tube that just gets bigger and wider as the swell increases," he says. "The sun shines into the tube for most of the day, providing perfect light conditions." One day in 2002, during the filming of the Australian movie *Blue Horizon,* crew members and surfers were returning from a boat trip when a new swell arrived just as they did, producing heavenly surfing conditions–and a terrific photo op. Using a fish-eye lens and custom-made water housings for his gear, McKenna positioned himself (with the help of swim fins) where the tube was forming. "The waves that day were very hollow, and I managed to place myself inside the tube with the surfer," he said. "Positioning and timing are crucial. A few inches out of place can result in the wave actually breaking on you and sucking you back over the falls onto the reef." Surfers are bloodied by Teahupoo regularly, but not this man: Andy Irons of Hawaii has won three straight Pro Surfing World Championships since this photo was taken.

Photograph by **Tim McKenna**

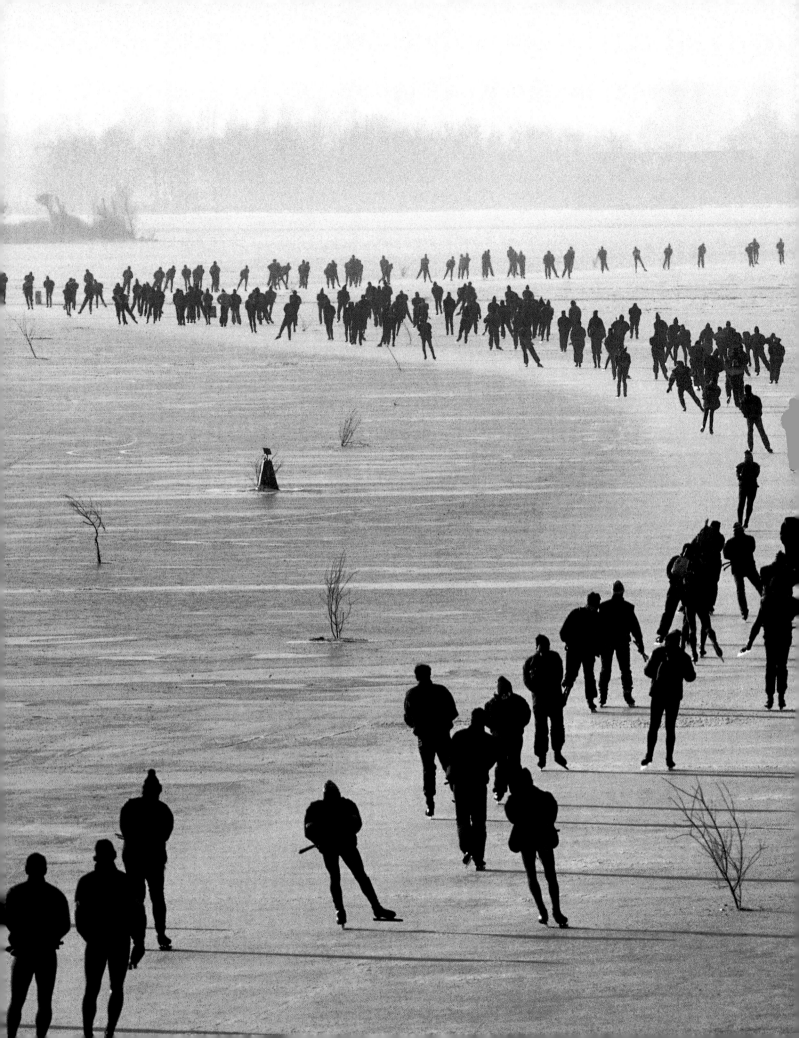

Dutch Treat

Co Rentmeester has been living in the United States since the 1960s, when he first began his enormously successful career here. Yet through all the years he has, understandably, retained a warm place in his heart for his native Holland. Or perhaps one should say "a chill place," for when Co thinks of that land, it is usually a winter setting, with the canals frozen over and everybody out on the ice delighting in the particular joys of skating. He, like everyone else there, began to skate as a toddler. The pastime, he says, "is part of the Dutch psyche, an obsession like nowhere else." Because of all this, he has for decades taken pictures of the various icy frolics and escapades, competitions and contemplations, and has compiled a book called *Holland on Ice*. In this image from 1997, the horizon is lined with some of the 10,000 participants in the 50-mile marathon called *11 Meren Tocht*, or "11 Lake Tour." The branches, by the way, are there as signposts to indicate a safe passage around rough ice.

■ Photograph by **Co Rentmeester**

Society

The son of a Ringling Museum employee, Loomis Dean studied at the Ringling Art School before turning to the camera and becoming an advance man and photographer for the Ringling Bros. and Barnum & Bailey Circus. In 1946, on the second of many assignments for LIFE, he visited the circus's winter home, in Sarasota, Fla. It isn't all that easy to get an elephant and an acrobatic troupe in sync, but Dean had help. Ruth was a very patient, oft-photographed pachyderm, and after all, when Dean had been with the circus, he'd had his own elephant named Jewel. As for the Karrels, well, what could be simpler than working with a group that billed themselves as a "prodigious pyramidal plethora of equilibristic marvels."

Photograph by **Loomis Dean**

All in the Family

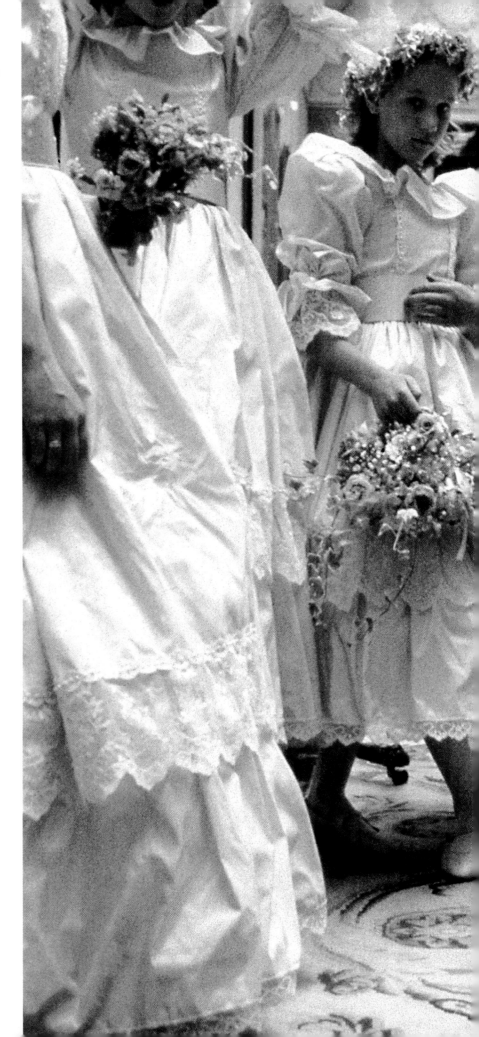

Being the queen's cousin meant Thomas Patrick John Anson, the fifth Earl of Lichfield, would in any case have been on the guest list for the Wedding of the Century. After all, some 120 relatives, including 55 British and foreign royals, were in attendance when Prince Charles married Lady Diana Spencer in July of 1981. But Patrick Lichfield, as the earl and fashion-celebrity photographer is more commonly known, was also the official photographer. The setups for the countless pictures had gone on for weeks. But perhaps the most memorable photo from the entire event came after the jubilant carriage ride and before the famous balcony kiss. The bride and groom were about to go to the balcony and acknowledge the crowds. Then Lichfield noticed that little Clementine Hambro, the great-granddaughter of Sir Winston Churchill and, at age five, the youngest attendant, was getting fractious. She had, in fact, slipped and bumped her head. The new princess—and erstwhile kindergarten teacher—spontaneously bent down to comfort the child. Lichfield's "real" cameras were elsewhere, but he happened to have a simple little camera in his pocket. Said the photographer, "I went click, and it became a double-page spread in LIFE."

■ Photograph by **Patrick Lichfield**

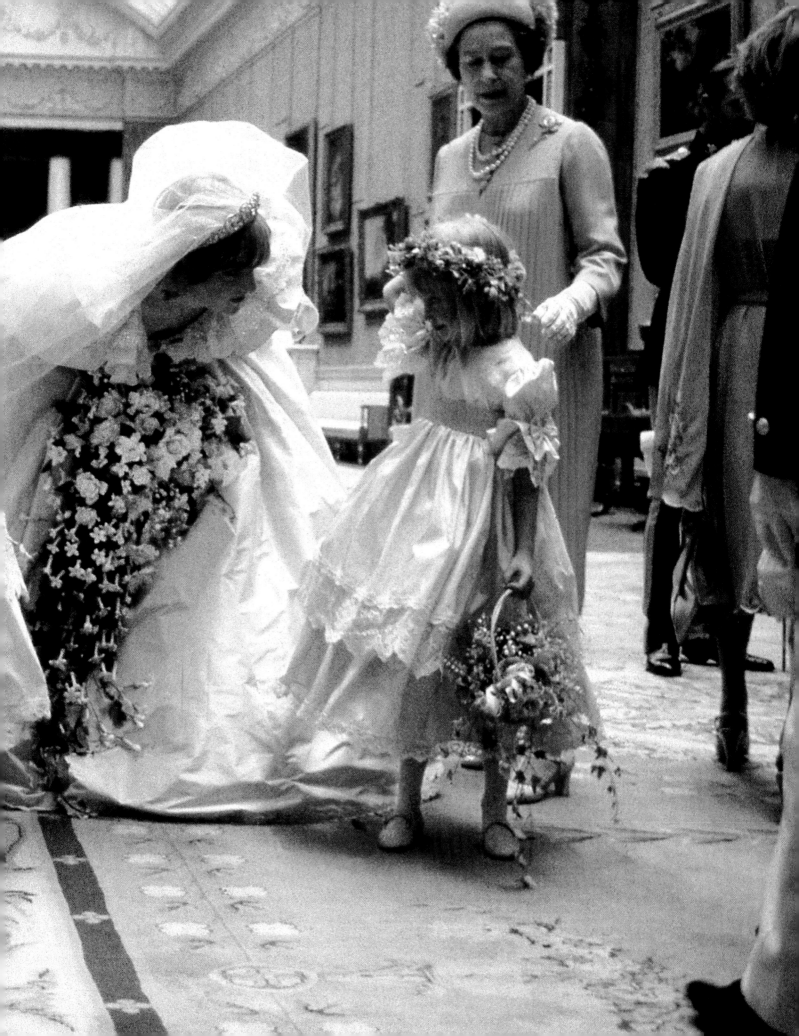

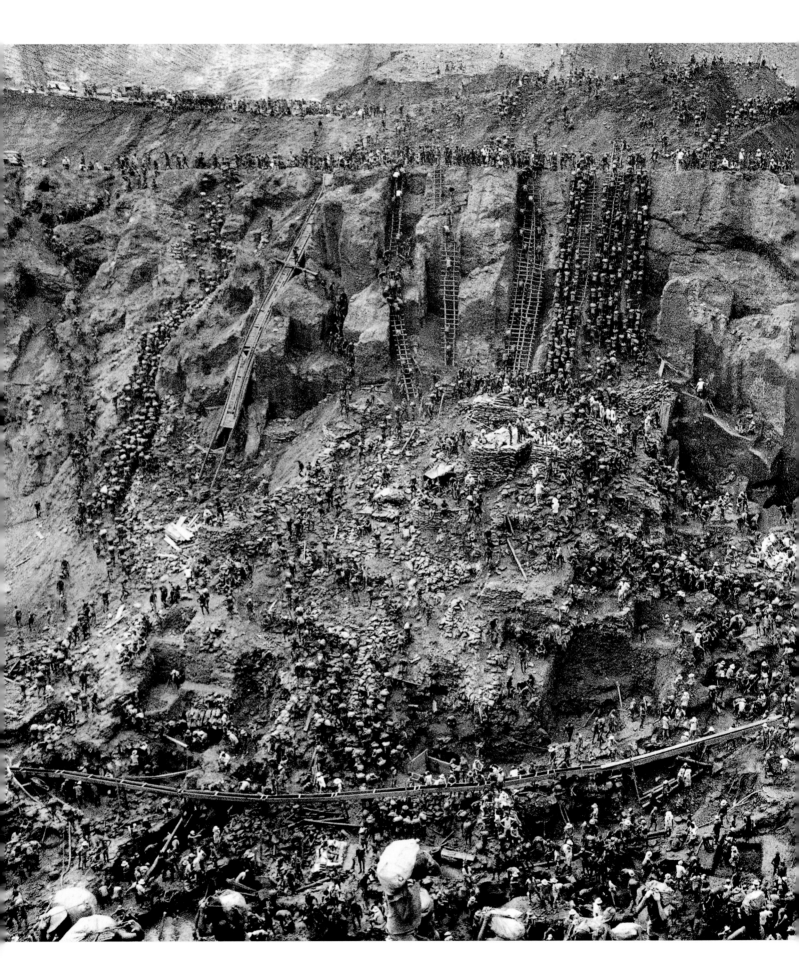

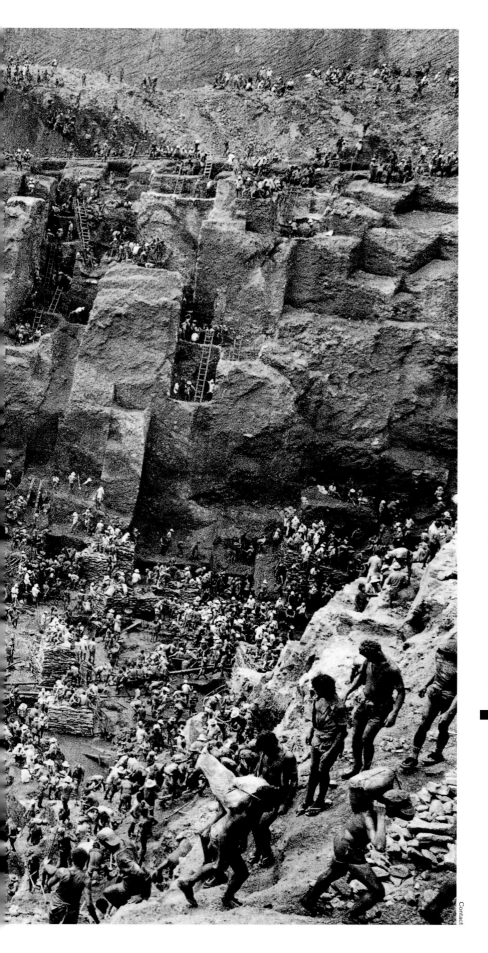

Contact

Sebastião Salgado's photography is a profound exercise in formalism, deeply rooted in a rigorous sense of composition. And yet there is always a quality of otherworldliness. Born in Brazil in 1944, Salgado began with a career in economics. In 1970, while working for an international coffee consortium, he bought a camera; his first picture ever was of his wife. He then began taking photos in earnest while visiting coffee plantations in Africa, and by 1973 decided to become a freelance photographer. In the coming years he would traverse the globe, training his eye on the plight of man. Salgado, who shoots only in black-and-white, is a practitioner of "concerned photography," deeply committed to a variety of social causes: "I don't want anyone to appreciate the light or the palette of tones. I want my pictures to inform, to provoke discussion—and to raise money." Whenever possible, Salgado lives for a while with the people he photographs. "I tell a little bit of my life to them, and they tell a little of theirs to me. The picture itself is just the tip of the iceberg." This photograph, which was taken in 1986, shows a mine in Brazil where gold had been discovered six years earlier. Every day, 50,000 people toiled here, hacking at the vast pit's floor or scaling its walls with 100-pound sacks of rock on their backs. The image is a nightmare of surpassing intelligence and terrible beauty, and a photographic psalm for these anonymous laborers.

■ Photograph by **Sebastião Salgado**

Behind the Curtain

We know today what happened in April 1986, at the nuclear power plant in Chernobyl, Ukraine: A flawed design, poorly trained staff and disregard for safety combined for an explosion that blew the top off the reactor and sent a cloud of radioactivity over much of Europe. But at the time, with the Iron Curtain still firmly intact, there were only whispers—bits and pieces that leaked out. Official U.S. offers of assistance were declined, though the Soviets did welcome Dr. Robert Gale, a bone-marrow transplant expert from Bel Air, Calif. When he also turned out to be handy with a camera and sold his story to LIFE, Americans got their first, very personal view of the disaster. Dr. Gale saw scores of victims, coordinated the shipment of $800,000 worth of high-tech medical equipment and, with his Soviet counterparts, performed transplants on 13 patients, five of whom survived. His tale lent a human dimension to a technological debacle. "The most difficult time came on the wards," wrote Gale. "Together with the Soviet doctors, we had to decide who to save, who could not be saved. It was like a battlefield situation." The firefighter at right, who had come to the site after the accident, was one of the lucky ones treated, and he survived.

■ Photographs by **Dr. Robert Gale**

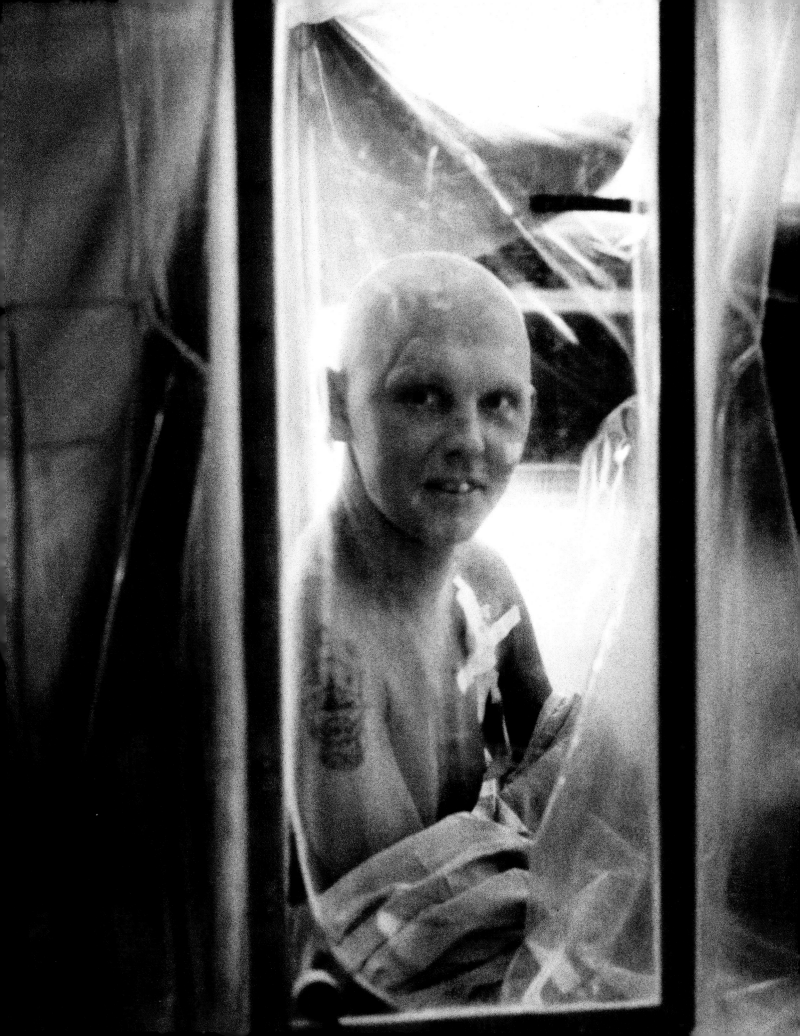

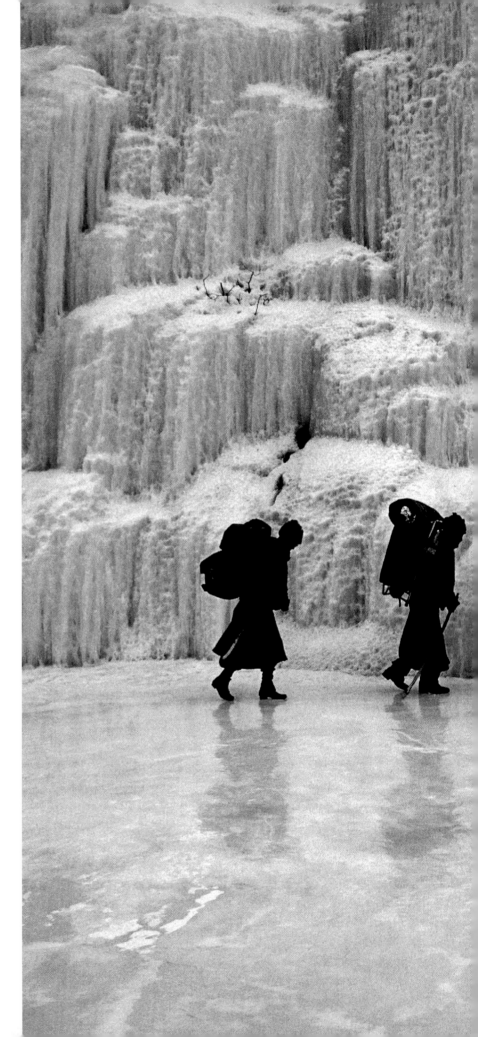

The Road to Knowledge

The importance of education varies from culture to culture and from family to family. Education can also take many different forms, and different paths. In the 1980s, Swiss photographer Olivier Föllmi visited a town in northern India called Rizin, 12,000 feet up in the lap of the Himalayas. There he met a young farmer named Lobsang, a Tibetan Buddhist, and took him on a five-week tour of a plain beyond the mountains. Lobsang saw things that he had never known to exist, and although astounded, he was not frightened. He vowed that his son "must be raised to understand all this." When that son, Motup, reached age eight, he traveled 100 miles to a school there. Three years later—here, in December 1989, Motup is second from the right—he came home along the frozen Zanskar River, which winds through zigzag gorges 12,000 feet high. The journey takes 12 days and requires utter concentration. In this picture, the little caravan cannot pause to admire the frozen wonders about them but must instead listen as the leader taps the river surface with his stick to gauge its thickness. When Motup at last reached his village, he brimmed over with talk of elevators and multiplication, English and cricket. There would be days of celebration, and then it would be time once again to make the trek to the faraway school, only this time it would be with his little sister in tow, for she, too, must have an education.

Photograph by **Olivier Föllmi**

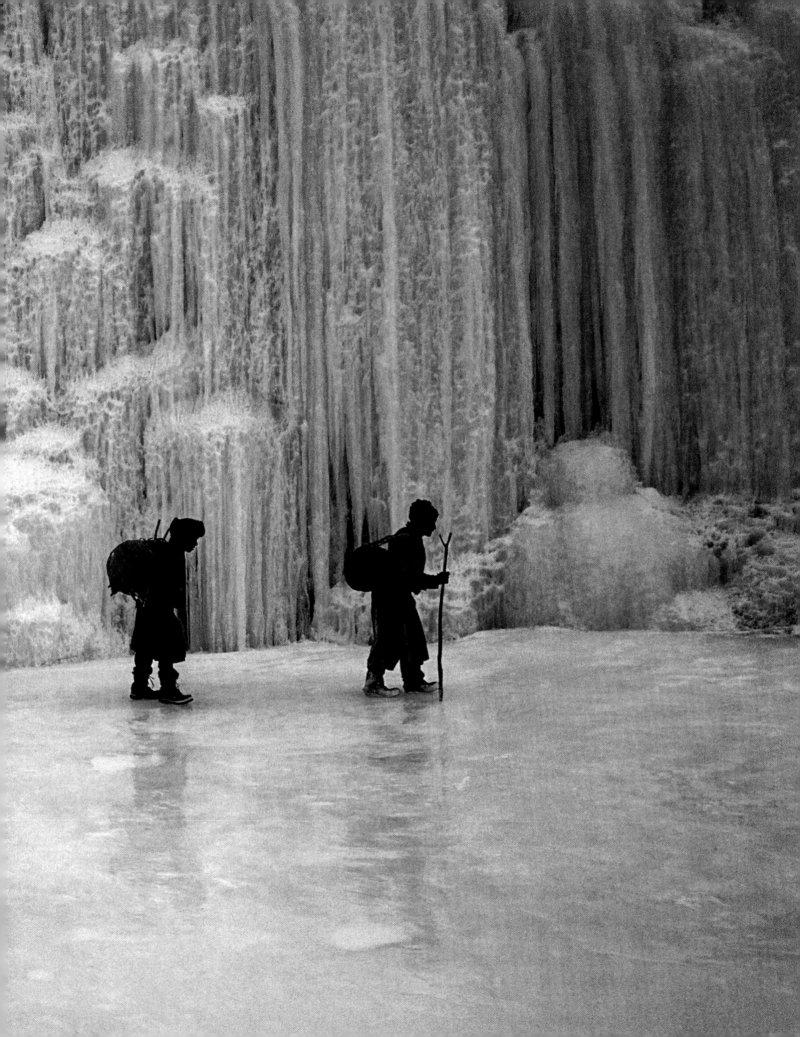

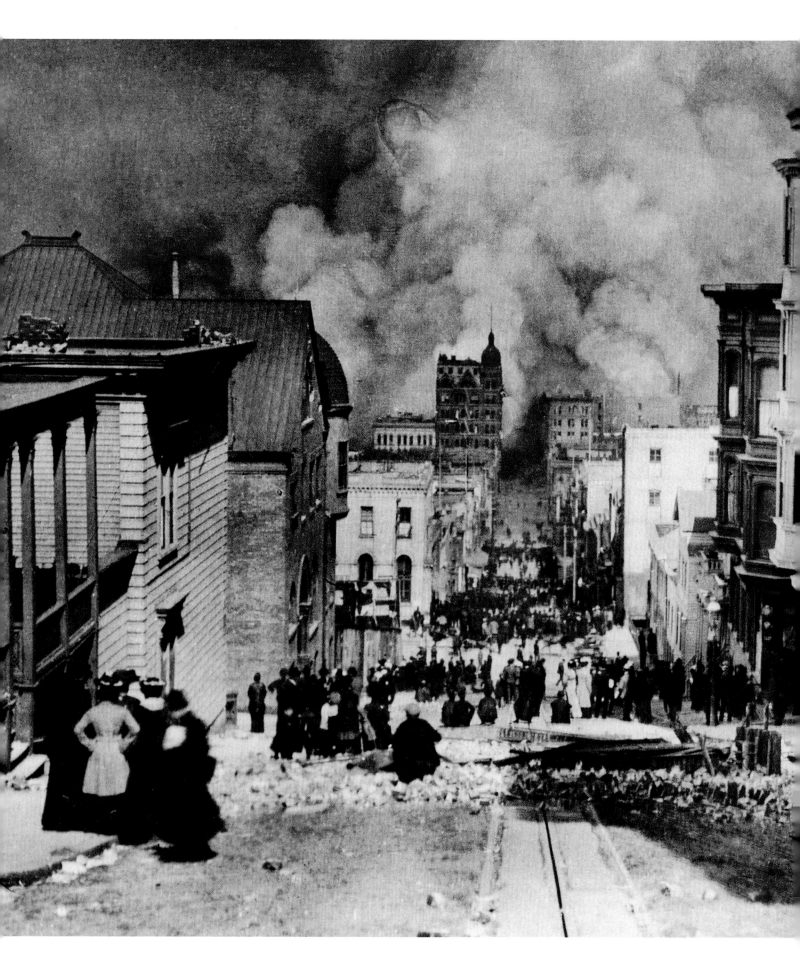

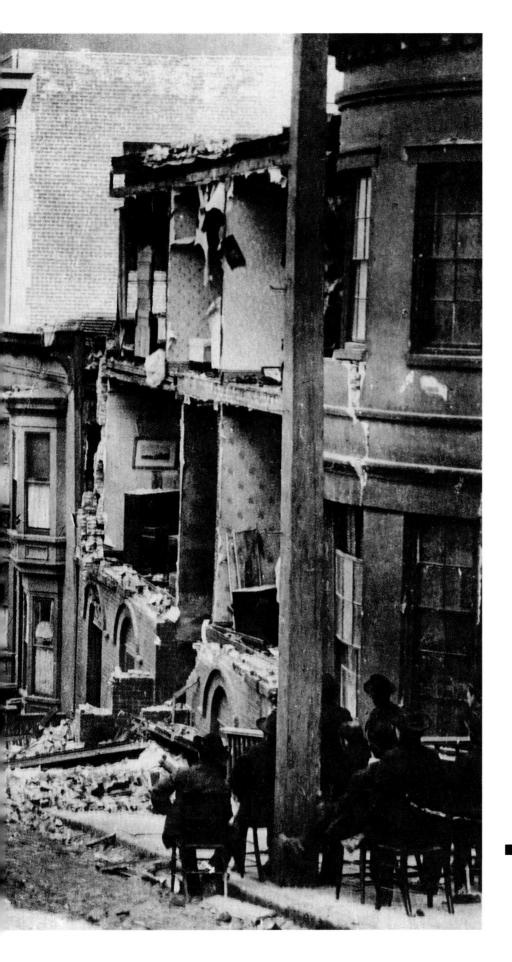

Very early on April 18, 1906, photographer Arnold Genthe was awakened by the sound of Chinese porcelain crashing to the floor of his San Francisco home. "I felt as if I were on a ship tossed about by a rough sea," he wrote in his memoir, *As I Remember.* The occasion was not, of course, a perfect storm. It was the Great Earthquake and Fire of 1906, a temblor that hit 7.8 on the Richter scale and killed some 3,000 people. From the window of his top-floor portrait studio, Genthe observed activity in the street, but like many other San Franciscans, he felt no sense of panic. He dressed, walked around a bit and had breakfast at the St. Francis Hotel (they were serving free food) before thinking to take some pictures. Finding his cameras damaged, Genthe went to a local shop. "Take anything you want," the owner said, "this place is going to burn up anyway." By that time, fires were breaking out all around, and burst water mains hampered firefighters. When at last Genthe realized his house might be lost, he rushed home, bribed a guard with a bottle of whiskey and rescued—of all things—a fine bottle of wine (Johannisberger Schloss, 1868). Then he continued to take photographs. This image, taken on Sacramento Street, is remarkable for the blazing fires, tumbling buildings—and the people sitting calmly next to a partially collapsed house. "I have often wondered, thinking back, what it is in the mind of the individual that so often makes him feel himself immune to the disaster that may be going on all around him," wrote Genthe. "I know that this was so with me."

■ Photograph by **Arnold Genthe**

One Small Step for Girls . . .

Wow, talk about a time capsule! This picture ran in LIFE in April 1945 as part of a photo essay on teenage girls in the Midwest, in this case Indianapolis. Of course, girls today still have slumber parties, although they're called sleepovers and they don't look much like this. The photographer, Nina Leen, was a longtime LIFE staffer, and her European eye led to some memorable portraits of Americana that natives just took for granted. Here is how the magazine introduced this story: "High-school girls are the most violently gregarious people in the world, and Sub-Deb Clubs are one way they get together. Sub-Deb Clubs are particularly popular in the Middle West. In Indianapolis they are epidemic. The reasons for this are: 1) Sub-Deb Clubs have replaced . . . high-school sororities, which have gradually been abolished and 2) people who live in Indiana are traditionally joiners." . . . Umm, O.K. . . . "Sub-Deb Clubs," we learn, "have meetings and initiations and even print newspapers but their main purpose is to have parties. In Indianapolis they are enormously successful in achieving this purpose. One reason is that girls on their own might be shy about asking boys to parties, but clubs of girls can be downright aggressive." . . . Hmm . . . Here, the girls are boning up for that inevitable soon-to-be party, when the boys will apparently be present.

■ Photograph by **Nina Leen**

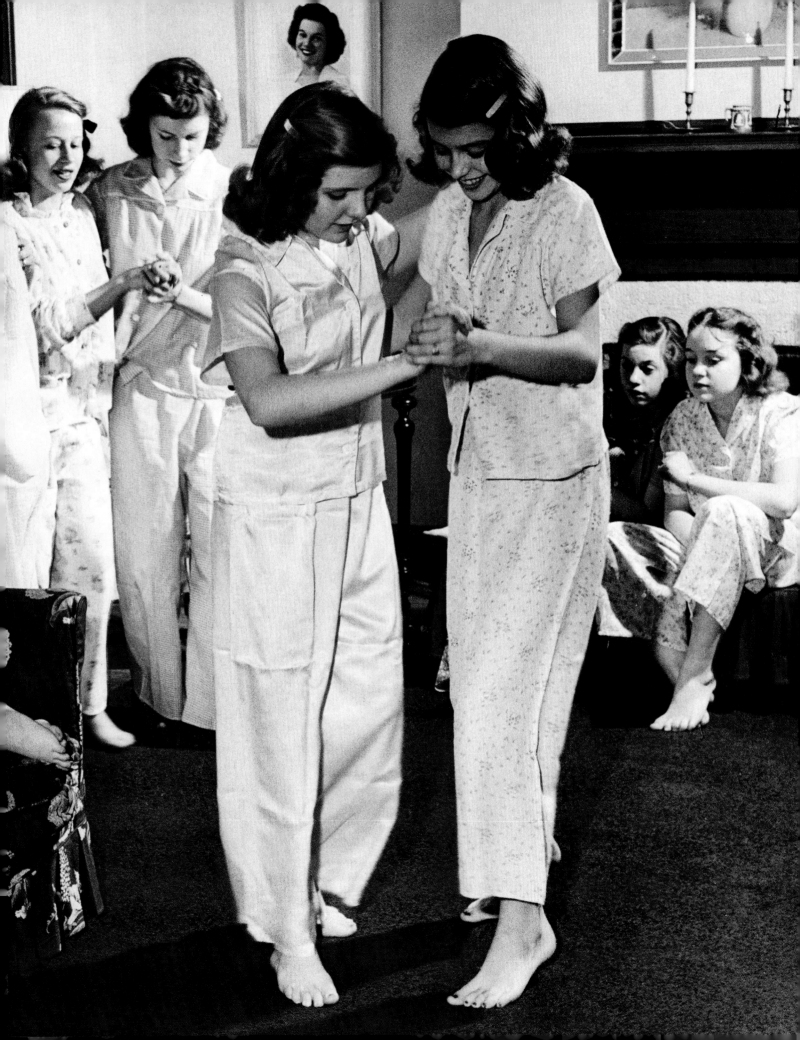

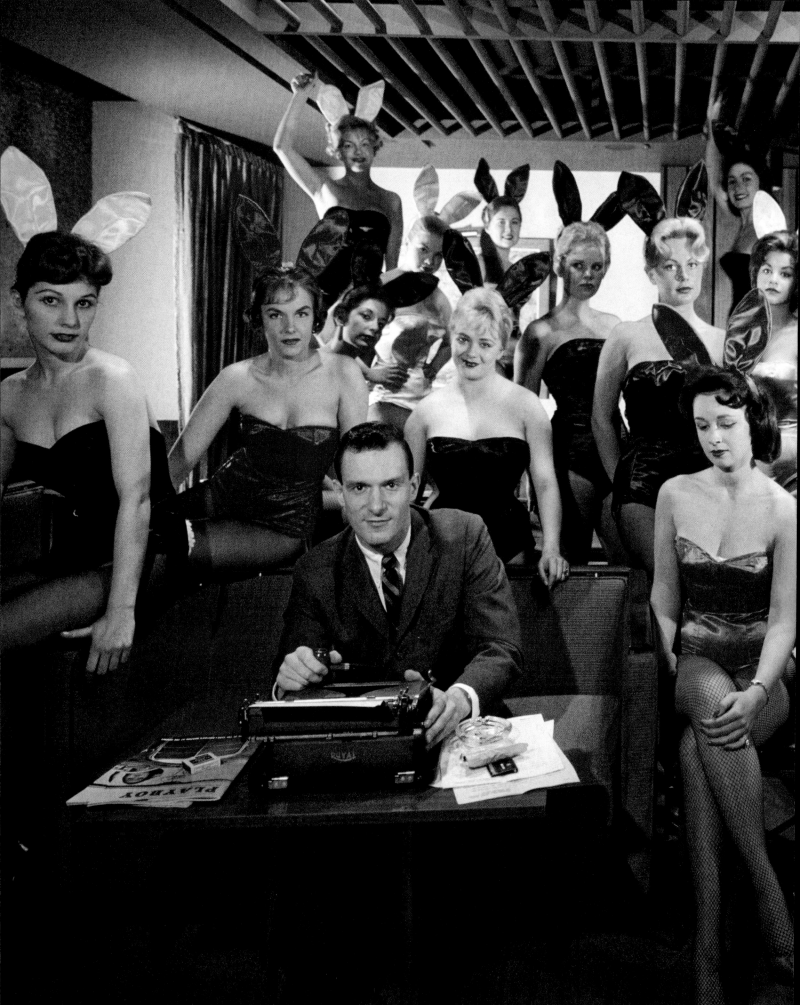

The Inaugural Hutch

Slim Aarons saw all the blood and misery he needed to see as a combat photographer on the beachheads of World War II, so when that long struggle finally came to an end, he knew the only beaches he wanted to shoot on anymore would be "decorated with beautiful girls tanning in a tranquil sun." So Aarons spent the 1950s, '60s and '70s patrolling the lairs of the international jet set, all the while returning with sharply luxuriant images. In early 1960, he visited one of the best known of those lairs, one housed in Chicago. Aarons had taken pictures of Hugh Hefner before. Hefner had published the first *Playboy* magazine in December 1953, and his combination of humor, interviews and, oh, yeah, photos of mostly nude women had become a big hit. He was going to open the first Playboy Club (left), and he wanted Aarons to photograph the place, and show it in its best light. At one point, Aarons rode in a small, European-style elevator with a blonde, a brunette and a redhead. Looking back on it, says Aarons, "I'm 88, but I still remember there were bosoms everywhere." Aarons says that at the time, Hefner's stuff was considered "risqué, almost porn." Similar adolescent fantasies are now virtually standard family-hour fare. As for the Playboy Clubs, the last of them closed its doors in the 1980s. According to Playboy Enterprises, the move came in response to changing consumer trends.

■ Photograph by **Slim Aarons**

Etched in Stone

The merry expression on this young girl's face might be seen anywhere around the world, and it may be that her companions harbor a similar glee, but they are determinedly not looking at the camera. These are Hutterite children making their way home at the New Rockport Colony in Alberta, Canada. There are today some 40,000 Hutterites living in approximately 460 colonies in North America, mainly in the west. Theirs is a Protestant sect that was founded in the 16th century. They are somewhat akin to the Amish and the Mennonites, but even more than those peoples the Hutterites assiduously keep to themselves. They have no TVs or radios, but they do use computers to run their collective farms. Until the age of six they speak only German, then they may learn English. Sometimes their unconventional ways make their neighbors uncomfortable; they have, for example, encountered problems during wartime for their pacifist beliefs. Andrew Holbrooke has had a long fascination with the Hutterites, and in 1997 he spent weeks driving from one colony to another to get permission from the elders to document their ways. Holbrooke eventually went to 25 colonies, but only nine would let him take pictures. In three colonies he was allowed to stay more than a day, but other times it was only for a few hours. He was often asked, "Why do you take so many pictures? Don't you know your Ten Commandments?" Holbrooke replied that he did. Then he was told, over and over, "One of the Ten Commandments says THOU SHALL NOT PHOTOGRAPH." Finally, Holbrooke said that there weren't any cameras when the Commandments were written. The response was prompt: "Yes, that may be true, but they knew cameras were coming." Thank goodness it didn't pertain to Holbrooke's Canon.

■ Photograph by **Andrew Holbrooke**

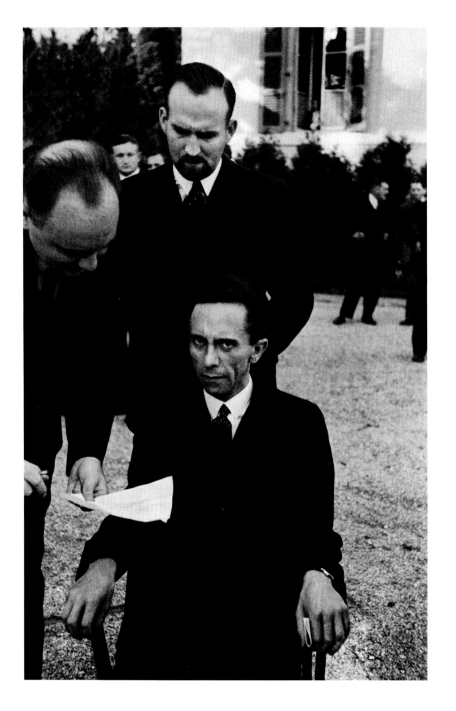

In a career that spanned more than 60 years, Yousuf Karsh took pictures of some 15,000 people, including many well-known photos of world leaders. In his portraiture, he sought to depict his subjects "both as they appeared to me and as they impressed themselves on their generation." Karsh was born to Armenian parents in 1908 in Turkey, but owing to persecution in that country his parents sent him to Canada at age 15. By 1941, he had a blossoming career and, better yet, an important advocate: Canadian Prime Minister Mackenzie King. It was King that arranged for Karsh to set up his gear for a portrait of Winston Churchill, who was in Ottawa giving a speech. When the British leader saw the camera, he promptly lit up a cigar and groused, "Why was I not told of this?" Karsh quietly asked him to remove the cigar while he took the picture, and Churchill predictably refused. Then Karsh walked over to the global titan, gingerly removed the stogie from his lips and said, "Forgive me, sir." Churchill's response was, gloriously, as plain as the look on his face. Eight years earlier, Alfred Eisenstaedt was in Geneva covering a League of Nations meeting. While outside, he noticed in the distance Adolf Hitler's propaganda minister, Joseph Goebbels. Eisenstaedt tried a long shot but wasn't happy with it, so he moved in on his subject. (As Eisie later stated, "There is no substitute for close personal contact and involvement with a subject, no matter how unpleasant it may be.") When Goebbels glanced up and suddenly saw the photographer in his presence, his expression of annoyance—and the bottomless darkness within—was as clear as the expression on Churchill's face. So, in sum: two great photographers, two politicians who were instrumental figures in World War II and two different but memorable portraits.

Photographs by **Alfred Eisenstaedt** and **Yousuf Karsh**

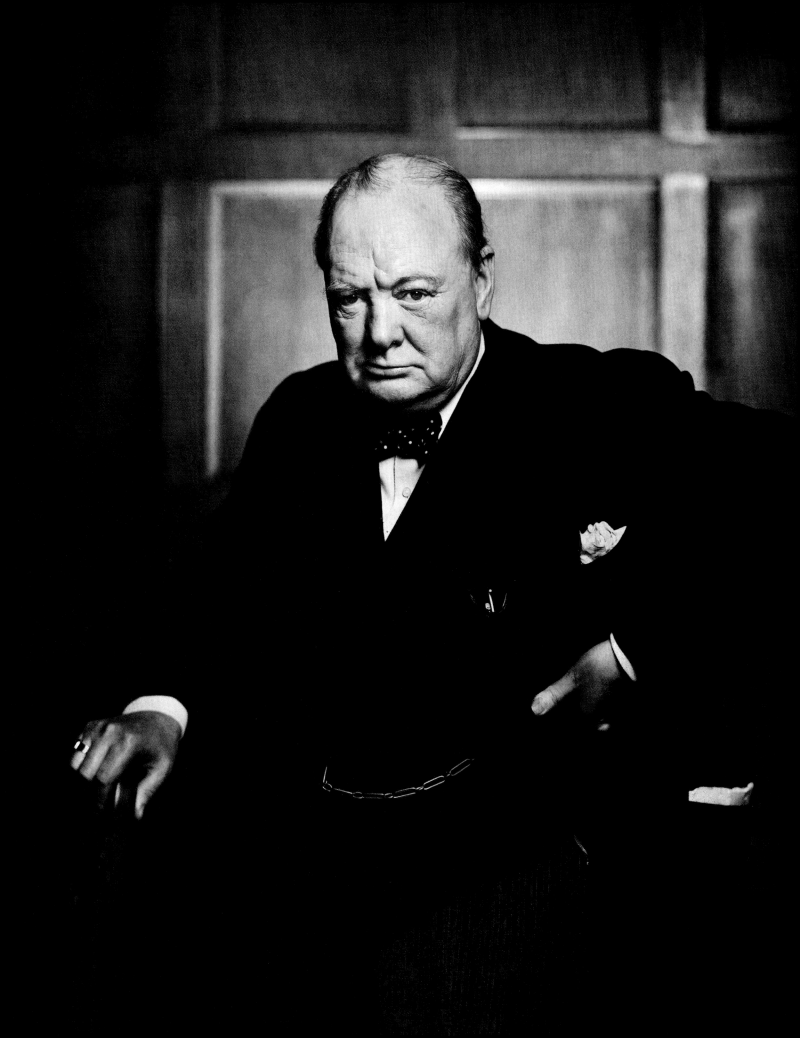

Day of Infamy

On September 11, 2001, Austrian-born Klaus Reisinger was in New York making final preparations for a documentary film. Perhaps this condensed version of his recollections best conveys the story behind his photograph: "I was in Brooklyn when I heard the explosion of the first plane. I turned on the TV and immediately went to a friend, a fashion photographer, who lent me an old Nikon F2 and a 28mm lens and drove me to the Brooklyn Bridge. Police were not allowing anybody across, then the first tower collapsed, and in the panic, as everybody was running across in the opposite direction, I ran across the bridge, and kept running toward the smoke. The second tower collapsed and smoke engulfed the whole area. Running toward the center of the smoke, I ended up in the fire station opposite the World Trade Center. Two firemen and one student started searching the rubble. I had taken off my T-shirt to put it on my face, so the firemen gave me a fireman's jacket and took me with them to help. We climbed onto the rubble pile, but it was dark like night, with smoke and dust blackening out the sun entirely. We had only one flashlight and kept calling for people. It was very dangerous, holes in the rubble everywhere, and the bent-up metal shards were sticking out of the ground . . . We went around to Building No. 5, where part of one of the Twin Towers had collapsed and slashed a gigantic hole 12 or 13 floors to the cellar . . . All that time we were calling and shouting but didn't find anybody . . . When we got down, a policeman saw me in the fireman's jacket taking pictures and screamed at me. The firemen tried to explain that I was helping them, but the policeman took the jacket off me, leaving me without a shirt, which we had cut up to protect our faces from dust. I kept on taking pictures until I had no more film left."

■ Photograph by **Klaus Reisinger**

Editing/Paris

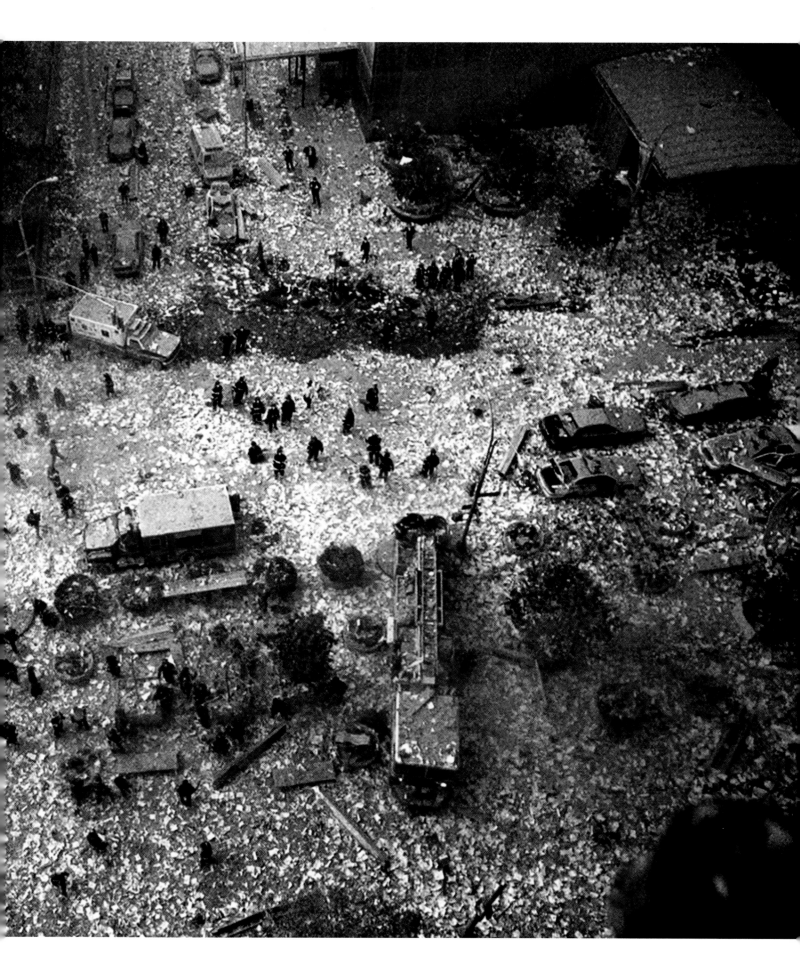

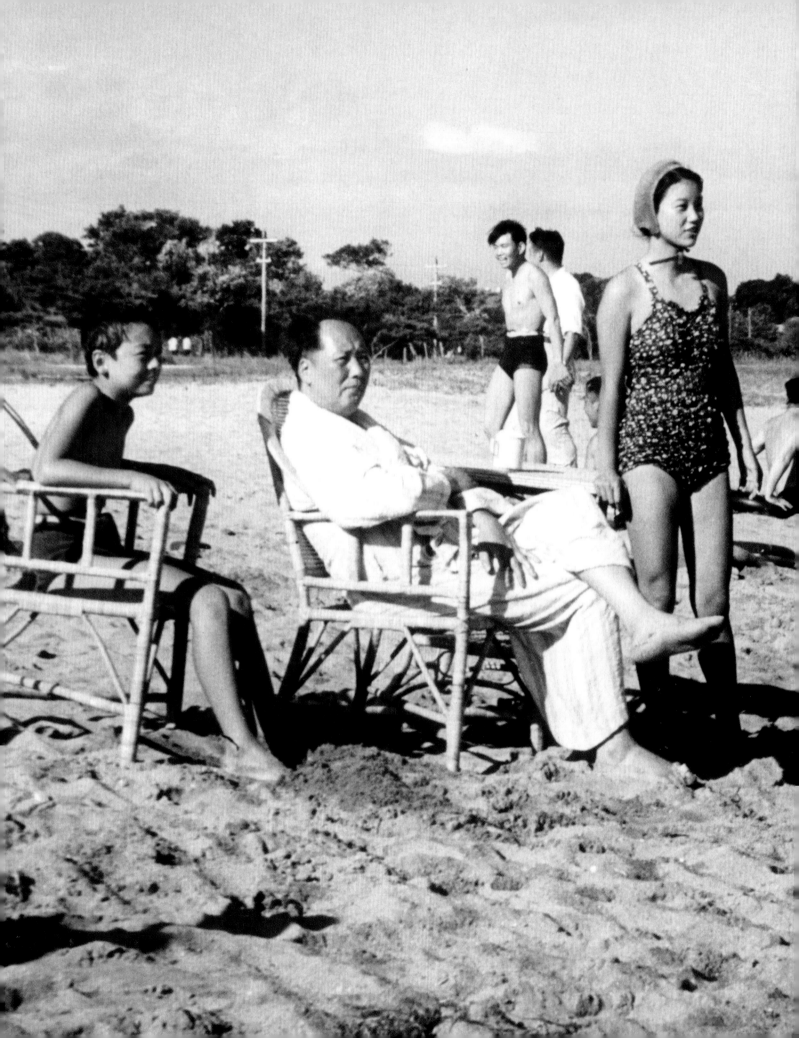

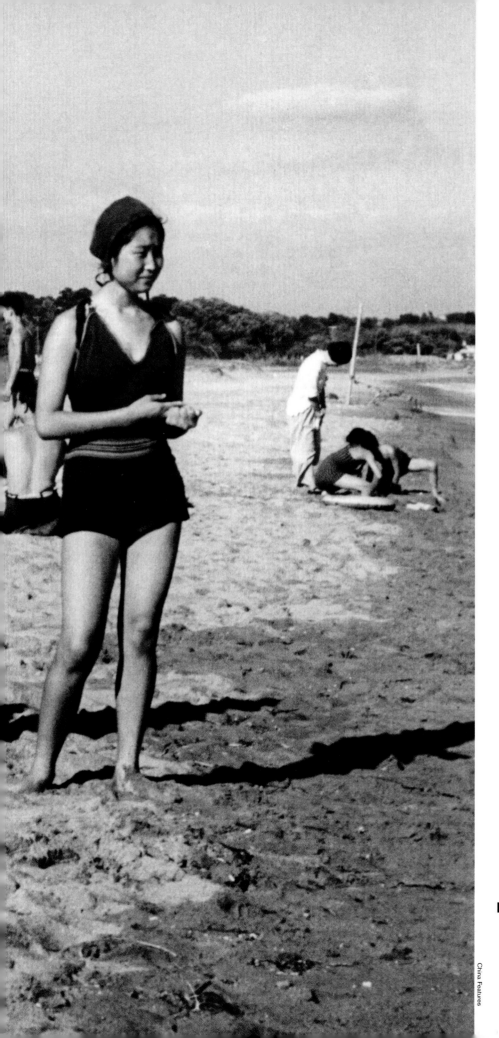

Another Day in Paradise

In this uncommonly seen photograph, Mao Zedong relaxes with his family at the beach in 1954. Of course, we already know that Mao had a yen for things aquatic, because in one of the 20th century's most widespread, and analyzed, photographs, he was depicted in 1966 "swimming" in the Yangtze River. The image of the 73-year-old head of China's Communist Party blanketed the country, evidently proof that the man was nothing short of godlike. Both of these pictures were taken by a woman named Hou Bo. Born in 1924 to a poor rural family, she was a teenager when she met the man who would become her husband. Xu Xiaobing was eight years her elder, and had some experience with a camera. He taught Hou how to take pictures, and together they followed the path of "the revolution" as proposed by Mao. She first heard Mao speak in the early '40s: "I suddenly felt things were changed and a brand-new world would appear as long as we follow Chairman Mao." Hou was there in 1949 when Mao proclaimed the founding of the People's Republic of China; her photograph of that historic moment provided her with access to the chairman's inner circle, and she and her husband became his court photographers. Most known images of the leader from the 1950s and early '60s were taken by them. These beautifully crafted images provide a tutorial in propaganda. Any sort of intimacy—of normalcy, of humanness—was outlawed, thus this seashore image was not, in all likelihood, seen publicly until after Mao's death. In 1968, Hou, no longer working for Mao, was accused of never having taken a flattering picture of him and was sent to a work camp for three years.

Photograph by **Hou Bo**

R alph Crane had endless energy and a
passion for exacting work; both traits were put to
full use in 1947 when the German-born
photographer was working on a story about a
psychiatric center in Seattle that was having
better-than-usual results in its approach to treating
emotionally disturbed youths. Crane found one of
the Ryther Child Center's success stories, a
13-year-old whom Crane would call "Butch" in a
LIFE photo essay, and asked the boy to reenact
scenes from his past. Painstakingly reconstructing
the boy's spiral into the depths—the tantrums, fire-
setting and other antisocial behavior that landed
him at Ryther—and then his slow reconnection with
society, Crane portrayed his subject with masterly
insight. In this photograph, Butch is reliving an
incident from five years earlier when, denied his
clothing because of a previous runaway episode,
he made a naked dash for freedom from a
children's home. The towering, shadowy figure in
the foreground deftly captures an archetypal
adolescent image of a looming grown-up. Crane
never completely showed the boy's face, but he
didn't have to, as his constructs told us all we
needed to know.

■ Photograph by **Ralph Crane**

The Sustaining Character

"Once a year for 10 years I applied to the Chinese embassy for a visa, and every year I heard nothing more," Eve Arnold recalled. "Three days after diplomatic relations were re-established with the United States in 1979, I had a visa. Five days later, I was in China." At the time, she was in her mid-sixties, so it was somewhat of a challenge to take on an arduous trip to a country that had essentially been closed to Americans for three decades. But Arnold, who had become the first female member of the prestigious Magnum Photo Agency nearly 25 years earlier and had gained fame for her portraits of, among others, Marilyn Monroe, gloried in it: "Oh! To be there then—to be an American and a photographer and a woman—was heaven! Everybody welcomed me. Because of my age, they respected me. I went everywhere." During two extended trips, Arnold traveled some 40,000 miles across vast deserts, remote mountains and teeming cities "to try to penetrate to their humanity, to try to get a sense of the sustaining character beneath the surface." This photograph, taken in Inner Mongolia, is an example of things not being what they seem. Despite its calm, bucolic air, it is, in fact, a local militia drill. The horse was being trained to lie still enough for the young woman to shoot over it.

■ Photograph by **Eve Arnold**

Hot News

When Queens, N.Y., housewife Ruth Brown Snyder was sentenced in 1927 to die in the electric chair, more than 1,500 people applied to witness the execution. On the fateful day, January 12, 1928, voyeurs dotted the hills overlooking Sing Sing Prison, in a northern suburb of New York City, waiting to see the terrible, telling flicker of light. The public was spellbound by the lurid tale of Snyder's conspiracy to kill her husband, Albert, a staid magazine editor 30 years her senior, for insurance money (some $100,000) and love (a corset salesman named Henry Judd Gray, who was also convicted in the murder). The New York *Daily News* was determined to feed the frenzy, but the tabloid's editors knew Sing Sing officials would recognize their photographers and bar them.

So they recruited out-of-town photographer Thomas Howard to strap a small hidden camera to his leg and pose as a reporter. As the switch was thrown, sending a surge through Snyder that cut her off in mid-sentence ("Father, forgive them; for they know not what they do" was her mantra), Howard hitched up his pant leg, pressed the photographer's bulb in his pocket and snapped the shot. The next day, the *News* plastered the photograph, sans reporters' legs, on its front page, under the headline DEAD! "This is perhaps the most remarkable exclusive picture in the history of criminology," the paper modestly noted. Note: The negative was torn through mishandling.

Photograph by **Thomas Howard**

Split Second

A great photograph is often a distillation of copious research, exquisite planning and any number of takes. Or a great photograph can be strictly a matter of chance intersecting with talent. In 1979, in another chapter in an endless tale of civil unrest, the Irish Republican Army detonated eight bombs in a hotel in Ballycastle, a town located in Northern Ireland. In this photo, one of the bombs is exploding just as two policemen outside are trying to make their way inside to free trapped guests. The picture was taken by Claus Bienfait, a West German journalist, photographer and filmmaker who had been in the building, had escaped after the second blast and, now, was taking cover behind a nearby wall. It is appropriate that Bienfait was also a filmmaker, because to catch an explosion in mid-second is usually something that happens only on a movie set.

■ Photograph by **Claus Bienfait**

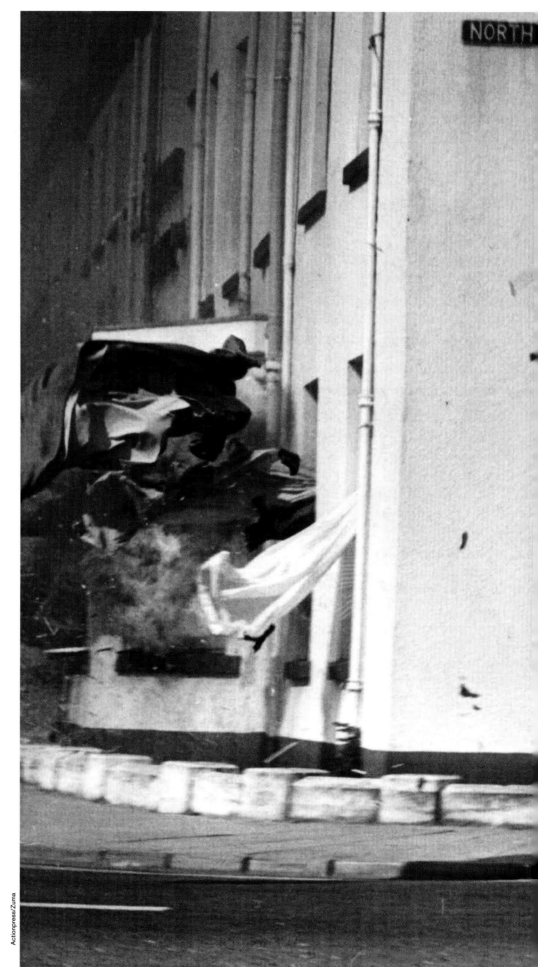

Actionpress/Zuma

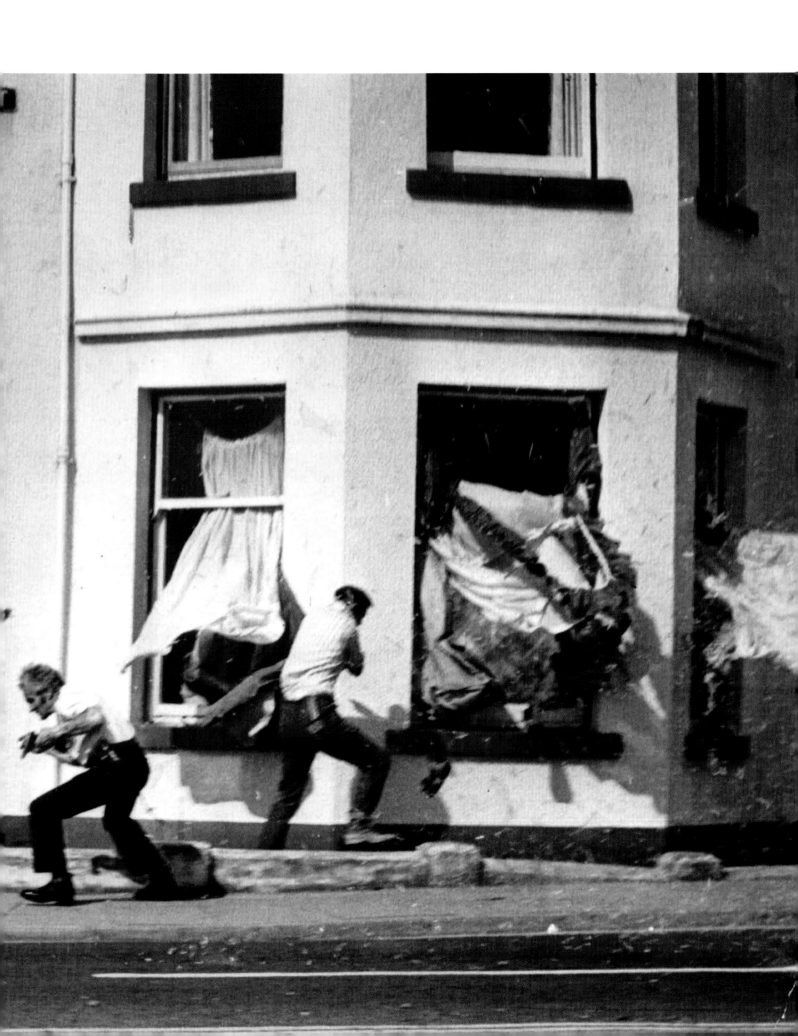

Farewell to a Dream

On June 8, 1968, the nation was still reeling from the shooting of Robert F. Kennedy three days earlier in a Los Angeles hotel kitchen. People had waited in lines that stretched 25 blocks to pay their respects at St. Patrick's Cathedral in New York City. Now, in searing heat, hundreds of thousands more lined the tracks from New York to Washington, D.C., to catch a glimpse of the coffin as it rode past, elevated on two chairs, in the 21st, and last, car of the funeral train. With 1,000 people—most of them friends or family—aboard, it would seem that those photographers permitted on the train would be busy documenting scenes within. And Paul Fusco, a staff photographer for *Look* magazine, had fully expected to be doing just that—until he actually got on the train. "I pulled a window down and photographed the people all day long." The range of emotions in the Fusco portfolio (there was later an acclaimed exhibit and book) is staggering, reflecting feelings the photographer, too, had about Kennedy's murder. "The blow was monumental. Hope-on-the-rise had again been shattered," he said. "And those most in need of hope crowded the tracks of Bobby's last train, stunned into disbelief, and watched that hope, trapped in a coffin, pass and disappear from their lives."

■ Photograph by **Paul Fusco**

SOCIETY **LIFE** 159

A Matter of Anticipation

In his seven decades as the master of the magical moment, Alfred Eisenstaedt never lost his ability, or his enthusiasm, to wondrously convey the humanity he found everywhere around him. "I'm still a spring chicken," he asserted in 1973 when he turned 75, "and I'm still a photographer because I still get excited about it." If excitement was Eisie's career theme, then this image could have served as his calling card. Taken at the plot apex of a Guignol (the Gallic Punch) puppet show performance in Paris's Parc de Montsouris, the photograph reflects uncanny timing. "It carries all the excitement of the children screaming, 'The dragon is slain!'" said Eisie. How did he manage to capture that instant? "Anticipation," he often said, "is one of the secrets of my success." At another, more loquacious time, he elaborated: "The world we live in is a succession of fleeting moments, any one of which might say something significant. When such an instant arrives, I react intuitively. There is, I think, an electronic impulse between my eyes and my finger. But even this is not enough. I dream that someday the step between my mind and my finger will no longer be needed, and that simply by blinking my eyes I shall make pictures. Then, I think, I shall really have become a photographer." The master of the moment was, it seems, also a master of modesty.

■ Photograph by **Alfred Eisenstaedt**

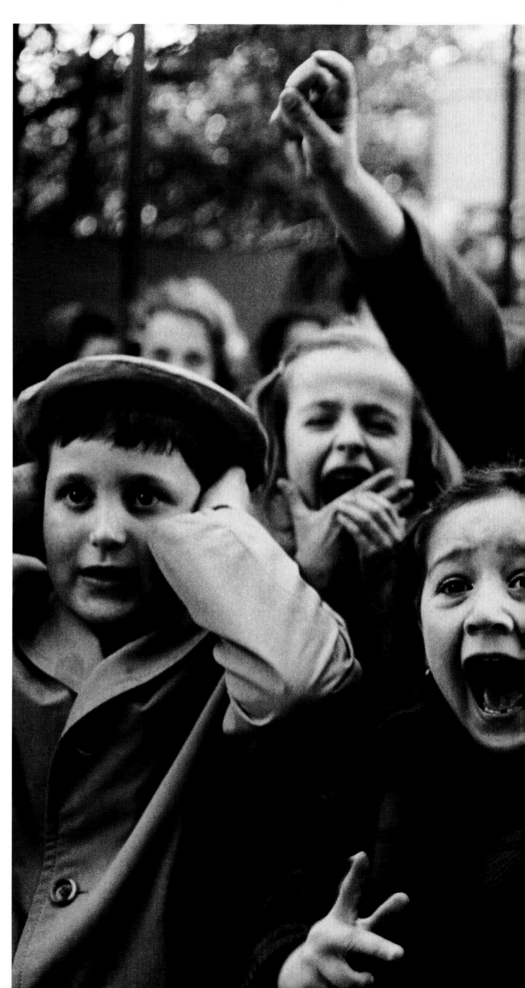

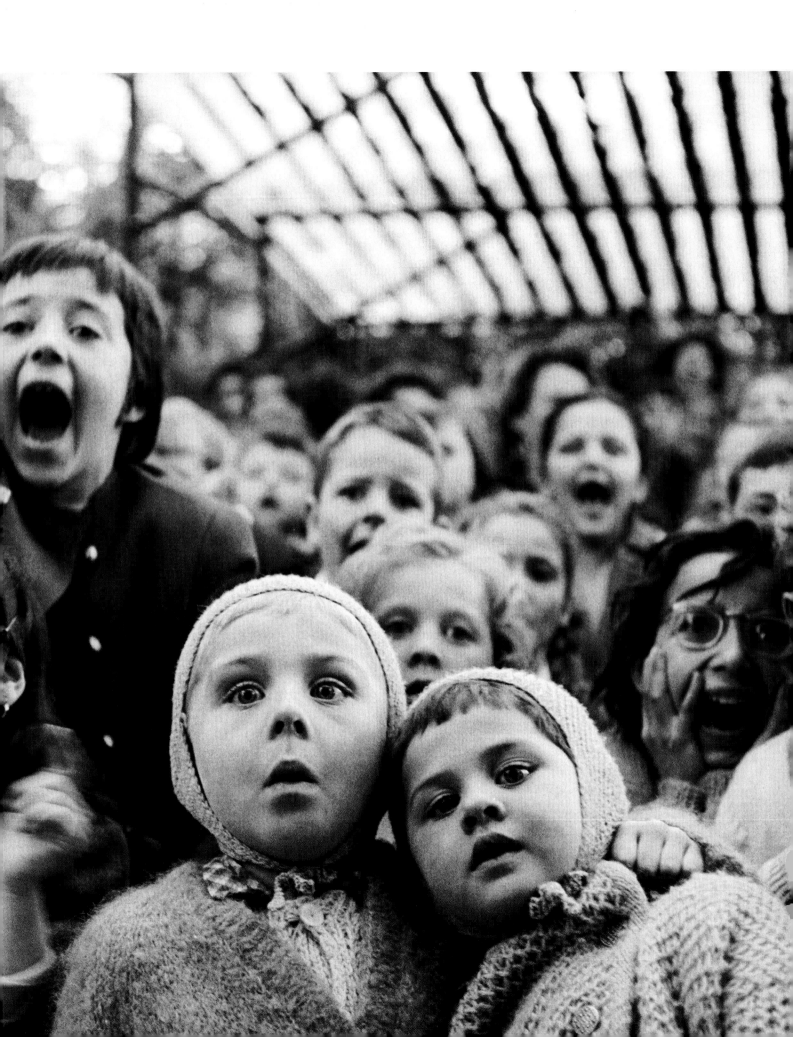

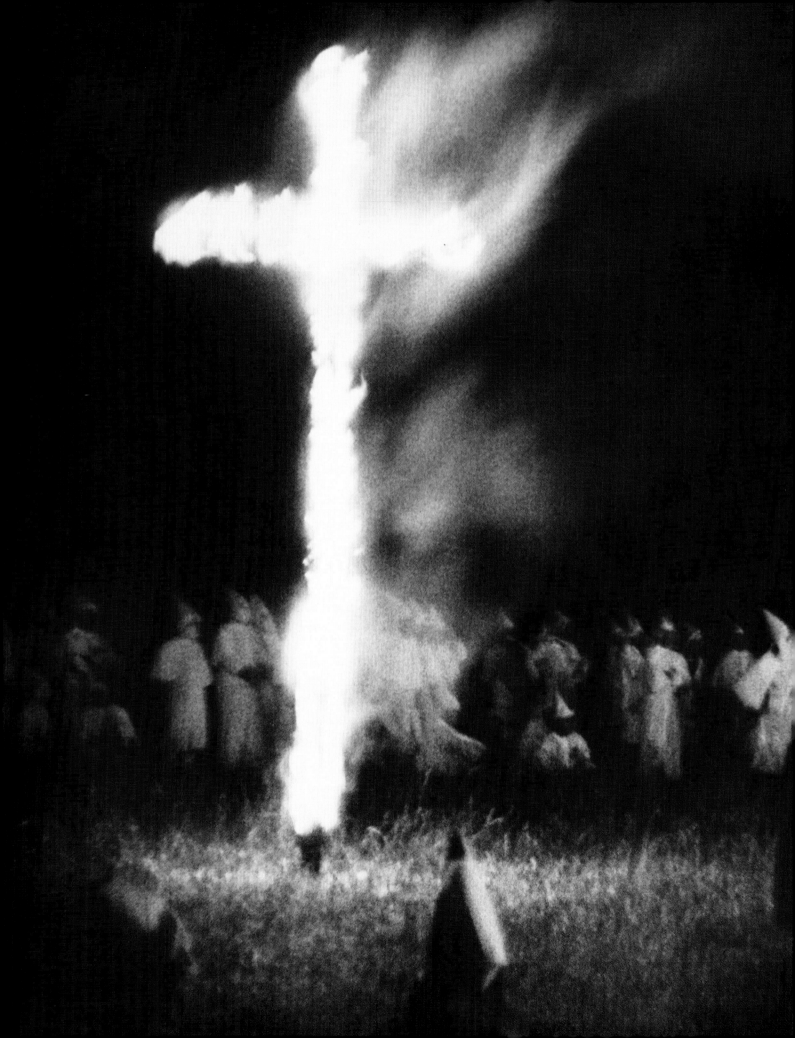

Above All, Truth

W. Eugene Smith was working up to creating another of his epic photo essays—a genre that he cultivated with moral purpose as well as skill and talent in the mid-20th century—when he had the opportunity to photograph a KKK rally in North Carolina. It was a mind-bending experience for the Kansan, and, he readily admitted, it deeply affected his subsequent project, "Nurse Midwife," a landmark photo essay about a South Carolinian black woman. "I admit the KKK meeting was a strong dose of poison to receive at the beginning," he wrote his mother in April 1951. "The leaders spoke in warped, vicious hatred that disregarded truth almost completely, while the majority of the 'common folks' who agreed spoke out of ignorance warped by the ravings of the leaders." From time to time during his career, Smith would run afoul of magazine editors because of his insistence on controlling the way his work was used. But rather than a matter of ego, this seems to have been a reflection of a fierce emotional involvement with his subjects, and a fanatical dedication to the truth in each picture. "Photography is a small voice, at best," he said. "But sometimes one photograph, or a group of them, can lure our sense of awareness."

■ Photograph by **W. Eugene Smith**

A Not-So-Simple People

The rainforest in southern Mindanao, in the Philippines, is a place that for centuries was rarely entered by outsiders. So in 1971, it was fascinating but hardly beyond belief when reports began to emerge of a major anthropological discovery there. Some two dozen people had been found living in caves. They knew nothing of agriculture or animal domestication. They were hunter-gatherers, dependent on nature, with tools made of stone and scant clothing that was fashioned from orchid leaves. They were called the Tasaday, and they were a gentle people with waist-length hair who had no words for *weapon* or *war.* The picture here was part of an article that appeared in *National Geographic.* In 1974, in the wake of a media circus hosted by one of his cronies, President Ferdinand Marcos declared a large area of land around the Tasaday off limits to outsiders. After the corrupt Marcos was toppled from power in 1986, a journalist named Oswald Iten went to the rainforest, but found the caves empty. He finally located the Tasaday living nearby in simple huts and clad in jeans and T-shirts. Incredibly, according to Iten, the Tasaday told him they were local farmers who had been paid to act like cavemen. They laughed at their pictures in *Geographic.* Then, a little later, other reporters found the people again wearing leaves. One anthropologist referred to them as "rainforest clock-punchers" who dwelled in caves by day and returned to their families at night. In short, a bizarre tale, and there is a good chance the exact truth will never be known.

Photograph by **John Launois**

Creature of the Night

U sher H. Fellig was born in Austria in 1899, and moved to America with his family at age 10. Eight years later he was on his own in New York City. His particular take on that town in the late 1930s and '40s is a peculiar artistry—tawdry, lurid and incomparably vulgar images that are also masterpieces of composition, of lighting, of immediacy. By then he called himself Weegee (the origins of the name are open to debate), and he was a furtive habitué of the night, prowling the streets for crime, for parties, for anything in which life itself was on parade. He was never without his Speed Graphic camera and Compur flash unit, and the trunk of his car served as his darkroom. At left is Weegee's best-known photograph, *The Critic*, taken in 1943. Making their way to the Metropolitan Opera House are a couple of swells, Mrs. George Washington Kavanaugh—plastic surgery has left her face an eternal smiling mask—and Lady Decies. The identity of the third woman remains unknown, but not her opinion. One might say that this picture is ample evidence of Weegee's uncanny sense of the moment. But it's much better than that: This was the Met's opening night, and its 60th anniversary. The scene was certain to be jammed with social celebrities. Weegee had an assistant named Louie Liotta pick up a woman on the Bowery at 6:30 p.m., and she was given as much vino as she could handle. Or maybe even a little more. When the patrons began arriving, Weegee had Liotta hold the woman up near the door. When Weegee saw this duo stepping out of their limousine, he signaled to his partner, who released the woman. According to Liotta, "It was like an explosion. I thought I went blind from the three or four flash exposures that Weegee made within a very few seconds." As for Weegee, he maintained that he noticed the third woman only after developing the film.

■ Photographs by **Weegee**

A Grim Carnival

This troubling image of young Lebanese Christians, playing with a looted mandolin as they stand by the body of a dead Palestinian girl, was taken in Beirut by the Briton Don McCullin, a veteran photographer of war and other dark subjects. In January 1976, he was there as Christian Falangist fighters "cleared out" Quarantina, a Muslim neighborhood in Christian-dominated East Beirut. When McCullin saw the body of a dead man, a Falangist soldier told him to put his camera away. "Take no photos, my friend," he said to him, "otherwise I kill you." McCullin persisted through several more threats (and rolls of film). Later, it was the Muslims who threatened his life, thinking he was a Falangist spy. Still McCullin persisted, when he happened upon this scene. "My mind was seized by this picture of carnival rejoicing in the midst of carnage," he wrote. "It seemed to say so much about what Beirut had become. Yet to raise the camera could be one risk too many." Ironically, one boy invited McCullin to take a picture, so he took two quick frames. He knew he had what "would tell the world something of the enormity of the crime that had taken place." The Falangists knew too, and issued a death warrant for him. "I don't believe you can see what's beyond the edge unless you put your head over it," said McCullin, who escaped Lebanon by hitching a ride with two Japanese typewriter salesmen. "I've many times been right up to the precipice, not even a foot or an inch away. That's the only place to be if you're going to see and show what suffering really means."

Photograph by **Don McCullin**

Contact

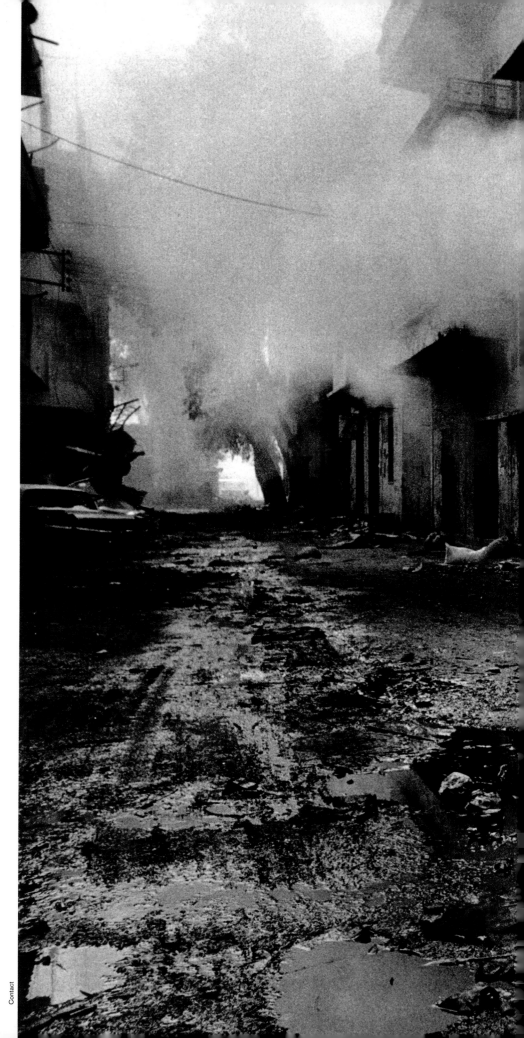

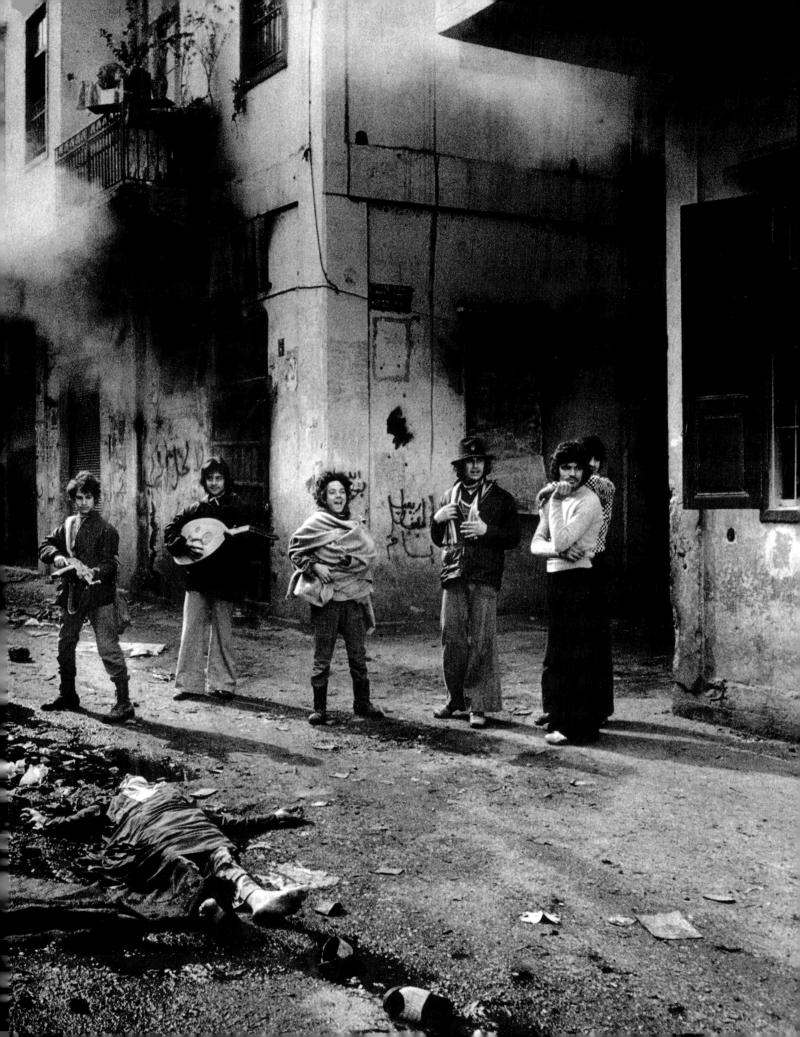

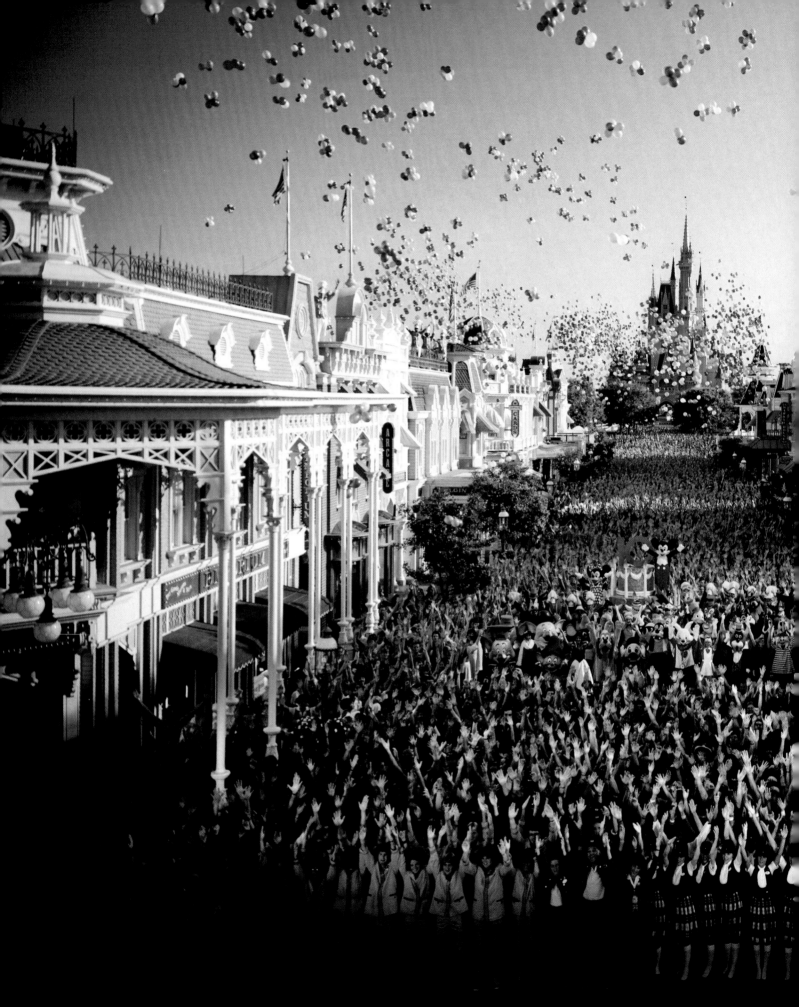

The Magic Kingdom

All successful photographers are aware of the power of the camera, and LIFE staffer Henry Groskinsky is certainly no exception. However, even Henry had to have been a little awed by a shoot he undertook in 1981. To mark the occasion of the 10th anniversary of the Walt Disney World debut, Groskinsky was assigned to take a classic "cast of thousands" photograph of park employees. "When I first set the picture up, I realized that I really needed everyone closer to the camera. So on the microphone [which was hooked into the park-wide P.A. system] I said, 'Would you take one giant step forward?'" Groskinsky recounted. Then—presto—5,000 people did, in unison. "It was incredible. I thought, 'My God, let me do that again.' I had them move up a little bit more."

■ Photograph by **Henry Groskinsky**

An Eye for Prey

The word *paparazzi,* the plural of the term, has its origins in Federico Fellini's 1960 classic, *La Dolce Vita.* In that movie there is a photographer named Paparazzo, who is forever sticking his camera into the faces of the famous. Fellini concocted the term, saying it suggested to him "a buzzing insect, hovering, darting, stinging." While Ron Galella may not have been the prototype, he has certainly been the photographer who defined the form. With more than four decades of hovering, darting and stinging, Galella has caught thousands of famous faces at both their worst and, sometimes, as here with Robert Redford on his way to a cocktail party in New York City in 1974, at their best. Galella is, of course, most notorious for being ordered to stay 25 feet away from Jacqueline Kennedy Onassis (and even farther from her children), although he has had countless other brushes with public figures. One could make the argument that Galella has done as much as anybody to lay the foundation for today's omnipresent culture of celebrity.

Photograph by **Ron Galella**

On the Wings of Eagles

During the winter of 1929–30, Margaret Bourke-White, having already opened eyes with her original approach to industrial photography, was hired to take pictures of the construction of the Chrysler Building. (The structure would briefly lay claim to the title of World's Tallest Building, but only until the Empire State Building was completed, in 1931.) Deploying a camera in freezing temperatures from a dizzying height above the city pavement might have overwhelmed lesser souls, but as Bourke-White said in *Portrait of Myself,* "Heights held no terrors for me . . . My sister Ruth and I had a pact to walk the entire distance to school and back on the thin edges of fences. It was a point of honor to dismount only for crossroads and brooks." Clearly, she was quite at home in the aerie, as one day, on the 61st floor, she noticed work beginning on "some curious structures . . . When I learned these were to be gargoyles à la Notre Dame, but made of stainless steel as more suitable for the 20th century, I decided that here would be my new studio. There was no place in the world that I would accept as a substitute." Indeed that space did become her studio. There were two of these gargoyles outside her windows, and she called them Min and Bill, presumably after the 1930 film of that name starring Marie Dressler and Wallace Beery. Bourke-White often perched on the 800-foot-high gargoyles "to take pictures of the changing moods of the city." Here, in 1934, she is doing just that in a photo taken by Oscar Graubner, her longtime darkroom technician. Graubner was of incalculable importance to Bourke-White's career. He handled a hundred details for her, always with a shared perfectionism. And his abilities as a printer enabled the great artist's images to convey the subtlest shadings possible in black-and-white photography.

■ Photograph by **Oscar Graubner**

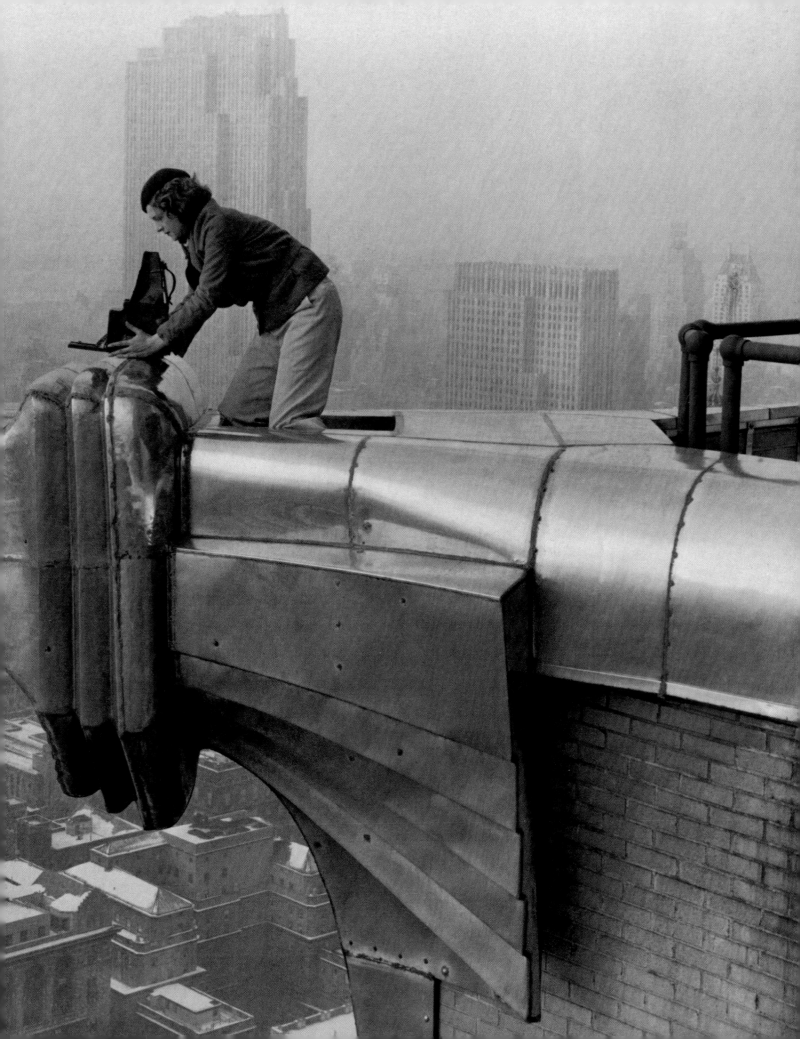

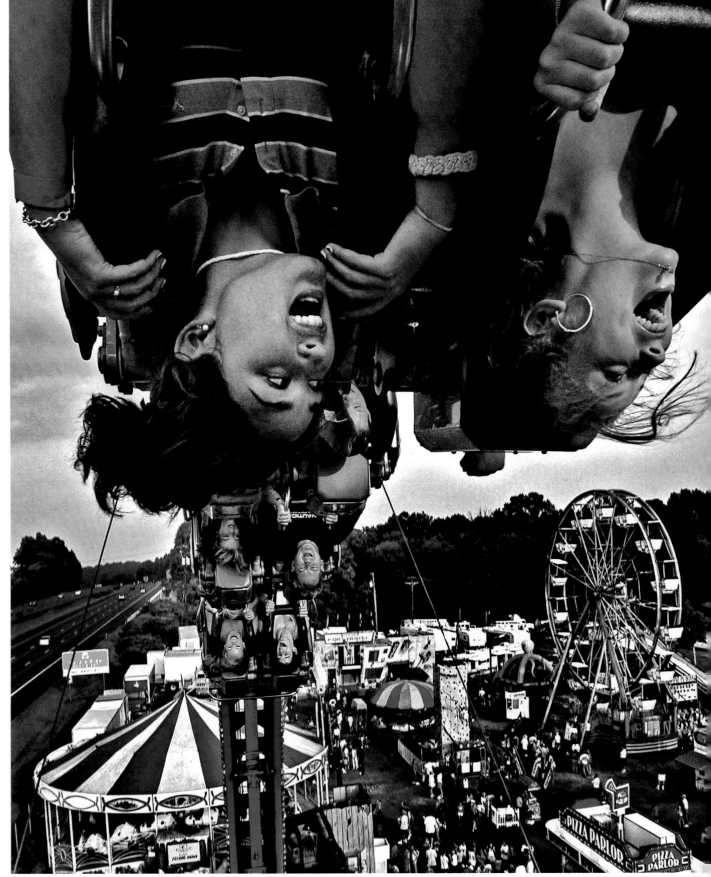

As the summer photography intern at *The Baltimore Sun* in 2004, Chris Detrick was covering the annual crowning of the Howard Country Farm Bureau Queen. There were rides at the fairground, and Detrick had loved roller coasters as a boy, so he hopped onto The Fire Ball. "I was nervous," he says, "but tried to focus on making good pictures." Chris got his shot, which is good, because some of the less intrepid among us would no doubt have stuck to the crowning of the queen—and terra firma.